CW01082520

the cinema of TAKESHI KITANO

DIRECTORS' CUTS

Other titles in the Directors' Cuts series:

the cinema of
TAKESHI KITANO

flowering blood

Sean Redmond

 WALLFLOWER PRESS LONDON & NEW YORK

A Wallflower Press Book
Published by
Columbia University Press
Publishers Since 1893
New York • Chichester, West Sussex
cup.columbia.edu

A complete CIP record is available from the Library of Congress

ISBN 978-0-231-16332-3 (cloth : alk. paper)
ISBN 978-0-231-16333-0 (pbk. : alk. paper)
ISBN 978-0-231-85023-0 (e-book)

Series design by Rob Bowden Design

Cover image of Takeshi Kitano courtesy of Sony Pictures Classics/The Kobal Collection/
Kumagai, Tsuranuku

Columbia University Press books are printed on permanent
and durable acid-free paper.
This book is printed on paper with recycled content.
Printed in the United States of America

c 10 9 8 7 6 5 4 3 2 1
p 10 9 8 7 6 5 4 3 2 1

CONTENTS

ACKNOWLEDGEMENTS

New ideas and moments of inspiration emerge in the unlikeliest of places, at the most unlikely of times. I have been caught by a revelation, found the right question, or the analytical solution to something that had been puzzling me for weeks, on the evening train, after a bad dream, at the playground with the kids, or while chilling out in front of the television. My best work though is always fashioned in and around the wonderful research being carried out by my students; their ideas, freshness and hunger to find a way out of a blind alley, is just the burst of energy I need to borrow on a Kitano blue day. In particular, while writing this book, Dick Whyte, Bran Gnanalingam, Allison Maplesden, Torben Antonsen, Kendra Marston, Brady Hammond, James Morris, Amber Johnson and Mark Ellsworth were all incredibly helpful to the journeying I undertook. Thank you. This is the sea.

for Josh, Caitlin, Erin, Dylan and Cael

Becoming Lost in Tokyo

I will begin this monograph by way of a detour of sorts: the story of my becoming lost on the streets of Tokyo, a cine pilgrim in search of Takeshi Kitano. I will define the cineaste pilgrim as the film fan that goes in search of the art and artist they most admire and who has left an enigma or legacy of some kind for them to discover. The cineaste pilgrim may also be captivated by a 'purer' phenomenological desire to find experiential truth in the great art, artist or star they go in search of. The cineaste pilgrim who journeys to the East, however, is arguably a culturally or ideologically heightened example of this awe-struck travelogue since their journey is readily connected to issues and questions of Otherness, Orientalism and stranger fetishism. My own desire to write about Kitano, to journey to Tokyo to find him, is placed within this sea of troubling contexts. In this introduction I ask the questions: *Why Kitano? Why me?* I place my own (Western) subjectivity centre stage. I then proceed to explain my position vis-à-vis film authorship and my critical and conceptual take on Kitano as an auteur of loss whose discourse of atomisation speaks across the waves. I conclude the introduction with an outline of the structure of the book.

The Cine Pilgrim

Film fans regularly make a pilgrimage to the locations of their favourite features, or to the birthplace or resting place of their favourite director, actor or star. At these holy or charmed sites they will re-enact the key scene(s) of the film, or try to get a better sense, get at a higher truth, of the artist they have gone in search of. A spirit of carnival invests these encounters, as does an imagined spiritual or transcendental sense of place, space and personhood. The cineaste pilgrim searches for the traces of the film in the real buildings, roadways, savannahs and forests, or in the bits and pieces of set that have been left behind. They excavate the site, measure the distances and depths they first

encountered in the fictional realm, and then they climb, enter into and focus on the space – setting their eyes like the camera or character in the film they imagine being. They visit the haunts of the figure they so admire in an attempt to understand their *real* motivations and desires; to find hidden secrets or truths about them that no one else has yet discovered. Since authenticity, originality, specialness or firstness invests these encounters, the cineaste pilgrim often wants the experience to be singular, interpersonal and magically one-to-one.

But the cineaste pilgrim can also want it to be a collective and communal experience involving a gathering of devotees dedicated to preservation, declaration and renewal. Candle-lit vigils take place at the sacred site. Flowers and wreaths are laid. Homages are enacted. Heart-felt poems and songs are written and read or sung out loud. Memories of the artist are shared. Photographs of the vigil or gathering are taken and pinned to public displays or posted on online memorial sites. Mementoes, merchandising and keep-sakes are brought out. Through these rituals, the dead actor, star or director is brought back to life, reanimated in the celebration and commemoration that is undertaken.

Nonetheless, this searching for the authentic site of the film and/or the artist is also often a commoditised experience, driven by commercial imperatives. In New York City, for example, organised tours take (international) film and television fans to iconic sites such as Times Square, Macys, Central Park and the Statue of Liberty, to reference their importance and to allow the pilgrim to directly re-experience one famous film or television sequence after another. New York is a cinema city, in part made legible and meaningful by film and other visual media (see Jermyn 2008). The flow of the city image and its marketability flood the real and the real dissolves into the image. As the publicity declares for a tour of the haunts and inspirations for *Seinfeld*, '"Seinfeld" aficionados may opt for Kramer's Reality Tour, offered by Kenny "The Real" Kramer, the man said to have inspired Jerry's colorful friend Cosmo Kramer'. The cineaste pilgrim – caught up in this frenzy of the hyperreal, further heightened and enchanted by guides and experts – consume the text, the textmaker, the actor-star, again and again, stop after stop, in a ghostly, in situ, reverberating inter and extra-textual relay.

Through this cineaste journeying questions about self-identity and belonging emerge. The cineaste pilgrim is a searcher, pleasure-seeker, hobbyist, cultist, escapee, dreamer, diarist, writer or fanatic, fleeing from self, culture and society while simultaneously looking to embrace the freedom of the experience they encounter. The cineaste pilgrim often finds quantifiable, metaphysical meaning in the text they go in search of. Perceived lacks are met, loneliness is negated, the sheen of the art-object is transferred, discoveries are made and rebellion is re-ignited. The pilgrimage may be gendered, queered or raced, such as the fan worship that followed the death of Leslie Cheung. It may be nostalgic, a yearning for the past the film or artist represent; and it may be taboo or questionable, involving the pursuit of a crime, murder or an unsolved enigma the film holds, or the dead artist raises. For example, Maro, on a movie tour of New Zealand, was so overwhelmed by a visit to the sheep farm in Matamata where Hobbiton was created for *Lord of the Rings*, she broke down:

I just stood there and cried. It was like, 'I can't believe I'm actually here … I loved the movie so much, and to actually be there where they filmed that, it overwhelmed me. (http://www.cnn.com/2009/TRAVEL/04/03/movie.tours/)

Another, widely reported story demonstrates the power of the film text to warrant cineaste journeying. In early November 2001, 28-year-old Takako Konishi flew from Tokyo to the US to look for the cash buried by Steve Buscemi's character in *Fargo* (Joel and Ethan Coen, 1996). Carrying a crude treasure map she'd drawn to lead her to the money, Konishi made her way to Detroit Lakes where she was later found dead from hypothermia. Konishi became a victim not only of the Coen Brothers' ironic ruse for *Fargo* (the film's opening inter-titles proclaim that this is a real event) but of America's constant commodity calling to the East. Ethnicity, 'once a genie contained in the bottle of some sort of locality … has now become a global force, forever slipping in and through the cracks between states and borders' (Appadurai 1993: 413). These cracks or leaks lead to multiplicities in the self and the self that travels, radically altering identity formation in local and national terms.

Eastern Multiplicities

John Thompson argues that 'mediated worldliness' has had a dramatic impact on how one experiences travel and arrival in the modern world:

> The diffusion of media products enables us in a certain sense to experience events, observe others, and, in general, learn about a world that extends beyond the sphere of our day-to-day encounters … So profound is the extent to which our sense of the world is shaped by media products that, when we travel to distant parts of the world as a visitor or tourist, our lived experience is often preceded by a set of images and expectations acquired through extended exposure to media products. (1999: 23)

The cineaste pilgrimage from the West to the East carries its own particular register of meaning, and can be situated within a wider colonial and post-colonial history in which one travels to the East to map and define it as Other (see Kaplan 1997). The cineaste pilgrim arrives having already had their expectations and visualisations set as Orientalist, in part, by the visual media. In and across adverts, videos, art works and films the chaos of India, the speed and density of Hong Kong, and the hi-tech, screen-drenched architecture of Tokyo has already been suggested, carried and cemented as a sensory signifier. Of course, when such an arrival involves the love of, and homage to, the art text or author, the engulfment is arguably heightened. The cineaste pilgrim arrives in the East expecting, hoping and yearning for the experience that the artist and the art object previously conferred. In search of the Other, the exotic-taboo, the mysticism and aura of Eastern film art and artists, the cine pilgrim searches for authenticity and transcendence in and through an art form that is imagined or *felt* to be more vital or more intense than one encountered in the West.

It is as if being here in the fictional-real East will double the intensity, rebirth the individual.

One can argue that this desire for the Other, for the strange, radiates out from a Western cultural centre that is lacking, and which stems from a need that is about both owning the exotic Other, and devouring or ingesting them so their energy becomes (y)ours. Jackie Stacey defines this as the desire to (be able to) get closer to the Other, to 'literally ingest otherness in consuming these exotic products' (2000: 104). In this context, the art of the 'strange' is imagined to give the cineaste pilgrim a more intense life experience – an experience that is hard to match within Western culture – and symbolic power over the Other. The cineaste pilgrim consumes the exotic Other in a process of cannibalistic exchange that Sara Ahmed, in a broader context, refers to as 'stranger fetishism'. Ahmed argues that through consuming the commodity (or art form) of the Other one is both making the 'strange' familiar and subordinate to the Western subject since such consumption confirms the 'subject's ability to "be oneself" by getting closer to, and incorporating the stranger (a form of proximity which produces the stranger as *that which can be taken in*)' (2000: 133).

East Asian Extreme Cinema is packaged and promoted in the West as offering the viewer a transgressive, consumptive experience of the Other *like no other*. This is an experience that breaks formal and thematic cinematic conventions, and tests ethical and moral positions, particularly around gore, bad taste and perversion (see Hunt 2008: 224). Tartan Metro's now defunct 'Extreme Asia' label, for example, offered the Western viewer a diet of horror and exploitation films that pushed boundaries, very often making the Eastern female body and oriental eye the cornerstone of much of the marketing, and the supposed conduit of pleasure for filmgoers.

Taking Ahmed's position from above, the carnal, orientalised body of the East, laid out on the embodied screen, is taken into the body of the Western viewer in a cannibalistic-like ritual that promises them renewal and regeneration. The cine pilgrim extends and deepens this practice and can be imagined to be little different from the sex tourist, journeying to a heart of darkness, where they are to be revitalised and renewed through ingesting Eastern extreme film. As Jackie Stacey suggests:

> By consuming global products, the Western subject and the exotic other are thus reaffirmed even as such a dichotomy is apparently transcended by the appeal to a universal global culture. (2000: 104)

In a similar manner, one can argue that 'Cult Asian Directors' are branded as particular figures of Oriental genius and difference. Miike Takeshi, for example, is identified in advertising as an agent-provocateur, whose insides-out horror oeuvre tests (Western) decency. Similarly, one is asked to consume a Miike Takeshi film like one is taking in the violent and cool Eros of the Japanese – although through the cult authorship framework one's latent Orientalism is effaced and given critical or artistic legitimacy.

The cult Asian director invites cineaste journeying since they are given 'rare' qualities that appeal to the Western devotee. Takeshi Kitano, another cult Asian director, is marketed in the West as an auteur whose work straddles populist and art cinema

Kitano on the set of *Zatoichi* (2003)

aesthetics and conventions. Kitano's place within a pantheon of great Japanese direc-
tors (particularly his indebtedness to Yasujirô Ozu) is highlighted, as is his 'inscruta-
bility' and unknowability. It is suggested by Western critics that Kitano shifts his posi-
tion in interviews, works across many generic forms, and plays with the interviewee.
Such media commentary – such branding – confirms his Otherness while legitimising
his artistry so that the former is displaced.

Nonetheless, one can also or alternatively argue that the desire to travel to the East,
to experience the spaces and places where Eastern cult films are set, and to pay real-
time worship to its directors and stars, cannot be so easily read as an West/East power-
saturated binary opposition and the re-articulation of Otherness. I would suggest there
is light in this Eastern cineaste journeying so if I may take a moment to take up a
criticism of the position just outlined.

First, the core/periphery model once espoused as defining the relation between
the West and the rest/East has been severely criticised. It is recognised that culture
(art, goods, services, rituals, myths, people) flows and folds in complex, intense and
irregular patterns and connections. Second, the binary term, East/West, may well be
too homogenised, one that ignores or effaces the multiplicities of differences that exist
within and across these very broad regions. Third, there is much evidence to suggest
that a 'global' text is transcoded at the local level; that it is interpreted through the
lens of the culture (subcultures) it is received in. Finally, with the so-called Asia-
nisation of Hollywood and the Hollywoodisation of Asia, mainstream American
and Asian (Japanese) film texts are often (and perhaps always have been) bricolage
constructions. With franchise remakes such as *Ringu/The Ring* (Hideo Nakata, 1998;
Gore Verbinski, 2002), and the increased migration of key artisan figures, technicians

and directors from Asia, the industrial context shifts also. The influx into America, for example, of Hong Kong artisans in the 1980s included John Woo and Jackie Chan. Similarly, the high concept, blockbuster design of American film has impacted on the production of (big budget) features in Korea, Japan and Hong Kong. As Scott Nygren argues,

> The destabilisation of the cultural object is further displaced once we recognise that a rhizomatic networking of multiple mirroring has developed, so that the Japanese community in Brazil produces films such as Tizuka Yamasaki's *Gaijin* that are seen in the United States and Europe, US pop culture is appropriated in different ways from Spain to Indonesia, and so on. It quickly becomes impossible to specify a cultural construction according to any central or binary schema because all such schemas now circulate among multiple sites across the world. (2007: 2)

In summation, cultures and art forms commingle. In this sense, much of modern life involves a circular, wired-world experience. But much of global life is, as I will subsequently argue, atomised. All this to say that the journey of the cineaste pilgrim is one borne out of complex, multi-layered influences, needs and desires. The Western cineaste pilgrim, who may be residing in a country, city, neighbourhood, where ethnic cultures of all kinds mix and conjoin, may not be journeying to Hong Kong, Japan, China or Korea to simply taste, consume or cannibalise the work of the artist that they have gone in search of. The journey may be much more substantive and phenomenologically enriching than that.

Becoming Lost in Tokyo

This is my first extended visit to Japan and I am lost in Tokyo. I am here in search of Kitano, to interview him, and to somehow find the arterial pulse of his films in the urban jungle where a great deal of the drama takes place. I guess I am led by the sense that being here in Japan will get me closer to the films in spatial, representational and thematic terms. I am excited by the prospect of finding something of the Japan that Kitano has created on screen. While it is true that I am here to do research for an academic book, I know also that I journey as a cineaste pilgrim or a devoted fan, hoping and anticipating that something new and original (about Kitano, his films, Japan, *me*) will take place while I am here. These would be revelations and transformations not just scholarly dry but existentially, phenomenologically wet.

It is true, in a mediated sense, I have been to Tokyo before through the consciousness of Kitano's film work; through much of the Japanese cinema I am a fan of; and through a whole interconnected web of images, associations and narratives that the media have offered me. I immediately recognise the topography of the city, the lines and shape of the Shibuya district; the architectural mix of the old and the new; the concentration of building and people across vertical and horizontal axes; the face masks; the giant, pulsating video screens; products and foodstuffs, labels and elec-

tronics; and a multitude of Japanese signs that I have seen flicker before me in advert, television show and film text. As I wander, the perceptual clichés run on, one after the other, their familiarity 'strange'.

If I am a devouring cineaste pilgrim then what I may have been confirming and consuming was the 'difference' that attracted me to Kitano's film work in the first place. I was a stranger (Western academic, cineaste pilgrim) fetishising the Other (Takeshi Kitano, Kitano's Japan) as I walked the streets of Tokyo. However, these ethnicised signs or signifying systems was not a total or an exact way in which I met and was greeted by Tokyo. Neither did it feel like I was projecting my Western fantasies onto or into the Japanese Other. In fact the centre of my self was not holding, the city slid from view, and in this experiential sliding, Kitano's film work emerged in ways familiar but shockingly new.

I am lost in Tokyo in the realm of the senses. Unsure of direction, district, and overwhelmed by size, noise, smudged movements and flows, I tremble a little. While I attempt to read the signs I am familiar with, to perhaps unconsciously replay the films and adverts, and to re-view the photographs and guidebooks that might help me navigate or root myself, the experience of Tokyo is too sublime, pregnant with firstness, to be fully legible at the representational level. I have *not* been here before, no amount of virtual trafficking can prepare me for the (un)reality of the city, or fill me up and close me off so that I experience or rather read the city second-hand.

I am experiencing these moments of being lost through chaotic physical sensation: my body wavers, my fingers fumble, and my eyes strain to touch those things that it sees – my haptic attempt to ground the floating world in materiality. I am dizzy from the possibilities that open up before me in this liquid state of being-in-the-world. The experience is terrifyingly pleasurable, a state where, 'truth happens … with extraordinary awesomeness' (Heidegger 1975: 68). I have been lost like this before, at home and in other 'foreign' spaces I have travelled to. I have been lost like this in films in which the image is defamiliarised or overwhelmingly spectacular or affecting, or the narrative fragmented and full of multiplicities. I have been affectively lost like this in many a Kitano film in which through ellipsis, enigma and primal carnality, language and perception failed me. I am finding that being lost in Tokyo is exactly like being (a character) lost in a Kitano film. This is a delicious experience. For me this is an experience of cinesexuality, that is,

> … the desire which flows through all who want cinema as a lover. It knows no gender, no sexuality, no form, and no function. Cinesexuality occurs in a particular space of relation between spectator and cinema. What cinema is cannot be known, its affectivity and our ecstasies are limited only to the extent we limit desire … cinema brings to us the unbearable excess of the simplest planes within an image … We desire cinema as an intensity, which creates a particular aesthetic terrain. (MacCormack 2008:1)

Presently lost in Tokyo I experience what Deleuze might describe as a cinematic 'any-space-whatever' moment of essential heterogeneity so 'that the linkages can be made

in an infinite number of ways'; I am in a 'space of virtual conjunction, grasped as pure locus of the possible' (Deleuze 1989: 109). My experience of being a cineaste pilgrim lost in Tokyo very much registers as an actualised time-image. The loss I experience of temporal and spatial connectivity, replaced by 'incommensurable', non-rational links, creates a situation in which void and disconnected spaces begin to appear before my eyes, in front of my fingers, in my entire dazed and confused sensorium.

As a consequence, my journey, which at this moment registers as free or outside of material time, much resembles the inner, psychological journey that the protagonist takes in the time-image film (in the Kitano film, in fact). This I would suggest allows me to experience time directly, again in much the same way that one witnesses a direct image of time (a time-image or crystal-image) in the time image film; in a Kitano film. I experience the time of a Kitano film in Tokyo Time. I am experiencing a perfect(ed) moment for the cineaste pilgrim, one in which author and text come new to me, so that an intense 'doubling' and 'splitting' revelation occurs in, through and with my body. Of course, one can read Kitano's authorship as a continuum of doubling and splitting, of temporal and spatial shifts, as if he/his films are a body-without-organs, as I will go on to argue below.

I am lost in Tokyo and this pure experience of time opens me up to an infinite number of possibilities and potentialities. This is overwhelming, dreadful of course, since without representation or language to hold onto, I am adrift of the world. But this is a strangely familiar form of an experience that I know too well, and one which I would suggest haunts modern life and living. I am experiencing a feeling of atomisation, of being alone in the world that is too fast, too socially and culturally disconnected, too disappointing to hold true to. The fan-self or the free-self is one of the few things I have to invest in, and to empty, replenish and refill the atomic with.

One can argue the cineaste pilgrim belongs to a neo-tribe populated by people that are self-conscious, self-aware and bio-politically hybrid, particularly around what were once represented to be fixed and essentialised determinants of the human condition, such as gender roles and sexual preferences. The cineaste pilgrim is part of a tribe that places feeling and emotion before language and rationalism. The attraction of belonging to a neo-tribe is that they provide a spiritual home for the isolated, possessive individual of the liquid modern age who has no other social network to belong to, or no other ontological 'truth' to believe in. As Zygmunt Bauman argues, 'tribes are simultaneously refuges for those trying in vain to escape the loneliness of privatized survival, and the stuff from which private policies of survival, and thus the identity of the survivor are self-assembled' (1992: 25). Neo-tribes emerge because 'in political terms, identities are in crisis because traditional structures of membership and belonging inscribed in relations of class, party and nation-state have been called into question (Mercer 1992: 424). The experiential journey of the cineaste pilgrim, their desire to commune and connect in pure time moments, speaks to a desire to invest atomisation with self-realisation and becoming, a becoming that is a body-without-organs: 'When you will have made him a body without organs, then you will have delivered him from all his automatic reactions and restored him to his true freedom (Artaud 1976: 571).

The body-without-organs is the self dismantled and pure potential, 'made in such a way that it can only be populated by intensities. Only intensities pass and circulate' (Deleuze & Guattari 1988: 153). My journey to Tokyo, to find Kitano, is an intense illustration of this becoming-lost in the folds and flows of various assemblages or 'haecceities', affects, subjectless individuations' (1988: 266). What I experience on the streets of Tokyo is what I experience or take from a Kitano film: sublime atomisation, the loss of the body, of self-image, on a 'plane of immanence' (Deleuze 1989: 27).

Nonetheless, as numerous cultural and historical scholars have indicated – and to draw back from my Deleuzian free-radical riff for a moment – one can read contemporary Japan as a particular or profound site of atomisation and its art work as deeply implicated in representing and effecting this liquid modern condition. For example, one can look to the J-horror film for an indication of this traumatic rendering of the Japanese self:

> The dominant tone of Japanese horror seems to be hysteria, propelled chiefly by Japan's mastery … of industrial and post-industrial capitalism … Images of out-of-control madness, bloodshed and mass destruction are often connected quite blatantly … with corporate capitalism's assault on the very institutions and values its superstructure says it holds dear: the home, the family, the community, the sanctity of the individual life. (Sharrett 2005:xii)

Similarly, the contemporary yakuza film, the youth-rebellion film and the post-human *anime* film deal with narratives and images of loss, disenfranchisement, alienation, the dissolution of the family and self-hatred (see McRoy 2005a). Woman is often found to be monstrous and masculinity unable to hold the social centre together. At the same time, there is a yeaning and a longing for the past, a nostalgic dreaming of what once was and what might be again. There is a rejection of the present at the same time the present is invested with the past that can reclaim and re-make it. Like much of contemporary cinema, then, Japanese film is caught between competing sentiments or ideologies or discursive formations that challenge one another in the text.

If one were to briefly summarise Kitano's oeuvre, one would find characters exiting in neo-tribes, or in traditional tribes torn asunder by liquid modernity. One would see a struggle between past and present, tradition and the modern, and the local and national, in spaces not vertically and horizontally organised but in matrixes that fire off in all directions. One would see Otherness as a determining quality but a strangeness not tied to simple us/them binaries, an alien alterity that shifts sides and folds into itself. One would see a film form caked out of temporal and spatial disjunction and images of time and melancholic reverie. Of course, the figure of Kitano I would suggest sits at the apex of this struggle, a struggle he performatively embodies.

Many Faces Kitano

Casio Abe (2004) has argued that Kitano the 'serious' filmmaker is involved in an ongoing battle with his alter-ego, actor and television comedian Beat Takeshi. This

contest or collision takes place in the flesh of the film actor and television comedian through carnal disintegration. Kitano the cool and cerebral film author directs Beat Takeshi the actor to be a melancholic and violent Other who kills and suffers physical loss. When starring as television personality and comedian Beat Takeshi, mayhem and madness ensue, and jokes about and with the body structure the various shows he appears in. There are at least three versions of Kitano in play: the artistic film director; the violent actor; and the crude comedian, each persona existing on the margins of cultural norms.

From an Orientalist perspective, inscrutable filmmaker Kitano seems decidedly Japanese. However, as the actor he seems to be both in the mould of the Japanese patriarch and lone wolf figure, and also part of a contemporary American tradition of melancholic and alienated protagonists who fail to understand the world (see Nicholls 2004). Beat Takeshi's comedy routines seem to borrow from American screwball as well as Japanese comedic tradition such as *Manzai* vaudeville, which renders him a fusion figure made in both West and East. The *real* Kitano, of course, states that both these personas are just that: performative modes or 'dolls' that he pulls the strings of (see Gerow 2007: 11). Even if taken at face value, Kitano quickly becomes a person of multiplicities – one somehow real and two performed. That there are Eastern and Western coordinates to these personas enable him to occupy a liminal space in the global/local, transnational/national imaginary and marketplace. That Kitano can contradict himself from one interview to another, and can offer different and sometimes competing reasons for decisions made, again point to the layering of the presentation of his author-star self, and the gaps that emerge in and between his film and television work.

I have elsewhere defined the contemporary state of celebrity as being one of liquidity, borrowing and developing the term from Bauman's work on late modernity (2000). Liquid celebrity is a condition in which famous people offer fans multiple nodes of heightened connectivity for emotional security and enrichment. The liquid celebrity figure is an avatar whose multiplicity (in meaning and affect) and availability or accessibility renders them perfected vessels for psychological investment and the hope of self-renewal. In an age of atomisation and rabid consumerism and individualism, the celebrity figure represents the epitome of, on the one hand, this terrible/terrifying lightness of being and, on the other, becomes the dominant way through which people can experience attachment and togetherness. One consumes the celebrity as if they will grant them access to an inner-world of greater connectivity and to a social centre where one becomes a member of a neo-tribe of fans. One is given a sense of self that has new meaning in the world. The problem with this is that the attachments are built on liquid connections and these very often run dry after a while.

Kitano is a liquid celebrity but one whom critically self-reflects on this mode of being in the world. In one sense, his multiple personas allow for various fan connections to be made, and for commercial gains to be made. As Aaron Gerow suggests, 'his different personalities remain separate, strategic positions for managing the Japanese entertainment world' (2007: 4). One can access Kitano as a cult Asian director,

an auteur, a Japanese auteur, an actor, writer, comedian, television host and political spokesman, for example. However, this is not simply a question of auteur-star-actor-artist-entrepreneur taking up different positions but rather one in which their liquid propensity enables them to flow from one to the other without easy demarcation or differentiation.

Kitano, I would suggest, is aware of the nature of celebrity and deeply affected by its pull in a Japan, in a world order, where connectivity and belonging have been weakened, and replaced by para-social relationships and hyperreal attachments. Kitano's self reflexive gestures, his play with persona, and his films which deal with the many faces of alienation, atomisation and Otherness, point to a liquidity that aims at its dehydration. There is a self-destructive tendency, a pathology that haunts his public and film and television work. There is a self-hatred and a self-love that mixes at the centre of his output. He is a figure of atomisation, he calls it into being and, as a consequence, he calls into question liquid modernity and liquid celebrity.

This, I think-feel, is what I have come in search of, a death-instinct driven by a desire to taste life differently, on the streets of Tokyo, in the streets of a Kitano film. In a very real sense, then, this liquidity is the end and the beginning of things. Kojiro Miyahara has suggested that in the Kitano film one is offered the representation or subjectivity of the 'vertical other', an alien alterity that cannot be known or fully understood (2008: 112). This vertical other disturbs identity positions, calls them into question, and renders them liquid. Like his films, Kitano is a body-without-organs.

One can find this watery reality in other contexts. It is found in the way he moves from film genre to film genre; in the way he plays with, subverts and mixes generic forms; and in his formal minimalism and 'subtraction' and yet replenished imagery deeply rooted in and uprooted from Japanese tradition. It is found in his shifting temporal and spatial axes, and in his sudden shifts in tone. As one can see my approach to Kitano is an auteurist one, albeit awash with a force or sensation that heats and cools this very notion.

Authoring Kitano

In many everyday conversations that I have with fellow film scholars and students, the name of a director is often (unconsciously, matter-of-fact) used to badge a film, or to group them together. It is the short-hand way to try to begin to describe a viewing pleasure or dislike, or to frame thematic, formal and ideological consistencies and prejudices. Value judgements, a 'criterion of value' can be attributed; and questions of identity politics tied to the appraisal. A passionate investment in the work of the director in question can light up a conversation and burn the ears. As scholars, we are all versed in post-structuralism and we have read Barthes, Foucault and Deleuze. A number of us studied film through the filter of cultural studies (in my case, British cultural studies) or Screen Theory. Nonetheless, the sheer delight we find in expressing ourselves through a vary basic authorship framework catches me every now and again because it holds such sway and yet in an academic context is so disputed and dismissed. I wonder if the intimacy that a favourite director may offer us is another emotive sign

of the fact that we live in an age of 'togetherness dismantled' (Bauman 2003: 119), an age where we long for a mass, technological art form to be connected to at the personal level?

Of course, the various branches of the film industry package, promote, distribute and exhibit movies through the persona of the film director. Their name will be found on posters and in trailers, in interviews and commentaries, and in merchandising streams. As already noted, feted film directors can be brought together under other collective banners such as Cult Directors and New Wave Filmmakers. Awards, funding, honours and receptions are organised and structured to recognise and promote the worth and value of the filmmaker.

In theoretical terms once we begin to recognise film authorship as discursive speech acts and a commercial construct, we move away from the romantic position in which the film director crafts a film text in their own image, to one where they function to serve various social and cultural interests. This is a critical position where language and power is argued to operate in the service of a political reality that masks or generates a worldview. As Foucault argues,

> The author does not precede the works; he is a certain functional principle by which, in our culture, one limits, excludes, and chooses; in short, by which one impedes the free circulation, the free manipulation, the free composition, decomposition, and recomposition of fiction … The author is therefore the ideological figure by which one marks the manner in which we fear the proliferation of meaning. (1998: 221–2)

I would like to take a different position to authoring Kitano in this book, one that returns us to the personal and the intimate. In one sense, there is no doubt that meaning happens at the point or the moment of reception. A viewer needs to make sense of the text they come into relationship with before it can be brought into the cultural world. Language, representation, subjectivity honed in the cultural sphere impact upon the reader as they do the makers of the text. The text is encoded, there are preferred readings and a degree of polysemy which renders it an interpretive space in which differing readings can emerge. The author is but just one sign in a sea with others. These texts are ideological or part of discursive formations involved in power networks and so the readings seem so readily to be tied to this relatively limiting, pacifying framework. And yet, I would suggest that not only is reception itself a more active and unwieldy process but the reading of the text is never only just about language in its widest sense, but feeling in its carnal sense. As Vivian Sobchack observes,

> As 'lived bodies' (to use a phenomenological term that insists on 'the' objective body as always also lived subjectively as 'my' body, diacritically invested and active in making sense and meaning in and of the world), our vision is always already 'fleshed out' – and even at the movies it is 'in-formed' and given meaning by our other sensory means of access to the world: our capacity not only to hear, but also to touch, to smell, to taste, and always to proprioceptively

Kitano as an assemblage
in *Hana-Bi* (1997)

feel our dimension and movement in the world. In sum, the film experience is meaningful *not to the side of my body, but because of my body*. (2004: 60)

Kitano emerges as an author for me because of the way he takes me outside of my body, through films which readily offer any-space-whatevers, time images, alien alterity and a sensorial engagement with the flesh. It is the loosening of language, an unfixing of an interpretative framework and a liquefying of the viewing experience that brings Kitano into the living world. That his own authorial persona is itself a body-without-organs, that he is a self-reflexive liquid celebrity complicates the experience further. One is *overwhelmed* by his films. In a more direct academic sense, Kitano is an assemblage, a network or nodule through which these texts and images emerge.

In a very real sense, the author Kitano is within me: while culture produces the cult of the author, and culture defines (gives language, identity to) the individual, there remains a bodily experience of the world that slides in and between the way one inhabits the world. I have used the term 'liquid' to define a range of ideas in this introduction so far; it is the condition of late modernity and the celebrity; it is my experience of Tokyo; it is avatar Kitano and his shocking filmwork. These forms of liquidity flow into one in another, in terrifying and terrifyingly liberating or freeing ways. In authoring Kitano I am attempting to connect self, fan, scholar, liquid modernity, alterity, Otherness, atomisation and becoming. In this becoming lost I hope to show that Kitano's work, or my experience of it, has radical potential.

* * *

The book has been organised to map a journey through Kitano's films. Each chapter grows out of the next, while themes, issues and sensations rise and fall between them. The book ends where it begins, just like a number of Kitano's films, its circularity not a mark of sameness but (my) shifting intensity.

In chapter one, *Time, Space and Whatever*, I explore the temporal and spatial coordinates of a Kitano film, linking them to the time image, the memorial image, and to the specificities of urban living and nomadism. I introduce or further contextualise some of the key themes of the book, particularly around colour sensation and the body without organs. I begin to establish the radical and transgressive potential of his work in terms of its ability to take the viewer beyond or through the limit. Kitano's artistic

aim, I will contend, is to enter chaos, embrace catastrophe, so that his work can see/sense beyond language and entertain thoughts outside of subjectivity.

In chapter two, *Flowering Blood*, I explore the affecting, troubling, carnal power of violence as it manifests in the Kitano oeuvre. Violence is not understood to be singularly physical but built into the emotional fabric of the Kitano film world. I define this type of violence as the pain image. Pathos wraps itself around Kitano's entire film universe. The chapter also explores the way in which the wounded body and the tactile, somatic qualities of red blood functions in affecting life and death moments of pure becoming. I go on to explore how the camera is involved or implicated in the forceful intensities that mark his work out. In summation, the chapter attempts to understand violence as not just acts, or feelings, but blocs of sensation that heat and wet the Kitano filmworld.

In chapter three, *Intense Alterity*, the focus is ostensibly on identity and subjectivity but this is filtered through the theme of otherness and alien alterity. Kitano's films are populated by minority characters, and are structured around a peripheral vision that draws attention to visibilities usually hidden or masked in much of mainstream cinema. Otherness, however, is also internal; it rises up in every character, so that gender and sexuality is called into question. The chapter links this bodily splitting and deterritorialisation to transformations warmed by liquid modernity. Alien alterity in a Kitano film is an awesome realisation, one framed in terms of the double sublime.

In chapter four, *Starring Kitanos*, I explore the multiple personas that mark out Takeshi Kitano/Beat Takeshi. I connect a particular type of embodied performance to stardom and celebrity culture. I then explore the national and transnational qualities of Kitano, addressing questions of Occidental Orientalism and self-orientalising projections and phantoms. The damage that fame can do is explored in relation to Kitano's own struggle with fame. Beat Takeshi's role in Takeshi Kitano's films not only suggests a fragmented or multiple self, but at the level of physical or corporeal performativity, and facial expressivity, he produces a silently brooding, melancholic presence that is the exact articulation or representation of masculine *mono no aware*, and existential exhaustion. Beat Takeshi's presence also of course gives embodiment to the director: Kitano's authorial signature, his concerns, his sense of things is given phenomenological 'body' through (Beat) appearing in nearly all his films.

In chapter five, *This is the Sea*, I explore the sea as a particular type of liminal heterotopia where time is unwound, and sensations lost in the urban world are newly found or re-ignited. The sea and the beach are the most significant sites for this limitless becoming. They are the places of play and of contemplation; a retreat, the last 'exit' and the point-of-no-return. They are feminine and enigmatic; a timeless landscape in which time has stopped and yet where it is running out for those who have gone there to escape and rejuvenate. The chapter suggests that Kitano uses the beach and the sea to play out the liquid politics of time in an attempt to find new temporal realities beyond the horizon of representation.

In the conclusion, *Standing Outside Office Kitano*, I draw the main threads of the book together while taking a closer look at Kitano's trilogy (*Takeshis*, 2005; *Glory to the Filmmaker*, 2007; and *Achilles and the Tortoise*, 2008). This destructive/deconstructive

tendency is read as a further indication of Kitano's artistic desire to ruin representation, enter catastrophe and emerge with pre-perceptual and asemiotic forces. Kitano's 2010 art exhibition, *Gosse de Peintre*, housed at the prestigious Fondation Cartier on the Left Bank in Paris, is explored in terms of the body without organs. Finally, I end up at Office Kitano, where my journey will hopefully begin again. Which after a two-year pubication hiatus it does: I return to Kitano's violent underworld, exploring *Outrage* (2010) and *Outrage Beyond* (2012) as a final statement in his death and life journeying.

Time, Space and Whatever

From my hotel bedroom window I can see two lines of electricity poles, their thick, black wires cross-connecting them all the way down the street. It is raining and the depressed clouds draw the grey buildings into their heavy stomachs. Rain drops burst open, illuminated by car headlights, or else they melt into the dark, just beyond the limits of my perception. Tokyoites below my window walk in Kitano slow-motion. It is time to go out.

Introduction

A number of authors have suggested that one can trace developments and transformations in Kitano's film work as if there is a certain formal and thematic trajectory to his output. The critical periodisation of his films, linear in approach, is often accompanied by a complaint that there has been a decline and a selling out, with Kitano becoming more mainstream and conventional in his aesthetic choices and arrangements. Kitano has himself suggested that his films can be grouped into three periods (see Jacobs 1999), with his motorcycle accident in 1994 (in which he was seriously injured) providing the catalyst or impetus for two breaks in his work. Kitano has said that there are those films made before the accident – *Violent Cop*, 1989; *Boiling Point*, 1990; *A Scene at the Sea*, 1991; *Sonatine*, 1993 – those films made during his rehabilitation period – *Getting Any*, 1995; *Kids Return*, 1996; *Hana-Bi*, 1997; *Kikujiro*, 1999 – concluding with the US co-production, *Brother*, 2000 – and a final, reclamation period that begins with *Dolls* in 2002.

Ryuichiro Tsutsumi (2006) sees a similar periodisation in place, analysing each set of films in terms of a dominant theme with the final film in the group acting as the purest embodiment of that particular 'project' or phase. *Brother* thus becomes the film in which the theme/issue of doubling presents itself in its purest form. Bob

Davis (2003) and Tony Rayns (2003) both suggest a movement away from the radical, raw and personal energy of his films up until *Hani Bi*, to an impersonal, commercial aesthetic made with one eye on the international market. The complaint that Kitano's early film work was radical or a 'pure cinema' (see Yamane 1993), and that in his later work he increasingly adopted formulaic continuity principles, is a dominant one. While Aaron Gerow refuses to offer a periodisation of Kitano's work, instead opting to look at each film in turn, recognising inconsistencies, 'divisions and contradictions', there is nonetheless an implicit recognition that in the early films his approach is oppositional and parametric, while more recent films become 'deliberate and expressive' (2007: 57).

My approach to Kitano's oeuvre also refuses to delineate in such ways. The complexities in the articulations between biography, culture and the practices and processes of filmmaking, render such attempts at periodisation at best unhelpful and at worst fraudulent. Any film history that attempts to propose an evolution or revolution of some kind is fraught with ideological and determinist leanings. Film history – in this instance, Kitano's filmwork – is made in the folds and flows of competing, uneven and intense articulations. As suggested in the introduction to this volume, I see multiplicities and reverberations in, across and *in-between* Kitano's films. Certain themes, stylistic traits, temporal and spatial relationships, and modes of camera-consciousness rise and fall, contract and expand, changing their elemental states like the atoms, liquids and gases that they are really made of. Kitano's film work 'heats' and 'cools' but in patterns and circles or sheets, in a commingling of past, present and future; and in a splitting and a conjoining that destroys and reassembles film time, or Kitano time as I will go onto argue. Again, I would like to utilise Deleuze's philosophical exploration of cinema and of the time image film in particular, to give theoretical grounding to the analysis of Kitano's filmwork that will then follow.

Deleuzing Kitano

For Deleuze, (cinema) history should not be understood as an organic process in which one traces origins and their developments to some inevitable, chronologically determined conclusion. Rather, it should be understood as that which arises from taxonomies or classificatory systems. For Deleuze, images and signs 'emerge in stratigraphic series, sedimented at unpredictable angles and betraying so many peculiar intersections' (Flaxman 2000: 24). Deleuze's history of cinema, which borrows heavily from Foucault's work on genealogy, considers there to be two particular, articulating taxonomies of the film image in play, that between the articulable (discourse, statements, utterances) and the visible (made from, out of a plane of light and the machinery or screens of vision). Articulable cinema, found predominately in the movement image, in the first part of the twentieth century, is rendered inherently or fully representational, in the service of representational cliché and action that is (pre)determined. Words, sounds, dialogue fix the image, the narrative action, holding it in the grip of a power geometry that impoverishes free-radical thought and truth. By contrast, visible cinema, 'corresponds to the emergence of a new episteme' (Flaxman 2000: 25), or the

development of a culture that effortlessly produces 'light'. This new episteme emerges after the end of World War II.

For Deleuze, this flooding of light into the cinema world produces a break or disjuncture between the articulable (movement and action) and the visible, which because of its luminosity, its zero degree possibilities, is or can be unhinged from the determinants of sensory-motor schema. After the end of World War II, in Europe particularly, Deleuze suggests that cinema gives birth to the time image (images of immanent light) in which what is said, spoken and acted upon is less important or determining than the overwhelming potential of the visible put before the viewer. In the time image film, narrative causation, chronology, the inevitable happy ending or hermeneutically sealed closure, are not just decentred or denied but brought together in accents or peaks of view, and aspects or layers, so that they are dissolved and blended into multiple layers of time and free-floating images of time.

Deleuze argues that in the time image film there are sheets of past which coexist between past and present, each sheet having its own characteristics. As he writes, 'the image has to be present and past, still present and already past, at once and at the same time … The past does not follow the present that it is no longer, it coexists with the present it was' (1989: 79). Because the time image film emerges out of slices of time, cleaved into existence through discontinuity editing; because its visibility emerges in character silence, narrative ellipses and causal gaps, and out of multiple and impossible links and articulations, all of time (all of thought) can be found there. For Deleuze this has radical potential since once the covenant between movement and time has been broken – once narrative logic has been washed away by time – the image can have an overwhelming truthfulness about it, allowing one to experience 'a thought that stands outside subjectivity' (Foucault 1990: 15).

I would suggest that Kitano's filmwork can be read (felt-thought, screen-sensed) in terms of these coordinates. His oeuvre is best understood as that in which past/pastness, present/presentness and firstness/thirdness commingle and wrap themselves around one another. The awesomeness of the Kitano film in terms of its timeless atomisation asks the viewer to face themselves in thought and contemplation as they are rendered a body-without-organs. The many bodies and faces of Kitano flood the image – as author, actor, star, modernist, traditionalist, nationalist, sadist, fascist – and such incongruent multiplicities demand a wrenching and a cleaving of order. To take his films in turn, or to look for 'breaks' or developments would do serious damage to the real of Kitano time and the way he and the viewer 'become' in a tidal flood full of possibilities. The approach to his liquid aesthetics (to his assembly of the time image), then, is not one where I look to see a vertical and/or horizontal progression, but to the sheets and circles that mark his work out.

While Deleuze marks out European Art Cinema as the primal scene of the time image, because of the trauma, violence and chaos that the war produced, I see in Kitano's filmwork the opportunity to mount a case for a 'minority cinema'. This would be a calling to Japan's own cultural annihilation post-Hiroshima, its ongoing American occupation, and to its version of 'infantile capitalism' and continuing economic woes read by some scholars in light of the social pressures facing Japan during the Heisei recession.

Marilyn Ivy (2000) has argued that the Heisei recession which bankrupted Japan during the 1990s led to the destabilisation of Japan's national imaginary; and to its imagined sense that one belonged to, was apart of, a unified, prosperous nation state. In the introduction I drew on the idea of the neo-tribe adrift in a liquid world, unable to root themselves, in an attempt to connect political and cultural context in and through the Kitano text. But to draw on Deleuze again, one might rephrase this as a form of 'nomadism', arising from a Japanese people with a profound sense of the loss of land, subject to continuing and effortless deterritorialisation, and left, therefore, with the terrifying, 'pure force of becoming' (1988: 478). That Western viewers also experience this loss of self and terrifying power and potential of the self remade, is testament to the fact that liquid modernity is a global condition and we will each find, albeit in 'local' or immediate ways, its awesomeness.

Deleuze considers French filmmaker Alan Resnais to be the one who best encapsulates the full potential of the time image film since he has passed through a historical time of death, therefore embodies living death, so that the image he conjures up – be they of the Holocaust or war or personal loss – consistently trembles on the cusp of expiration. Kitano has also passed through a death (the death of Japan's hierarchical Emperor System, the death of traditional Japan, his near-death due to his motorcycle accident in 1994) and so his images are full of unspeakable trauma and inexplicable light. They are found with life and death (present, past and future) organised in concertina sheets undulating before the viewer. Let us now find the time, the death, and the light in the becoming of a Kitano film.

Kitano Time and Space

In many ways Kitano's films display the conventions of the European art film, although these supposedly distinct qualities can actually be found in Hollywood cinema, and across a range of independent films produced worldwide. Of course, Kitano's films stutter in their use of discontinuity and anti-narrative techniques with internal shifts and movements across his work. Nonetheless, one finds in his films, in varying degrees or states, a number of art cinema conditions. Firstly, he regularly employs narrative/narration devices that contradict, unsettle or undermine the coherency of the fictive world, such as multiple diegesis, narrative ambiguity, character inaction and alienation, ellipses, story and plot circularity, and aperture or non-closure. Kitano's films often end on an ambiguous freeze frame or image-stillness, or an off-screen event that should end the film but registers as open-ended, or else they return to where the film started.

Secondly, temporal and spatial relations are rendered chaotic, and fluid vertical and horizontal axes emerge to de-centre and realign point of view, viewer knowledge and comprehension. A pre-representational and fragmentary 'seeing' (by characters and viewers alike) dominate perspective, particularly in terms of images that are cut free from their signification chain, such as blocs of intense colour found across the screen image.

Thirdly, key narrative images are haunted by memorial logic, and death in all its metaphysical or existential contexts rises up to shock the image into a plane of imma-

nence where existence falters. For example, Kitano's films often involve impossible, inter-subjective flashback sequences, and future-looking 'death' dreamscapes that come true, touched as they are by the death-in-the-life of the character that has willed them.

Fourthly, the image and cell-shot are often in collision, graphic mismatches and extreme tonal shifts rock, this way then that, the film's affecting capabilities. One shot can be minimalist in design, structured by vertical lines and hard edges, the next can be concentrated, filled with thick shapes or the violent movement of action.

Finally, there is a high degree of self-reflexivity: Kitano's own liquid sensorial authorship is leaked into, or rather pulsates through the films as he alludes to and reconfigures his own love/hate relationship with cinema. Kitano references his own film and television work, the work of other Japanese filmmakers, and the 'qualities' of his television persona, Beat Takeshi.

Kitano's oeuvre can of course be referenced against such filmmakers as Yasujirô Ozu, as Mark Freeman has done (2000), in which through his 'transcendental' use of spatial and temporal relations the ghost of Japan's aesthetic past rises up to re-claim and re-make the present. He is thus a filmmaker one can transplant into the canon of great European art filmmakers, and also be read as a 'new wave' Japanese filmmaker appropriating and reiterating the *mu* and *ma* (empty but full, and full of intensity) spaces of great Japanese directors such as Ozu. Kitano may also be a minoritarian or an intercultural filmmaker refusing, rejecting and re-framing the twin traditions that bear down upon him. As Laura U. Marks suggests,

> In intercultural cinema there is an additional, more overtly political suspicion of the image, given that its clichés bear the weight of dominant history. For many works of intercultural cinema, then, the image is barely a beginning, and any extension into narrative must be hesitant, or suspicious. In these works still or thin-looking images are the richest. (2000: 42)

This is another form of multicplicity or splitting that I will address in the next section, below.

If one was to disassemble the rather crude contents list of a Kitano film cited above, one would see linkages in the way time and space is foregrounded, cut up, dissociated and washed with possibilities and potentiality. In a Kitano film, the relations in and between shots are often broken, contested or realigned so that there is narrative ambiguity, and the resulting temporal and spatial coordinates liquefy. Vision, knowledge and understanding are questioned and/or freely activated, both from a character's point of view and in terms of viewer positioning, so that representational language cannot get to the sense of the thing that is being witnessed. The Kitano fictive world is often in constant flux so that one asks or rather one sensorially experiences (in silence) a recurring sense of doubt over *where to now?*; *why there?*; *where here now?* This 'bend' in sufficient reason leads to an experience in which one becomes a body without organs. Let me give a structuring example from *Dolls*, before I begin to develop my analysis, point-by-point below.

Where to now?

The part of the scene I am analysing occurs close to the beginning of the film: so far the viewers have been introduced to the tale on which the film is based or rendered from, and they have observed the two wandering lovers (beggars) carry on an ill-defined journey, connected by a red rope or umbilical cord that binds them. *Dolls* opens with a *bunraka* or traditional Japanese puppet theatre performance of the double-suicide play which metamorphoses or transitions into the life-like Chubei and Umekawa dolls seemingly bringing the realist-fictive world alive – their glance towards the camera a signal for the 'real' story to begin. This is the moment the film cuts to the two wandering, mute lovers (although this has to be interpreted as such) attracting the stares, gazes and ridicules of people they pass by. But *where to now?*

Shot 1: 'establishing shot' of a church with a white carpet leading to its pristine doors. *Is this a flashback? Is this a parallel-cut?* Non-diegetic music plays over the image, the same melancholic refrain from the shot before. *Where are we now and why are we here?*

Shot 2: (dissolve): a well-dressed man moves towards the camera, which moves from high to level angle to meet him at the exact point where another well-dressed man enters the shot from the foreground. His walk is filmed in slow-motion, and the non-diegetic music is again carried over from the last shot but slowly fades to leave only silence. *Why does he walk in slow-motion; why has all sound been bled from the shot?* The two men begin a conversation, as diegetic sound is restored, where bits of narrative information are revealed. We know or we can now guess that this is a wedding scene and the Groom, Matsumoto (Hidetoshi Nishijima), has chosen to marry the boss's daughter, jilting his long-time girlfriend, Sawako (Miho Kanno). *But who is the groom? What is the relation between this scene and the wandering beggars? Where to now?*

Shots 3–13 involve a conversation between a son (*Matsumoto?*) and his parents, cut together in a shot/reverse-shot pattern with 'impossible' subjective or memorial shots cleaved into the arrangement. Mother and father are asking their son to break off the arrangement with the girl he has proposed to. Of the eleven shots, only one is of Matsumoto, with the other shots picturing father or mother in close-up, or in a two-shot, in an intense direct address. The weight of their faces bears down upon the son we take the position of. Dialogue is out of sync, the image having being slowed down while the speech acts occupy 'real time'. Temporal and spatial dynamics seem hallucinatory and intrusive. *Whose memory of this event are we witnessing, taking subjective part in? Is this a moment of deterritorialisation where the bodies of the characters and the viewers begin to slide and slip?*

Shots 8–9 are from the wedding itself: first of the radiant bride, then of the bashful bride's parents, thus further complicating the memorial and temporal logic of the previous shots. *What has happened to past-present tense? Are these two*

shot-images the parent's future-dreaming of the day? Is it a cutting back to the present left behind in shot 2?

Shot 10 and 11 return us to the past-present, with mother, then father and mother pleading with Matsumoto to give up the girl. Shot 12 is of Sawako (but we have to guess or presume this because of the affecting power of the insert) laughing with Matsumoto (although he is marginalised in the shot, clinging to its corner). *Whose memory is this?* The dialogue laid over the image – 'I can't leave her' – suggests it belongs to him. The patterning of the sequence should (might) have cut back to his position but instead we get his memory image. *What is past, what is present, what is future in this sequence? Whose subjectivity are we being aligned with? Is this a real memory insert? How can we tell?*

Shots 13–15 return us to the wedding day, although it is again difficult to discern continuity or temporal order. In shot 13 a blank-faced Matsumoto is facing his parents, and the camera, in a clear reversal of the positioning of the characters from shot 3–12. Silence is again momentarily drained away and Matsumoto's movement seems to be in slow-motion. In shot 14 a medium, panning shot of a contended father, who says 'congratulations', is followed by a shot of a beaming mum who says 'I am happy for you'. *Is this still their future-dreaming?* The shot is configured as if it is Matsumoto's point-of-view but we cannot be certain of this because of the continual displacement of looks and looking so far established. Shot 15 returns us to Matsumoto's face, as he looks at something off-screen. *What is he looking at?*

Shot 16 is an outside tracking shot (*why outside again?*) returning us to the *mise-en-scène* of the first and second shots. The camera pans the congregation, as they idly chatter, as it moves towards the church. However, shot 17, on screen for a very short duration, cuts into this lateral movement. The shot is of two characters not yet intro-duced or established, directly addressing the camera. *Who are they? What time and space are they in? Is this whom Matsumoto was looking at, in his peripheral vision, at the end of shot 15? But nothing matches?*

Shot 17 returns us to the lateral, tracking shot, ending when the two well-dressed men from shot 2 can be clearly seen laughing together in the background of the shot. *Is this again the present of the film? Where to next?* One cannot be sure in a Kitano film...

In a Kitano film one experiences different manifestations of time, of temporal and spatial relations. I would suggest that these are connected to interior and exterior states of being in the world, and to the different ways time is ordered and regulated, wound and unwound. This relates to not only the diegetic world of the film but the world of the viewer in what I see as a conjoining sea of affective immersion in and between these shifting or liquid fictive and factual constructions or taxonomies. In the urban encounters and in the exterior settings they are in part composed of – on the shifty streets of Tokyo – there is a powerful sense of the fragmentary but all-encompassing

potential of the metropolis as it impresses on the character and viewer that experiences it. This is, of course, in part due to the way Kitano cuts most of his films, with long, still/static shots of long duration edited against shots that may be decanted or from which a character or object is blocked or foregrounded, or in which violence suddenly emerges, or dialogue delivered as if in direct address.

Quick cuts or slices of time that are juxtaposed against shots of duration are not particular to Kitano's work of course: Eisenstein's theory of montage favours such collisions since this violence stirs the audience and politicises their senses, 'the maximum effect could be gained only if the shots did not fit together smoothly, but instead jolted the spectator' (Gomery 1991: 117). Similarly, Kitano's recurring use of ellipses and elliptical cutting (when an action/event is cut short) while not unique or singular, works to foreground the instability of time and the 'thought' of time as characters and viewers are encouraged to experience it. The viewer experiences jolts, as do the characters, although these jolts are better understood as intense blocs of sensation brought into being through images in which, rather than regulation and precision (as found with the montage cut), there is pure, unregulated potential. In *Hana-Bi*, for example, we watch the assassin throw the rose petals he finds on the beach into the air. There they take on a life of their own, hanging, falling like they are being propelled by an inner potential or quality. The graphic match cut that follows, to an in-flight red Frisbee, thrown by the gangsters he is intent on killing, connects their movement, flight and the heat of the red. Murakawa (Beat Takeshi) attempts to shoot the Frisbee out of the air but fails miserably and yet the 'blood' that has wet both these shots (and which can be found throughout the film) prepare the viewer for the red death that will follow. The rose petals and Frisbee loose their objectivity existing in a visible or luminous state:

> Visibilities are not forms of objects, nor even forms that would show up under light, but rather forms of luminosity which are created by the light itself and allow a thing to exist only as a flash, sparkle, or shimmer. (Deleuze 1988: 52)

Whatevers

As suggested in the introduction, in the urban settings of a Kitano film one is faced with an any-space-whatever, as if the looseness of Tokyo or its specific districts and locales overwhelmingly rises up before one, while producing a realisation of optimum choice in the world the moment they do. Even though stillness (in the shot, character and camera immobility) and its corollary, silence, dominate, the sound-image is nonetheless a moving, speeding void that has to be scoped and entered, heard and felt. Two orders of time are witnessed: the slow, melancholic time of the still(ness) image left for too long on the screen to fulfil any obvious narrative purpose, and the chaotic time that one finds freely firing in the image as soon as carnal contemplation takes over. Time and one's sense of time seems to be both slowed down and speeded up, given an ephemeral quality while also being meaty, sonorous, possessed by the flesh of the screen, the character and the viewer. Buildings, facades, faces, tonalities and signs

emerge in the realm of the senses and in this still/moving, free/restricted, silent/loud reverie, the anomic is fully realised and ultimately surpassed. In *Dolls*, Sawako has become obsessed with a toy pink puff-ball. She blows it incessantly, its aerial dance an enchanted release from the entrapment of her own mental breakdown. In one shot the pink ball flies so high it almost falls into the cradle of the crescent shaped moon. In another, an aerial shot of the yellow car they have been travelling in is framed in a horizontal to vertical relationship with the black tarmac of the road. In the space where the two thickly coloured axes meet, the tiny pink ball can be seen rising and falling, a sign of life, movement, in a frozen landscape.

There is an elective affinity or structural homology between the violent becoming in the dreary, grey city of a Kitano film, and the cataclysmic becoming one experiences on the city street, in an age of liquid modernity. In a useful comparison, Siegfried Kraucauer, writing about film and modernity in the 1930s, sees the city film attracted to the damaged, the marginal, the homeless, to 'the refuse' that constitutes its/the cities pulse:

> The affinity of film for haphazard contingencies is most strikingly demon-strated by its unwavering susceptibility to the street – a term designed to cover not only the street, particularly the city street, in the literal sense, but also its various extensions, such as railway stations, dance and assembly halls, bars, hotel lobbies and airports etc. (1997: 62)

One can readily connect this description to Deleuze's idea of the any-space-what-ever, to the nomad, and to the increased intensity that one finds in the contemporary metropolis. In fact, Kracauer's sense of 'fleeting impressions', 'flow of life', 'kaleido-scopic sights', 'loose throngs of sketchy, completely indeterminate figures' and 'inces-sant flow of possibilities and near intangible meanings appears' (1997: 72), conjures up the full terrifying possibility of the city as a void and space of redemption and unknowingly provides a bloc of sensation that defines Kitano's city work.

In a contemporary world, where capital time is minutely regulated and accounted for, where it is measured and fetishised in the service of schooling, work and consump-tion, and where people are constantly on the run, on the move, or left out of time (the disenfranchised, dispossessed, the nomads and the drifters of the neo-tribes), Kitano time connects with and re-expresses these out of kilter, helter-skelter reali-ties. While in contemporary mainstream, transnational cinema, time is also of utmost urgency – nothing remains still or silent for any length of time – this is due to faster cutting speeds, constant action and reaction, and spectacular visualisations. Kitano, by contrast, reconfigures time/cinema time in ways which liberate ones senses and sensa-tions. Jacques Ranciere (1998) suggests that Kitano creates a powerful pathos from stillness, and an overwhelming visuality from the suspension of movement. In *Boiling Point*, for example, silence and movement is employed to tremendous affect particu-larly where violent action forces itself into the image. At the end of the Okinawa sequence, the two gangsters Takuya (Hiroshi Suzuki) and Uehara (Beat Takeshi) catch up with Masaki (Yûrei Yanagi) at the airport. While Uehara waits in the car, Takuya

gives Masaki a bundle of cash and a 'butterfly eggs' card which is intended to comically explode on opening. In a series of parallel edits we move between Masaki and Uehara both of whom are entombed in silence and move, if they do at all, in slow-motion. The final cut between them is predicated on Masaki opening the card; however, the comic explosion of butterflies we should witness is circumvented by the graphic edit which has Uehara being gunned down in his car and the associated blood bursting out of his body.

Empty Space

There is also something particularly intense about the time of empty or insignificant interior spaces in a Kitano film. As Freeman suggests, they are often dwelt upon, do little to advance the narrative but act as vectors for transcendental realisations and profound moments of (unconscious) contemplation:

> The emptiness of the hospital in *Hana-Bi* echoes this purpose. With his wife dying, and Nishi bereft on a number of levels, Kitano's concentration on the emptiness of the corridors both follows the Ozu tradition, and acts as a resonant metaphor. These narrative pauses ostensibly do nothing to further the narrative, yet they allow us an opportunity to consider what we have seen, and to dwell on the emptiness before us. (2000)

One can also connect Kitano's spaces of silent, unconscious contemplation to Daoist philosophy where the void holds the key to creation, and to the Western concept of negative space and the collapse of language, particularly when faced with the trauma of the unspeakable as marked in events such as the Holocaust or the disposable project of modernism and liquid modernity. Of course, trauma doesn't just belong to the collective but manifests in intimate encounters in which when faced with self-annihilation one passes into a new realm of possibility. The hospital corridors in *Hani-Bi* hold the meaning of Nishi's wife's unspeakable death, and they register Nishi's (and the viewer's) ability to see into this space the 'performative presence of non-being'.

Deleuze argues that when we come to experience Nature sensibly, in terms of its 'immanence to experience itself', sensation is itself revealed to be a cauldron of forces, intensities and potentiality (2001: 25). One sees and senses beyond and before the natural form of objects and their relations to the non-organic life of things. When one purely senses, when the chaos of time and space is fully realised in the image, one is experiencing at that moment a nonhuman or inhuman becoming. In Kitano's empty spaces, where language has failed, and where death eats away at the image, one becomes non-organic, 'oblivious to the wisdom and limits of the organism'; one becomes a body without organs. This experience of non-being, where one resides at the point of uncontrollable becoming, is a force that one cannot comprehend, where, to repeat an earlier refrain, there is a bend in sufficient reason. This is, to use Kant's formulation, the dynamical sublime where, faced with the awesomeness of the world and its pure potential, one becomes a borderless mass as the terror of it takes one over

Death as an impossible reincarnation
in *Boiling Point* (1990)

(1987: 23–9). In this primal state of inhuman or non-human becoming, one is raised to a point of life beyond nature, where one is reborn again.

In *Boiling Point*, Uehara engages in a miraculous, future-predicting daydream sequence as they travel to get even with, or to get an advantage over, the yakuza gang they owe money to. Filmed with the windscreen reflecting lines and shapes into his body, and through a series of four rapid cuts, Uehara sees himself commit murder, crouch in a field of flowers (with a crown of flowers on his head), have sex with his girlfriend in the car, and die in a hail of bullets and flowering blood. The four shots link violence, nature, sex and death, in an explosive mixture of bodily borders being breached and welcomed. Uehara lives each of these moments subsequently in the film, but as a body that has already tried them on, death and all, in an impossible reincarnation.

Nonetheless, these silent spaces also work to bring sheets of the past – Japan's failed history, aesthetic antecedents and the authorial ghost of Ozu – into the body of the Kitano film. These contemporary 'pillow shots' or 'cutaway still life' are like memorial images that can be arrested from the narratives in which they occur. They rise up and float, connecting different points of Japan's cinematic history – as a present and past that greet one another. This, if I may make a more traditional auteurist claim, is Kitano's (un)consciousness impacting upon the time, space and membrane of the film – a yearning for that which has gone but which can be brought back into being again, if one only contemplates for long enough.Shigehiko Hasumi (quoted in Gerow 2007) has argued that Kitano's work is like a state of unconsciousness and his stripping away of artifice, of the literate and the obvious, is a form of 'subtraction' rather than aesthetic minimalism: what gets left is a telling nothingness that reverberates into something profoundly full.

To return to the question of performance itself for a moment, actors are required to offer little in the way of emotion in a Kitano film, their expressionless faces and silent or inactive responses to dramatic or violent events rendering them blank canvases. At the level of corporeality, they exist but barely, and this nothing existence, conjoined with the detached shooting style that Kitano often favours, creates another type of negative space where thought and free-indirect interpretation comes alive. Kitano is often an improvisional director, his actors asked to respond to minimal instruction, bare scripts, and each other in live, instantaneous exchanges. What emerges from such improvisation is an asemiotic cinema that takes his characters (and the viewer) from the realm of representational cliché to a new time image made up of intense sensations.

Kitano's directorial style demands that he happens on the accidental and blindly falls into the abyss of the sublime. In an interview with Makoto Shinozaki for *Studio Voice* magazine in November 1997, this is how Kitano responds to the following question about the hospital scene in from *Hani-Bi*:

> *Even in the shot at the hospital, there is a bunch of brightly coloured flowers by the door. Was that something you put there for the shoot?*

> No, it happened to be there. I told them, if you see flowers during the shoot, film them. When we went to the beach, these fish happened to be jumping so we shot it. There is no significance to those shots. You could have a man and a woman on a beach, and a third person and that person would mean nothing to the couple. Even if you share the same shot and space, there is no relationship. It's like that in real life – things that are completely unrelated exist side by side. It's the same with the flowers. You see flowers there and you don't know why they're there, but they just are. I'm not shooting the flowers with some heavy significance but I'm introducing them as bits of colour. The red of a flower in the blue. It paves the way to all the primary colours in the paintings.

For Deleuze, art should have as its goal the eradication of representational cliché (2003) or those images, sustained in signifying practices and discursive formations, that blinker or control or limit our ability to sense the world freely and uniquely. A new image-sensation cannot emerge until the artist destroys the cliché, a 'catastrophe' that leads to immanence. Kitano very often works with representational cliché, with film genres that have a historical weight fashioned on repetition and reduction. And yet, through his particular cinematic 'diagram' or abstract and experimental assemblage, he comes to a new type of sensational experience. His revisionist, re-building of the film genre leads to timeless creation in which multiplicities emerge as if for the first time.

Memorial Images

In interviews Kitano has often commented on the fact that the ideas for his films start with images rather than a story or from a well-worked script. Images cut free from story, and that materialise in the mind's eye of the author-director, can be timeless and yet memorial in form. They screech into view, take one over, run themselves into one's very being. Thinking of this now as I pause from writing, I can see Kitano lost in a moment, gripped by the image that has come to pass, staring out of a window, past the vast expanse of sand and onto the sea.

Kitano, of course, is nearly always materially and memorially present, in the guise of his alter-ego Beat Takeshi. The signification of the actor-star persona is accumulative, self-reflexive and inter-textual, with each performance 'haunting' the next, carrying with it a particular set of semiotic registers and performance cues. Takeshi's worn, pared down performance is often based on masculine characters who seem of

the past and who long for its return; and who seem out of time, on the point of extinction. Figures such as the desolate cop, lone wolf yakuza, or fantastical swordsman are downbeat protagonists when the film starts. Or else he appears in revisionist genres with a strong historical tradition, so that the present and past of the film blur and conjoin. *Zatoichi*, for example, pays homage to the Blind Swordsman franchise but invests it with a modernity particularly in terms of liminal characterisation and self-reflexive performance cues such as the dance number that ends the film.

Beat Takeshi seems timeless in another way; the roles he plays do not necessarily age, the blank state of the characters do not shift much: performative stillness even where there is supposed 'biographical' movement across a career. And yet of course, the viewer shifts: we age, we change, and we respond differently to different films in different contexts. We fill the canvas he offers us with images made in the moment of the live. Reception of a Kitano film, then, is one of constant movement even when faced with this repetition of stillness.

Memorial images find their way into Kitano films in other, quite diverse ways. Traditional Japanese iconography such as vases, paintings, national/local landmarks such as Mount Fuji, and key historic sites populate the *mise-en-scène* (although they are also more critically presented as kitsch tourist goods and spaces, their existence now manifest only as lost fetish). Various ancient ceremonies, rituals and practices find their way into the body of the films, for example, the body tattoos of yakuza in *Sonatine*, or Kabuki performance in *Dolls*. Kitano's use of the freeze frame is a technique that itself violently pulls the film out of the present to an immediate past. There is a camera aesthetic found in his films that seems to constantly remind one of its pastness. One constantly gets a sense of the camera having contemplated and of that contemplation lingering on that what was, or that which is just out of sight or at the edges of insight. For example, in *Hana-Bi* the camera sets itself on the ocean as Nishi and his wife (Kayoko Kishimoto) commit suicide off-screen. While the white sand and blue sea provides a well for contemplation, the two gun shots we hear draw us out of the silent incantation that the sea and the shoreline have underscored.

Kitano's use of the long shot is particularly telling in this respect, and can be related to the idea of the relations between the figure, colour and contour in painting. Deleuze's reading of Francis Bacon's art work (2003) is insightful again here because he contends that colour, contour and figure fold and flow into one another, merge or dissipate, rendering the canvas and the figure in particular, an intensive mass of indescribable fleshed intensities. This is another example of catastrophe, as perceptual or representational cliché is left behind for new somatic becoming. In Kitano's long shots of extended duration, while the figure (character, space, building and vista) is often discernable, and colour and contour use readable, there is also a wrapping around of these elements so that forces behind or beyond comprehension materialise. Jean-François Lyotard (quoted in Slaughter 2004: 244) terms this relationship the figure-matrix, which is 'invisible in principle' and comes from 'the other space' or the unconscious. The figure-matrix is formless, made from two incongruous orders – representation/signification and affect, which when blended into one another acts as a disruption to discourse, since it cannot be spoken, written, read or verbalised. In *Dolls*,

for example, Matsumoto and Sawako are drawn into the affective power of the film through the colour, light and texture found in their clothes and the fecund *mise-en-scène* they are found wandering in. In the autumn segment of the film the redness of the trees, clothes and environment move beyond simple symbolic representation into the quality of feeling it produces. As the sweep of the red increases, form gives way to volume and identity gives way to sensational intensity. Their death on the crooked branch of the tree on the side of the mountain, caught as they are in an intensity of a dawn light, involves a wrapping around of sensational forces beyond immediate comprehension.

At a political level, the incongruity works through as a dialectical relation: these memorial images are both affectively signified, and ironically employed to draw attention to the *real* Japanese present that conjures them up only as commodity and nationalist fetish for tourists. These memorial images critically invite or suggest the tourist gaze, and yet they also seduce the cineaste pilgrim to travel, to experience the nonrepresentable, to get lost on the streets of Tokyo, as I did. The present-past of these memorial images both a mocking, self-reflexive travel invitation to explore the past and present of Japan, and a haunting shout to the drifter to come and experience the terrible confusion at the heart of modern living.

Idle Time

There is, nonetheless, another way – another layer – with which to explore these time images, particularly when one senses them in liminal spaces such as the sea and the shoreline. In these in-between, threshold spaces where one is set free, the clockwork time of the city dissolves and circumstances and possibilities shift. In a number of Kitano's films, characters find themselves on the shoreline, facing the sea, either in contemplation, or engaging in play acts such as Sumo wrestling, baseball or kite flying. This idle time, in which nothing much happens in narrative terms, is nonetheless profoundly experienced as the end and the (new) beginning of time. The sea represents zero possibility or potentiality and the shoreline the breach in which one loses and finds oneself out there and *in here*, in the body-mind that watches the waves break, that learns to play freely again, and that waits for regulatory time to rear its head once again – as we (characters and viewers) silently realise it surely will. In these zones of liquid stasis, it is melancholic men in particular who learn to play again, to regress, to pass back in time to youth where one was brimming with hope and purposefulness. In fact, a degree of Bakhtinian Carnival enters the piece at these playful moments, where

> Carnival is the place for working out in a concretely sensuous, half-real and half-play acted form, a new mode of interrelationship between individuals, counterposed to the all-powerful socio-hierarchical relationships of noncarnival life. (Bakhtin 1993: 251)

In *Sonatine*, the Okinawa hide-out that the renegade yakuza retreat to enables them to throw off the shackles of role, responsibility and conformity. Ostensibly a site of

regression, of childhood play, it nonetheless allows the men to be free(er) with one another as they play games, set traps, dress up/down and drink sake. Nonetheless, this idle time or *muina jikan* as Sadao Yamane (1993) calls it, this time of new beginnings, is always marked by a point break, a violent dénouement, in which the death cloak of city time returns with murderous intent to bear down upon the break-pause, this playtime, we have been witnessing and experiencing. In a Kitano film, one can rarely escape. And yet this death of a type of time – and of those who were waiting for it to come – is never final, permanent; and it is never fully, inescapably tragic. In fact, it is often welcomed, embraced by the characters, since the joy they have experienced in this zero zone of pure potential can never be matched again, and the pain of their everyday lives (which they would have to return to eventually) is extinguished while they are there. The contemplative moments they have encountered, of course live on in those pillow shots, any space whatevers, and zones of void and nothingness which they are now memorialy apart of. I would suggest that in the way these scenes are staged and shot, the characters share with the viewers a feeling of *mono no aware* or 'sweet sadness'. Kitano time is a contradictory and uneven set of coordinates that fold and flow, much like the world it conjures up and comes from. Kitano doubles in multiples.

The Double in Multiples

Across Kitano's films, one can seemingly find a doubling of similarities and opposites so that his films can be read as a dialectical struggle between competing, power-satu-rated elements. These doubles are found at the level of theme, form, narrative, image and performance. They exist in layers porous in nature, so the doubling multiplies out and in, in undulating folds and flows. At the level of theme, we arguably have tradition set against liquid modernity, the national in opposition to the transnational, contemplation versus action, the individual against the group, herd or institution, and purity and cleanliness versus greed and filthiness. In a rudimentary sense these 'master antinomies' across his oeuvre seem to suggest bounded consistency in the way he treats these thematic opposites. Nonetheless, as Miko Ko argues in relation to the cinema of Mikke Takashi, the integrity of such opposites cannot be maintained in contemporary Japanese cinema; they are overcome by various forms of bodily disinte-gration, dramatising 'the break-up of the nation or, more appropriately, the break-up of the national body or *Kokutai* of Japan (2004: 35). Kitano's thematics 'break-up' in a similar way, since their difference to one another shifts or folds inwards, or reveal themselves to be false dichotomies. For example, in Kitano's yakuza films corruption affects all layers of the social hierarchy, particularly those bosses who exist near or at the top of the pyramid. Obligation, honour and duty have been superseded by self-interest and greed, a condition that it is implied also operates at the level of Japan's national imaginary. The constant wounding of the yakuza body, and its apparent death wish, suggested that neither individual nor national body can remain whole or complete.

Colourful Forms

At the level of form, long shots of extended duration are cut against mid-shots of short duration, the editing pattern often an unsettling dialectic between the violence of the cut (and the sudden violence in the shot) and the contemplative nature of the void that his films dwell upon either side of the blood and mayhem. Opposing graphical mismatches are common: bright, open exteriors are cut to low-lit, low-colour interiors or from natural objects of low density and shape to man-made objects of high density and rigidity. In a Kitano film it is as if the environment is caught up in an elemental struggle for domination, for the right to exist or co-exist in the frame/world. There is a wonderfully evocative use of colour sensation in a Kitano film, one in which hue and palette are not only semiotically rich but, beyond that, somatically affecting with physical propensities.

In interviews Kitano has spoken about how the colour blue is his base for all cinematic relations: it defines figure and contour and needs to be used 'adventurously'. It is not the signification of blue but the feeling, the sensation it produces when experienced. Again, in relation to *Hana-Bi*, Kitano recalls,

> Like the apartment by the sea where Horibe lives. The reason why I chose that place is because the roof of the crappy house behind it is blue. All blue. I set my heart on that house. 'Well if we shoot here, where exactly does Horibe live?' asked a crew member. I told him I didn't know. I figure if we shoot him coming home this way, the audience will just assume he lives somewhere over there ... I liked the blue of the roof, I wanted to shoot there. If the roof was of a different colour it wouldn't be half as interesting. And it was by the sea ... I really was fanatically picky about the blue. That also meant that whenever any other colour was introduced, I was doubly cautious as well. (Shinozaki 1997)

One then can consider Kitano's use of colour sensation in terms of tonality and their pure internal relations – as expressions, in fact, of hot/cold, expansion/contraction, stasis/movement, a pairing of relational elemental opposites. In this respect, colour use can render sight or seeing as haptic phenomena – where to witness or watch involves a touching of the thing with one's eyes, a tactile movement and a positioning over objects, spaces, things and people that act directly upon us as sensory beings. Haptic visuality penetrates the depth of a thing, so that grain, edge, texture, volume, weight and temperature are felt and felt anew. But it is in this pairing of the internal relations of colour that when drawn into a holistic or complete cinematic diagram makes 'visible a kind of original unity of senses' (Deleuze 1989: 37). This colouring unity also takes us into the realm of a body without organs, since to sense so fully is to move beyond the representable, the bordered and the contained.

The significance of this is extended when one considers the materials found in the shot. At the level of image, and image-iconography, one finds a division between natural and synthetic materials and qualities such as the sea, water, rain, sun, wind, blood, fire, flowers, wood, garden, as set against or contrasted with plastic, metal, steel,

stone, brick, tarmac, glass, neon, glasses, dark suits and cars. Liquid, solid and gaseous elements flood, heat or cool the *mise-en-scène*. A relational division also exists between urban and Other spaces; old and new objects, costumes and weapons; and between images of contemplation and emptiness and images of violence and pregnant aggression. There is an arresting of semiotically loaded images because of the incongruous way in which they are envisioned. In *Hana-Bi*, for example, Mount Fuji is a tourist image wrenched from its postcard setting to become one stop on the route to double suicide for Nishi and his wife. There is a pairing of vertical and horizontal framing of the image that contracts and expands the space, depending on the context. This often takes the form of the shot resembling or having the same quality as painting or the painter's canvas, or it contains a framed (Kitano) painting doubling or deepening the flat, static compositions. These landscape shots are sensory; encompassing a perspectival world, enclosed by a horizon that moves as our body moves. In a Kitano landscape we do not so much move in space as space moves with us. Stillness and movement is thus rendered beyond everyday perception and yet exactly like the forces that greet us in the real world.

Sensational

For Kitano, like Deleuze, film is sensation when it invents new affects and new bodies that are affected by these affects. Kitano describes his own paintings as reaching out for something new:

> But I couldn't shake the notion of painting the flowers. I wondered how I could do it, when the idea of arranging them into something else came to mind. Looking at a sunflower I thought it looked like a lion. This idea made me so happy. So I painted the lion with the sunflower head. I had that painting way before I started shooting the film. And then one looked like a deer, another leaf looked like a penguin. They would keep coming to me. It was really instantaneous. (Shinozaki 1997)

Henri Maldiney (quoted in Slaughter 2004) argues there are three movements in the becoming of an artistic painting. First, the artist faces the chaotic world of pure, unregulated sensation. Second, the artist freely opens themselves up to creation and all the terrifying possibility that brings. This is followed by a systolic-diastolic rhythm of formation and deformation, construction and destruction, in which new forms/shapes are created and then dissolved, and sensation passes between them. This is a useful way to consider Kitano's films, as built on a pattern of attaining sensation through systolic-diastolic forces that form and un-form themselves. Kitano's first movement of force is the isolated figure-character who is pressed upon by colour and contour, line and shape. S/he stands still in the frozen frame while the forces rub and flow in and around them. The second movement is one in which these forces re-shape the figure-character: while the force is barely discernable, it bubbles inside and deforms them. The third moment is one of destruction, in which violence enters

Sunflower lion in *Hana-Bi* (1997)

the shot and the figure-character splatters, vomits, defecates, bleeds or fucks. This is not simply an exterior form of violence but comes from within, a pressing out of forces. There is a commingling of colour and contour so that the sense of the image emerges from the blindness in and of the image. The animal emerges in the man, the man in the animal, and the forces that pass between them are sensational. That this third movement returns one to chaos, that the figure-character disappears from view, their death a new becoming, is profoundly affecting. There is alterity to this systolic-diastolic pattern.

For example, in *Hana-Bi*, Horibe (Ren Ohsugi) finds himself crying outside a florist's shop. The incredible beauty that he now sees in the flowers overwhelms him; he is overcome with emotion. He sees each flower fused to an animal, bird, insect or person. He sees and smells the sunflower and *images* a lion with a sunflower head, or he sees and smells the lilly and it becomes the face of a kimono-wearing woman. These images that appear on the screen inter-cut with his look of intensity; and we are asked to feel that it is this intensity that will eventually will these paintings into existence. Horibe, confined to a wheelchair and paralysed from the waist down dreams of movement and flight in natural things that at best can move only in the wind. Horibe is a fusion figure also: the wheelchair his machine ulterior half. He is pressed in, upon, and yet emotionally he presses out, the tears a recognition of the pain that wells within.

At the level of narrative, one finds pairs of characters either similarly typed or as mutual opposites. Buddy cop and yakuza brother, *oyaban* and *kobun* or father and child, man and wife, man and boy, friend and enemy. These pairs of characters will have similar pared-down psychologies, mannerisms and worldviews, and they will share (often silently) intimacies, dreams and fears. Or else they will be wildly differentiated, marked by a pronounced and profound alterity. In fact, according to Kojiro Miyahara (cited in Gerow 2007), Kitano presents us with an *absolute* alterity where

difference, Otherness, is so marked, so fundamentally alien, that it acts as a shock of force when confronted in raw terms.

This alterity is framed often from a 'margin' to 'margin' dynamic rather than one from which characters exist at the social or cultural centre looking out to, or over, a perceived Otherness. If there is a centrepoint given it is from the view of the marginalised, in marginal or liminal locations, looking critically back at the political structures that shape the world. Nonetheless, looking from a position of alterity is more complex than that. Lyotard (1988) has persuasively argued that peripheral vision is repressed in the contemporary world: one is taught to focus on an object. In the periphery, in the margins of vision, however, is difference, but it is almost impossible to see so structured or learnt is our looking and seeing in the world. The characters in a Kitano film look constantly to the periphery, while the viewer is asked to look at the periphery as they take in the object before them. The interplay between seer and seen constantly shifts so that the relations of looking converge on the periphery. The Kitano shot brings into being the peripheral look. For example, in *Boiling Point*, a group of rowdy youths are involved in a car crash near the beginning of the film. These minor, minority characters, who do not appear in the film again, draw attention to the way 'looking' is conventionally organised, forcing the viewer to not only see into the peripheral but to recognise its constituents. The crash is initially filmed front on, but a cut a moment later takes the position of the driver of the car they have crashed into. He is urinating on the roadside, facing an electricity pylon that splits the frame we find him in. The cut dislocates the action, and privileges a minority figure looking the wrong way.

Kitano's films are populated by the disadvantaged and the alienated, with many of his protagonists suffering from a physical, emotional or psychological impediment: characters are silent or mute, deaf, immobile, blind or generally short of a sensation. Characters can themselves be split, with their own divided selves a marker of competing or conjoining psyches that wrestle for control. Men, who are silent, melancholic and contemplative, are also suddenly shown to be brutally violent and masochistic. These are men, then, of time, movement and action with the former disintegrating the latter, as the latter disintegrates things, objects and people before the viewer. When all that is solid melts into air, in a Kitano film, these organ-less bodies are everywhere. Through this decimation of subjectivity, and through its new becoming, one is potentially freed to live out a fantasy which recalls 'Lacan's description of exoscopic experience, viewing one's own disintegrating body from a separate exterior position' (Igarashi 2000: 310).

Again, one can liken the condition of masculine men in Kitano's films to spiritual or transcendental homelessness. The world in which they exist in leaves them, to appropriate Kracauer's term, 'ideologically shelterless'. Their alienation and impoverished sense of the self stands in stark contrast to the nationalist, utopian rhetoric that attempts to bide them to the centre. Since their experience of the world does not match their ideology, or the ideology of the nation-state, they are stranded, and as nomads without a home they cannot find their rightful place in the liquid modern world. Kitano's films, of course, do not leave the characters (and viewers) in the thrall

of such loaded, well-worn, representational clichés (since these nomads have a long history in world cinema, whether it be the lonesome cowboy, the duped private eye of film noir, or the teen motorcyclist on the run). On the contrary, one can best make sense of Kitano's filmwork as a form of minority cinema that calls to a 'people to come', to wrestle themselves free of systems of differences so that all that is left is variation, reverberation, unchartered spaces and territories. To return to the painting context drawn upon earlier, Kitano's drifting cinema leads to catastrophe, to a passing through, where homelessness is reconfigured to reveal and revel in its potentiality.

This sense of homelessness can be extended to the idea of being homeless in one's body, a position from which alterity is fleshed in the erosion of gender and sexual binaries. Linda Williams' reading of sado-masochistic pornography in which the 'breakdown of rigid dichotomies of masculine and feminine, active and passive is the creation of an alternative, oscillating category of address to viewers' (1991: 8) is useful here. Kitano's characters often engage in sadomasochistic activities and it is here, also, that the 'culture' of bodies breakdown. Nonetheless, Kitano's female characters are often criticised for being thin stereotypes or the Other half of a power-saturated binary that empowers masculinity. My position, as outlined in chapter three, is different: the very performance of gender destroys its ontology in a Kitano film.

Takeshi Kitano/Beat Takeshi is also paired, albeit perhaps in the confused characters that embody their differences and distinctions as particular types of public personas and crisis figures. As Aaron Gerow intimates,

> The plurality here is less an inherent multiplicity behind a larger fiction ... than a duality offering Takeshi as both a single, overarching identity and an accumulation of distinct instantiations. We can say it is this duality, one which allows Takeshi to both 'have his cake and eat it too' – to be both a *tarrento* and someone who transcends it, a polysemous intertextual entity and a singular artistic genius, a Japanese *tarento* and an international star – that distinguishes his star image. (2007: 6)

In the complex play between the local, national and transnational determinants of Takeshi Kitano/Beat Takeshi, one is faced with much of the confusion that resonates at the heart of the liquid modern condition: he is a physical, hard-bodied manifestation of Japanese retrogressive masculinity and existentialist angst, suffering willingly from *mono no aware*; he is a thinker, creator, inventor, at the vanguard of Japanese cinema; he is a film star, star-auteur, a transnational image of Japanese cool, inscrutable, unknowable and exotic; and he is a comedian, presenter, game-show host, a national icon. He is, in effect, everyone and nobody.

The plot and story of a Kitano film can also be considered to be constructed from doubles: two (or four) simultaneous or parallel events that will come to impact on the key narrative agents by the end of the film. The mechanism used to construct multiple, parallel story worlds, ellipses and the elliptical cut, suggests a reality that opens itself up to forces and shocks, peaks and layers that render scene after scene a molten liquid propensity.

The Return of Multiplicities

I have so far set up a paradigm in this section in which doubles and divisions seems to be clearly designated, composed of their own order and regularity. As if there is sharpness and a neat and singular patterning to a Kitano film. What I would now like to suggest is a more complex idea of doubling in multiples, and linkages between doubles and divisions, and of a series of peaks and valleys where these doubles and splits drift or float in varying degrees of opacity in each film, and across his work. One scene in a Kitano film can be composed of a concentric ring of these dialects which reverberate and oscillate, constantly undermining their rigidity or fixedness. Nonetheless, there is, finally, another way to consider the exchanges between various elements and doubling multiples in a Kitano film; that akin to a Big Bang in which the various pulsating explosions that constitute his work are read as raw, wild, compelling, disintegrating blocks of violence. The flowering blood of a Kitano film deserves its own chapter.

CHAPTER TWO

Flowering Blood

I make my way to Ueno Park to walk among the flowering cherry blossom trees. It is their scent that registers first, and only then the pink spray and the fluttering of petals. They fall into puddles, creating ripples and tiny boats that soon capsize. The sun comes out, warming my face, and the cherry blossoms, that now look more red than pink.

Introduction

Intermittent bursts or squirts of physical and sexual violence mark much of Kitano's filmwork, as they do a great deal of cult Japanese film consumed in the West. While the violence is not as graphic or relentless as that found in the films of, for example, Miike Takashi, the body count is high and their ruination a decidedly bloody affair. Bottles are smashed against heads, eyeballs slashed open, brains blown out, and swords and knives penetrate skin and body parts. Kitano violence is often quick (even when shot in slow-motion), immediate, and yet the moment after the body falls is often dwelt upon, returned to, the camera tracking or cutting to the still victim and the blood spill that soaks into the ground. Violence traumatises the image, and the 'memory' of those who often recall it, an irregular flashback one of the devices employed to wrench the event into view. Violence as a form of stasis, as a thing in everything, sits as a brooding presence or present, even without these acts of mayhem and bloodshed taking place. Violence exists in the fabric of the Kitano world, in the everyday and the ordinary, rather than the extraordinary and spectacular that other forms of cinema often concentrate on. In this chapter I will look at violence in the Kitano film in four, interrelated and interlocking ways: first, as a pain image or a bloc of violent sensation; second, as the matter of blood; third, as body genre; and finally, as death, and death-as-life. Again my position will be centred on the affecting qualities of this violence, and on the way it

moves the viewer into the realm of feeling and being-in-the-world. This is a movement or becoming that challenges one to sense differently; that asks us to die to live again.

The Pain Image

The film image has often been compared to an act or enunciation of violence. For Eisenstein, the act of filming creates a wound in the world, tearing pieces of it from its place of natural origin (1949). Every frame is memorial and has the blood of the world as trace element on its photographic indexicality. The camera, as David J. Slocum suggests, 'has the power to destroy' (2001: 3): its invasive, penetrating potentiality unlimited in its ability to do what it pleases with that which it captures. This is the malevolent god-power of cinema. The metaphors used to define filmmaking are of course violent in kind: one shoots, captures, cuts and cans a film. The camera, as I have argued elsewhere (see Redmond 2008), is akin to an image weapon, particularly in point-of-view scenarios in which it becomes the sight-lines of a gun and shoots 'bullets' at that which it is lining up to murder. It is not just violence as a metaphor, therefore, but rather the instantiation of haptic carnality which the camera enacts. When the camera hits or penetrates, the viewer hits or penetrate flesh, symbiotically connected to its blade or cut; and the viewer is also hit, knifed and blasted by the camera's sensing, violating fingers or technological armoury. The image can itself be wounded or opened, and can disintegrate and bleed in the same way a body can. The contemporary fashion for the blood soaking the camera lens as it records the action is a striking case in point.

The affects and effects of film are similarly considered to be violent, albeit in contradictory or paradoxical ways. The emotional self is either seduced, compromised or bears witness to the terrible power of violence. The response to such malevolent seductions or happenings is often said to be an increase (imitation) or decrease (cathartic release) in violence in the real world. In witnessing violent acts we are asked to view violence as just, necessary and reasoned, or as an ugly stain on humanities quest to be civil. Of course, the violence found in film also has an aesthetic dimension; it emerges through the logic/illogic of narrative development, shot choice, editing, colour, lighting, sound and performative elements. Film violence is aesthetically arrested and affectively consumed.

The *mise-en-scène* of a film creates the conditions for violence to be suggested and enacted, and for its sensory qualities to be heard and felt. The crack of a pistol, the thud of a punch, the squelch of flesh opened and reddened are supported by the textures of the weapons in question, the dead space that surrounds a dying victim or corpse, and the colours that bleed themselves into the environment where violence has been undertaken. The violence of film is carnal, it is a pain image or one in which a bloc of violent sensation emerges or erupts. Film violence is felt as an incredible intensity at the corporeal level. These brooding blocs of violent sensation are at the core of the Kitano film text. This pain in and of the image emerges out of the pain in and of the deterritorialised nomadic characters that populate Kitano's films. This pain image meets the pain of the nomadic viewer in an intimately shocking inter-sub-

jective embrace. Like this broken sentence one 'snaps' together. That this sensational encounter speaks to the viewer in a particular register of bodiless becoming is telling, as I will go onto argue.

The pain image of a Kitano film emerges in two fields of activation: there is a residual pain, an anguish, which sits or floats across the entire *mise-en-scène*. This environment of loss is, on the one hand, carefully or classically signified, the product of genre codes and cliché representation. Certain yakuza-styled interiors, for example, are staged for the violence that will characteristically follow. On the other hand, however, the setting of pain is also sensorial and melancholic, composed of non-representational qualities. Settings, spaces, locations, characters, and time itself seem to be caught in a state of paralytic shock, in Kitano's *mise-en-scène* of carnal comatose. His method of subtraction, of concentrating on the vibrations of negative space, is suffused with an empty, empty pain.

Then there is the field of actual or direct violence, the acts and activities of physical and sexual assault, or actions and demands which threaten, bully and intimidate. Characters seemingly dead-on-their-feet, struck dumb by apparent disinterest or latent bewilderment, lurch into brutal moments of becoming animal. These two fields are of course symbiotically articulated: the forlorn melancholy of a drab city street gives 'birth' to the rage of the animal within. And the pulsating force of violence breaks through the melancholic human, staining red the *mise-en-scène* with animal becomings. In *Brother*, Yamamoto (Beat Takeshi) has just arrived in LA and is trying to find his younger brother. Alone, unable to speak English, he is making his way along a down-beat city street when he is hustled by Denny (Omar Epps). Denny deliberately walks into him, which is filmed as a walking into the camera, so the viewer's body is aligned with Yamamoto when the first aggressive action takes place. A bottle of wine is dropped and smashes, a ruse to get Yamamoto to hand-over money. Denny delivers a tirade of expletives to the camera, the viewer again taking point of view. Yamototo picks up the broken bottle and drives it into Denny's eye. This is filmed as Denny's point of view, so it is the camera, the viewer's eye that is being wounded. The viewer swaps sides, experiences the violence that both men are subjected to and have unleashed. Yamamoto then punches him in the stomach but the camera has now returned to a more objective position in relation to the action. The sequence is marked by Kitano's dislocated cutting technique, and a nonchalant lurch from inaction to violent becoming in a blink of an eye. The animal is within us, just below the surface, waiting to pounce. In *Boiling Point*, the animal-human union is particularly powerfully suggested through Uehara (Beat Takeshi) becoming lion-man. Barely visible, at the periphery of the shot, nestled in a field of flowers and wearing a crown of flowers shaped like a lion's head, he waits to pounce.

Kitano's residual pain image can be said to emerge into and out of his films in the following ways. His central characters embody suffering, it is carried in their 'blank' faces, their 'empty' stares and silences, their unshockable (or perhaps suffering from *too much* shock) responses, and lethargic bewilderment to violent encounters. It is carried in their movement – their aimless wandering, lazy walking, or, when on the verge or in the act of violence, hard edged, sharp and heavy bearing. While Kitano uses few

Kitano the lion man
in *Boiling Point* (1990)

macro- close ups in his films, the forlorn human face and the tired face of objects, spaces and buildings, are a constant presence. They are caught staring back at each other, at the viewer, or into spaces ill-defined, fragmented or never witnessed. There is always something just beyond the limit of the frame, the image, beyond the limit of reason which we are directed to. While these faces are in one reductive sense emotionless, they actually hold a weighty melancholic centre that fills the image with anguish. For Deleuze (1989) the close up of a thing, object or face is classified as an affection image, one that achieves a direct power of the 'entity' being brought into sensation, whether it be passion, hate, love or dread. The forceful qualities manifest in a Kitano close up is of pain, of a particular expression of pathos or suffering or deep feeling. In *Kikujiro*, Masao's (Yusuke Sekiguchi) face carries with it the bewilderment of childhood loss and loneliness – with few friends, and an absent mother, we see his eyes look on the world with a pathos that liquefies the lens.

According to Mary Anne Doane, 'pathos closely allies itself with the delineation of a lack of social power and effectivity characteristic of the cultural positioning of children and women' (2004: 5). Similarly, Ien Ang suggests that the 'tragic structure of feeling' (1985: 61) is a melodramatic affect correlating to a particularly female experience of frustration and disempowerment. In a Kitano film, however, pathos seems to wrap itself around space, time and character, regardless of social status, age or gender. This colossal mass of pathos, nonetheless, does draw attention to the repressed 'child' that exists in the man, and the feminine that crosses over the borders of the masculine – an argument developed in the next chapter on 'intense alterity'. The pathos extends or folds itself into terror, as indicated in the last chapter of this volume. Kitano's images of cutaway still life, or the strategy of staying with an image (space, object) long after the action has taken place, opens it up to sensory exploration that goes beyond language. In this hinter region of experience, all the potential of pain forms and swirls, rises and falls, awesome in its overwhelming sensibilities.

Kitano's intermittent use of the nightmare dream sequence is one particular way in which this terror manifests. For example, in *Sonatine* Murakawa (Beat Takeshi) dreams (or re-lives) his own suicide. Earlier that day he had pretended to play Russian roulette with Ken (Susumu Terajima) and Ryoji (Masanobu Katsumura), although they were not aware it was a game at the time. Murakawa had lost on the last round where, when he pulled the trigger, a bullet should have entered his brain. The shock of the scene is particularly visceral or overwhelming, but taken into the nightmare it is given added

resonance. Here, replayed, Murakawa does shoot himself in the head in front of Ken and Ryoji, although the looking relations are reversed. We take Murakawa's point of view as Ken and Ryoji plead with him to stop. They move their lips but no sound comes from their mouths, instead a discordant whoosh fills the sequence. Language cannot explain these actions. When Murakawa pulls the trigger we are at their point of view but not in exact alignment. Blood oozes from the bullet wound but Murakawa does not fall but rather stands in conscious awareness of the experience of the death that he has just initiated. This moment arrests Murakawa from his nightmare but he barely registers emotion when he lifts his body from the bed. There is little difference between the realms of reality and dream, and life and death, and words will never be enough to make sense of them.

Comedy does emerge in a Kitano film but it is a strand of comedy which is itself physical, constructed out of surprises, tricks and pratfalls. As such, it bears a close relationship to the violence it exists alongside, and its comedic effect/affect always seems ready to be consumed by the pathos it bends itself around. There is a relationship between the visual gag and death and destruction, and between the viewer laughing and then being reduced to silence, as comedy leads to tragedy and tragedy is ringed by comedic release. Aaron Gerow suggests, in relation to *Boiling Point*,

> that the 'narrative structure of the gag … is homologous to that of violence in the film … this combination of the gag and violence can be humorous, but the alternative logic/frame explaining these absurdities can sometimes be so disconcerting that it undermines the comedic effect. (2007: 83)

Drawn together, of course, in affective economies of loss and bewilderment, these tired, then explosive bodies, these sad but expressive faces, these gags of destruction, and these quiet faces of limp spaces and things, is incredibly painful to sense. They draw attention to, or sensorially conjure up, the dislocations and dissatisfactions that haunt his characters, that have taken a hold of the *mise-en-scène*. There is, as suggested earlier, a past and present tense about them, as if the thread or ache of their existence is made of time and timeless loss. The history of their extra-diegetic, beyond the film world disenchantment rises up in the image, taking it over. The image is filled with tears that are rarely directly spilt and screams that cannot be easily heard but which nonetheless rain down, call out, from beyond the universe. Given the length of time that one can sit with these residual pain images in a Kitano film, the imperceptible feeling of shared loss is acute. It stares back, right into you, deep down into the solar plexus and beyond, turning one's own body, own's own face, into a stretched out, liquid thin mass of contortions.

Minor or everyday activities and events contribute, or give affecting breadth, to the pain image. The flying of a kite, riding a bicycle, doleful fishing, playing baseball, drinking sake, Karaoke, hiding out, visiting monuments, are infused with present anguish and forthcoming self-annihilation. In a Kitano film, the sites of play and leisure are nearly always inscribed with heartbreak, dread and loss. This is doubly resonant, however, since this feeling of impending doom is laid over micro-narratives

where happiness is being momentarily expressed or shared. Characters, who have struggled to get to this happy place, having undertaken a road journey of sorts, or who have chanced upon it accidentally, are at their most free and joyous. Games are played, relationships enriched, smiles and intimacies shared. And yet, at another layer of experiential understanding, barely visible but there at the level of an 'awakening' of the *mise-en-scène* and narrative foreshadow, the playtime already has the imprint of its demise etched onto its body. Pain exists like an oedema across the skin of the Kitano film. For example, the trajectory of *Kids Return* allows no doubt that the rebellious time that Masaru (Ken Kaneko) and Shinji (Masanobu Andô) share at school is already a lost nirvana, and their ambitions will be thwarted. The urban sprawl, the colourless city locale, and the directionless routes that criss-cross the film, fill it with a dead-end mentality that they will be eaten up by. Their hope washed with an aesthetic hopelessness that never goes away, even while they prophesise they will never, finally, be defeated. This hopelessness structures the other parallel sub-plots in the film. As Keiko L. McDonald suggests,

> All concern classmates bullied and outdone by Masaru and Shunji. As might be expected their contact with the two is anywhere but the classroom – school staircase, coffee shop and gym. The academic hopes of these youngsters are dashed, not by careless rebellion but by failing to make the grade. They will not be going on to college. (2006a: 227)

In terms of Japanese aesthetics one might term this painful life philosophy *Mujo awareness* (see McDonald 2006a: 96–7) or the acceptance of, and resignation to, the fleeting and impermanent nature of the world and one's existence within it. Characters, things, objects, spaces and temporalities are caught up in the great collisions of existence, ebbing and flowing in a sad but inevitable tide of potential. Kitano's intermittent shots of a blue, full moon link his work to a 'Japanese cultural context' which 'is rich in metaphors expressive of the impermanence to earthly things'; if 'the moon changes according to the law of mutability, then surely mankind, being part of ever-changing nature should follow suit' (McDonald 2006a: 190). While McDonald's reading is astute here, the floating shot of a pregnant moon is no singular or simple metaphor in a Kitano film but a bloc of painful sensation that forces the feeling of impermanence to rise up within the viewer. It is also a device to draw attention to the death that hangs over the living. In *Sonatine*, the moon is revealed over three separate nights but in a state of stasis, impossibly not shifting from its full state. In the liminal place where the characters find themselves, in a hide-out on an Okiwanan beach, it is as if they have already died or are waiting to die, as if in a state of purgatory.

The residual field of the pain image manifests in one final way: through the wandering, nomadic patterns of narrative, editing, character becomings, and the liquid spill of temporal and spatial relations. A Kitano film is in constant search for comprehension beyond language, truth before meaning, chaos after representational cliché. This homeless journeying is created out of pain and the power of pain to move film, his characters, his viewers, and to transplant the pain beyond the bordered body.

Pain in a Kitano film may very well be salvific, redemptive, affectively transgressive and transformative. The direct violence of the pain image, a palette of percepts and affects, is where this best finds its incredible manifestation.

Direct violence is at the heart of the matter of a Kitano film: it is graphically represented but also willed into an indescribable existence. As Elaine Scarry has noted, violence is a threat to language 'in its world-making and sense-making possibility' (1987: 17) because the body's pain is inexpressible in speech and words. Kitano offers us violence which is isolated and random, relational and regenerative, revengeful, sadistic and masochistic, and a product of self-determination, with suicide a recurring way to enact and destroy (while enjoying) one's own pain. Direct violence is written into the human body in a number of ways: first, many of the characters are physically damaged in some way or suffer damage along the way. They are often a sense short (sight, hearing, feeling) or find their senses reduced or taken away after the violent event. For example, Zatoichi is blind, Shigeru (Claude Maki) and Takako (Hiroko Ôshima, *A Scene at the Sea*) cannot hear, Horibe (*Hana-Bi*) cannot feel in the lower part of the body, Akari (Maiko Kawakami, *Violent Cop*) is mentally handicapped, and Sawako (*Dolls*) and Masaki (*Boiling Point*) cannot or will not speak. Their flesh carries the imprint of their own negation and potential for disintegration. Bodies malfunction, fail at simple everyday tasks, and these faulty bodies call upon themselves to be punished and disciplined. A line of unrelenting bullying and intimidation takes place, as a consequence or by implication. *Violent Cop*'s entire narrative and characterisation is structured out of violent acts, revenge and a relentless pursuit or enactment of willing the flesh into painful submission. Its blood-lust is immense, its ordinariness sublime:

> One reason violence does not stand out is because the everyday is so cruel and violent. The film offers a litany of examples of the corrupt or unfeeling, from the kids throwing cans at a boat captain to Kikuchi, Azuma's partner, practising his golf swing outside Iwaki's funeral, so commonplace they rarely occupy the centre of the frame. Lacking difference, violence infects everything and thus threatens to become mundane. (Gerow 2007: 68)

Second, and in a related manner, characters are regularly brutally assaulted and carry out violent attacks, with the opened body the evidence for the pain inflicted or received. There is a wish fulfilment, a death instinct, which inscribes these forceful relations, one that has sadistic and masochistic impulses. It is as if the ruined body may be ultimately reclaimed, reborn, reabsorbed, once it passes through the chaos of this violence. Both 'Sade' and 'Masoch' make cruel and lovingly cruel appearances in the Kitano film. On the one hand, it is Beat Takeshi who often takes on the role of Sade, or the 'father who is exalted beyond all laws' (Studlar 2000: 203). He chooses male and female relationships based upon his ability to inflict pain and to destroy. A sadist consumes or destroys the object in order to experience the pleasure of orgasm, but in a Kitano film the peak of annihilation is transcoded into the carnography of the blood spill.

Torture is the most perverse way in which this violence peaks in a Kitano film. In *Sonatine*, for example, a crook that refuses to pay his dues to the yakuza is hoisted on a crane and immersed in the harbour on two sequential occasions. They guess the time it will take for him to drown and engage in idle conversation as they wait for his death to arrive. Torture, though, is more often physically intimate, such as in *Violent Cop*, when Azuma repeatedly slaps the drug dealer for a confession, or in *Boiling Point*, through the various rapes and assaults that take place. In *Dolls*, Sawako dreams her own abuse and rape by three masked men, each taking a role in a play. Kitano's aesthetic choices make these abuses that much more carnal and affecting, so that it is as if through the screening of the tortured body one violently gets to *touch* bodies wracked with pain, and to be subject to and the object of violent assault. Arguably screening torture puts one in haptic touch with the sickening bio-politics of violence, in a way which may release the body from the regime of docile obedience that it is put under. Kitano's torturous oeuvre may be an attempt to get viewers to experience their bodies without organs.

In the capillary networks through which power relations circulate in his films, characters often desire or enjoy being attacked, invaded or assaulted. There is a love for the pain that can be inflicted, and for the death that may follow: this is particularly true of the yakuza films in which hierarchical roles are based upon a masochistic relationship to duty and obligation. Of course, classically the world of Masoch is centred on love for the punishing woman. The female in the masochistic scenario inflicts cruelty in love in order to fulfil her role in a mutually agreed-upon arrangement (see Studlar 2000: 204). Masoch's work subverts patriarchal power relations, with the male as slave willing to transfer power to the female. Again, in a Kitano film masochistic scenarios are male-on-male, or male-on-female, so the manifestation of subversive becoming is different, but no less transgressive. There are homoerotic, homosexual and performative masquerade indicators to masochism. These emerge in interstitial zones of becoming and throw into doubt normative subjectivites. For example, in *Boiling Point* there is an explicit undermining of Uehara's sexuality when he comes onto Sayaka (Yuriko Ishida), allows Takashi (Gadarukanaru Taka) to have sex with his girlfriend (while he watches), and when later he buggers Takashi. In *Getting Any*, Asao's dream of heterosexual romantic coupling is constantly interrupted by prat falls and detours, throwing into doubt the legitimacy of this desire. When he eventually gets to travel in the airplane where he imagines a romantic liaison taking place, he is instead treated to a drag show where the pilot performs a near-naked routine. That this may be *his* dream sequence implicates him in a desire for the Other. By the end, Asao has become a fly-monster, a fusion creature that craves shit. Bodily borders have been breached, his otherness a wish-fulfilment that the film has hinted at all along.

I have drawn attention to the fact that it is the actor Beat Takeshi who very often plays the role of sadist in his films. I think this is important because it is the director Takeshi Kitano who is impressing this performance on him(self). Beat willingly if painfully takes on this role, and therefore comes to (also) occupy the role of masochist (slavishly willing to transfer power to his dominant other-self). In this inversion of incest, Beat may very well be 'woman' to Kitano's man, the violence of their relationship transgressively telling.

But what of this painfully pathetic becoming; this violent overthrowing of the body; or this sadistic and masochistic rippling of the flesh? Why this pain image, this terror sensation heating, burning the Kitano filmworld? Mary Ann Doane is again insightful here:

> The etymology of pathos insists that suffering is its critical emotion, that it concerns not just an excess emotion but one that hurts, that is inextricable from pain. Pathos names a condition in which feelings have gone awry: to feel too intensely is to suffer. (2004: 15)

If one was to examine this feeling too intensely in a Kitano film one would see a movement or a becoming that emerges out from this cauldron of suffering. Suffering leads to salvation, deliverance, to a re-birth outside of the body/body world that it was hitherto connected to. Death is just the beginning. The pain of suffering is written on the skin, etched into the face, floods the entire *mise-en-scène* with its propensities and colours. It is ultimately salvific this pain image; one is resurrected after the fall, melting into the immanent nature of the world. To return to the sadistic/masochistic duality that sits at the centre of the Takeshi Kitano/Beat Takeshi self/other, one can argue that the violence of their relationship, and their willingness to submit to it, throws open the ontological security of their being in the world: Kitano punishes Beat, Beat abuses himself, and in their suffering, a new body-without organs emerges.

Darrell William Davis and Emilie Yueh-yu Yeh have suggested that during the recession of 1990s Japan, and associated narratives of moral malaise, there emerged the phenomenon of *kireru*, or 'to snap'. They note 'quiet atrocities like the Hase Jun case' (2008: 7), where an 11-year-old boy was beheaded by his friend/bully, as an example of a 'cultural' mental-break down and its corollary of unspeakable violence at the individual level, as a dramatic example. Characters regularly 'snap' in a Kitano film; they are constantly on the verge of breaking-up, barely able to hold their (moral, subjective) centres together. When the mind and body breaks in a Kitano film, blood spills.

Kitano Red

Blood is one of the most powerful identity and difference metaphors in culture; the way blood is storied and represented tells a great deal about a society's motivations, fears and repressions. It tells a great deal about the way the body is bio-political, experienced as bordered flesh and yet one that is so easily opened, so readily made abject. Blood is tied to family heritage and national identity through a whole interconnected web of cultural statements such as life*blood*, *blood* on your hands, *blood*line, *blood* has been spilt, *blood* brothers, *blood*-stained flag, a *bloody* battle, *blood* is thicker than water, *blood* runs deep; and *blood* that is mixed is bad *blood* – when it crosses from one human to another of difference it often becomes a terrifying 'racial' horror, transferring difference, multiplying it, reproducing it across ethnic lines. Blood's meaning shifts between cultures, as Osamu Hashimoto suggests,

To Westerners, who are a meat-eating race ... blood is not considered impure (*kegare*), we can understand this because wine is offered as the blood of Christ. Granting this, as for Japanese people blood is taboo. (Quoted in Standish 2006: 291)

Blood is gendered, sexualised and sensationalised: it is encoded with masculine, phallic and sexual (semen, 'coming') metaphors: blood is rich, crimson, blue, vivid, striking and intoxicating. It spills, pours, runs, flows, gushes, squirts, pulsates, replenishes, enriches, battles and protects. When it is masculine and heterosexual it is aggressively active: it stands to attention. Blood is also encoded with feminine, menstrual and 'loss' metaphors: feminine blood drains, drips, saps, weakens, empties, pollutes and stains. The loss of blood produces amnesia, hysteria, a loss of energy, an eventual loss of life; it essentialises the feminine body and is complicit in creating a discursive space for it to be rendered bordered, and consequently docile.

If one was to examine a range of contemporary body genres, blood is filmically and narratively everywhere: one witnesses, revels in what becomes the spectacle of the ruined body as it is washed, soaked, covered, and immersed in blood. Blood floats outside of, over the body, and beyond, confirming that flesh has been torn, and that insides have become outsides. Characters watch themselves bleed; they observe, comment on, and interpret their emptying out through the death rattle, the piercing scream, and their own death rites. The liquidity of blood, its stickiness, redness, its arterial or somatic gurgling or whoosh, a sensorial confirmation of bodily disintegration. As scholars such as Christopher Sharatt (2005) have noticed, much of contemporary film is obsessed with showing the visual evidence of the 'opened body'. This material breakdown of the flesh occurs across an increased range of genres; particularly in the context of images and enactments of torture which, in a post 9/11 context, litter the cinematic landscape.

As briefly mentioned above, blood is not only spilt diegetically; one finds it appearing, perhaps increasingly so, on the lens or the camera eye. This startling moment – when the blood spill hits the screen/the camera eye, when liquid traces of blood speckle or splatter the lens – acts as a jolt to the aesthetic of the film, and the blood-soaked viewer. When the lens is splattered the camera can be static, or handheld and mobile, up close or in medium to long shot. The aesthetic effect can be gut-wrenching *cinema vérité*, heightened expressionism, or splatter-gore with comedic, cathartic affects. It can be profoundly shocking, revolting and pleasing. The shot or series of shots often involve the head/eye of a character being penetrated and the matter from the head/brain/eye coating the lens. When blood hits the screen the victim has been opened up and is either dead or is dying. In a similar fashion, the eye of the camera has been injured or traumatised by the event – the stain of which clings to its embodied nature. Like skin upon skin. The two bodies open up to one another – the flesh of the dead and the dying; the flesh of the screen covered in the flesh of the dead and the dying.

In a Kitano film, blood works in complimentary but also contradictory ways to the aesthetic, sensory and ideological introduction mapped above. There is what I would

like to refer to as Kitano Red, a violent sensation that runs throughout his film work and which is implicated in the ruination of representation itself. Kitano red is a colour, an intensity, a bodiless union, and a life and death force that paints or senses itself into the entire logic of the filmworld.

At the level of signification one finds the colour red being used in classic, relatively non-stereotypical ways: to bring the symbol of blood into the scene, to foreshadow inevitably violent narrative events, and to heighten the natural or human value of the image – red being vital and alive (if ultimately destructive and reconstructive) in relation to the general green/blue/brown earthy pathos of the Kitano *mise-en-scène*. *Sonatine* is one Kitano text in which the colour red, its recurring appearance as motif, in the splashes or shapes in the film's *mise-en-scène*, exists in a fairly clichéd semiotic chain of warning, foreshadow, danger, sexual urgency and (ultimately) blood-letting. In *Kids Return*,

> Red here is clearly symbolic of a young man's desire to resist authority. Miyao adds correctly that it is also clearly symptomatic of danger, violence and even defeat. Certainly it works out that way. Masaru's bully career at school ends with a bloody nose. We see him training for vengeance in red boxing gloves. Unbeknownst to us, he is probably wearing boxer shorts decorated with a bold red. Red is the colour of his punishment; that gangland scene ends with him in a pool of his own blood. (McDonald 2006a: 228–9)

Nonetheless, at the level of affect and precept, the colour red becomes more than its semiotic properties would suggest or allow. In an interview, for example, Kitano reveals the reasons behind the use of CGI to animate blood in *Zatoichi* so that is was less realistic and painful:

> So, I decided to exaggerate the blood splattering to give it a more video-game look. I had a lot of discussions with CGI artists and one of the most frequent requests that I gave him was: I want the blood to look like a flower blossoming. (Cole 2005)

Red can bathe or wash a Kitano scene; it can be picked out in shirts, dresses, signs, objects and things such as flowers and frisbees, and it can be sensed into the incandescent rage that bursts out of the explosive violence his characters unleash upon the world. It is often found in a tonal relationship to blue (or Kitano blue as other critics have termed it). They are set against one another or layered over one another in a subtle fusion or blending, which makes for a compelling Kitano blood image to crystallise. The cold and expansiveness of the blue is contrasted with the heat and thickness of the red, while they are also brought into synaesthesia alignment, the crisp taste of the blue melted by the volatile flavour of the red, stinging, warming the air, the flesh and the tongue with their aggressive mobilisation of the senses. In *Dolls*, red and blue clash and commingle in the realm of the senses as the three wraparound stories come to their tragic dénouement. Haruna takes Nukui to a blossoming field of red roses where their

colour, brittle textures and perfume permeates the screen. He is that night killed on the road, his body bathed in a blue moonlight that cools his thick blood, now dried-up on the road. A sharp cut then reveals the emergency services cleaning up the blood, hosing water on to it so it literally washes the screen, bringing Nukii's ghost back into the image. Hiro (Tatsuya Mihashi) has begun to meet up again with Ryoko (Chieko Matsubara) in the park, on the blue bench where he left her decades ago. She is still wearing the same red dress and comes with the same parcel of food. As he leaves her, again promising to return, he is gunned down, the blood of his body leaking into the blue air of the day. Matsumoto and Sawako are dressed in blue and red kimonos, respectively, and their fall off the mountainside is also caught in the blue wash of the moonlight, only to be soon replaced by the warm radiance of the rising sun that morning. In all three instances, the red and blue are not singularly semiotic signs but intense qualities that affectively express the life and death they embrace.

Kitano red, his cinematic blood image, is inscribed with particular sensational power or force in those scenes where the matter of the flesh is laid bare. The order of events is often as follows: into a quite scene of little movement, action or exposition, violence suddenly emerges or erupts. Its occurrence is so quick it flashes into view with unparalleled indecency. While in one sense it is not unsurprising that violence takes place – narrative, generic and scenic cues are readily in evidence – but it nonetheless rips the artifice, the pathos, away from the scene with a cleaving that acts as a haemor-rhage in its spectorial ramifications. These acts are filmed so that there is either a delay or a deferral in what one witnesses: the victim has their back to the camera, or the viewer is aligned with the victim through a dreadful point-of-view shot, or the extent or fullness of the act is cut short through initial ellipses. The violent act is at once both easy and detached, little emotion is shown by either attacker or victim, and yet its somatic and sonorous qualities are acute, even when there is a complete draining of sound from the image – a soundlessness that heralds death. One may not initially witness the destruction of the flesh but its presence is nevertheless fully felt. Blood may bubble and force itself into the frame, a shower of red may spray in the air, or it may leak out slowly. After this delay or deferral, however, one gets to see the victim, the camera offering a view of what the violence has done. This shot, of medium to long length, and long in duration, bears witness to the liquid blood that now washes his face, clothes, fabric and floor. While there may be some camera movement, there is an overwhelming stillness about the image, with the victim immobile and the blood drying. Kitano blood has both masculine and feminine qualities and these qualities bleed into one another, a fusion and distillation that opens up the body to new border crossings. As the blood spills or drips, as the corpse falls and stills, gender binaries are subsumed or consumed by this new bodiless embodiment.

This Kitano blood image becomes evidential of the terminal and the organic nature of things. These bloody corpses, these bodies which display their bloody organs; just dead or barely alive, act as testimony to the workings of the world and its potential to continually take life away. Nonetheless, in the cyclical patterning of a Kitano film, in its life-beyond-the-shot philosophy, the opportunity to become more than one is emerges out of the blood image. One might term this the 'ruin of representation', to

draw on Dorothea Olkowski's phrase (1999), a moment in which time, space and material existence slips and slides. At this 'interval' stage, when a gap between affect, precept and action, and between being and becoming emerges, an alternative 'future' is spied at the edge of the frame. This is not 'the representation of violence, it is the violence of representation itself' (Sadao Yamane, quoted in Gerow, 2007: 82). Bloody we are born again into the world. Of course, if this re-birth is into the pathos of the world just left, the terror of living is itself resurrected.

Body Kitano

I now want to explore the way the 'body' violently functions in a Kitano film. This body I take to mean, first, the fleshed characters who meet, greet and assault one another, and who often throw the binary configurations of gender and sexuality into disrepute; second, body genre; and finally, the body of the screen, its haptic carnality, viscous/vicious in its affecting properties and propensities. Not only is the body central to the way affect takes place, but it is the force that propels character and viewer into a space where subjectivity is left behind and pure becoming materialises.

1. The body – Immobile bodies who wander populate the Kitano universe. These inert bodies burst into staccato movement, while the wandering or journeying is constantly interrupted. Stillness is arrested by violent action, journeying by lengthy stop-overs and detours. There is a pause-burst-pattern to the rhythm of the Kitano film, its systolic-diastolic force manifest in the stillness and movement of characters as they stand idly, walk slowly, react quickly, pressed upon and pressing (out) when the pathetic time emerges. The male bodies are often honed from heavy or thick shapes, hard lines and full smudges of set flesh; granite in their composition, statuesque in performance. The dark clothes, grouped around greys, blacks and Kitano blues, add to the foreboding physical property of the male characters that exist either as isolates or in tight clusters. There is a change to their materiality, nonetheless, as they wander: when they enter the liminal zone of the beach, or the *karaoke* bar, or the 'child' emerges in the adult, for example, their movements become more fluid, and the dress a sway of colour. One of the central narrative segments of *Kikujiro* happens down by the beach where a group of misfits come together to play childish games, ostensibly for Masao, but really for each other.

Tight clusters in *Sonatine* (1993)

The base emotion for a Kitano film is, as noted, pathos and this is sensed into blank faces and lethargic interactions. As an affect image, as negative space, the face emotes, its emptiness confessional in form. Even when characters are assaulted their responses are mute to say the least. They are constantly being pressed in, an invisible force puts upon them day-in, day-out, rendering the assault just an expressive manifestation of dysfunctional or corrupted normality. Men, women, and children (when they are present) move in similar patterns of stasis and activity, although direct violence is conducted mainly by male bodies who, warrior-like in their embodiment of retrogressive masculinity, force themselves into the world. The stasis of the body is so exact that a Kitano long shot can look like a photograph, cut together in a sequence of photographs, the body image dead before our eyes. And yet its force animates this death: this pressing out of the body takes numerous forms: hitting, kicking, poking, slicing, shooting, bleeding, singing, shitting and vomiting. The workings of the body are constantly in somatic and sonorous view, even when they are being silently repressed or contained. When sound empties from a scene, death grips its centre, and the viewers decentred selves. The Kitano body is in a permanent state of disintegration, or breaking down, as if disease, failed desire, is a virus or contagion that runs through his oeuvre, and the modern life it attempts to render. The cancer (that cannot be spoken about, or named) that afflicts Nishi's wife in *Hana-Bi*, or Hattori's wife in *Zatoichi* , an apt force to capture the poison that lies within. Kitano has linked this malignancy to American culture's influence on Japan, arguing however that the diseased tissue has been healed:

> I thought at first that film was the pus created when Japan became infected by the disease called Westernization. But now I feel that puss has transformed itself into a good tissue. Inside of me that is. From a young age, I've experienced and absorbed many things. When I wondered which culture it came from, I realized it was the one that sneaked in — the American culture. I'm just an old timer infected by this culture creating a paper theater, but I'd like to keep creating better paper theater. (Press Notes)

One only has to look at the sweet sadness that registers on the face and body of Beat Takeshi to understand the affecting quality of the body. Beat Takeshi's role in Takeshi Kitano's films not only suggests a fragmented or multiple self, but at the level of physical or corporeal performativity, and facial in-expressivity, he produces a silently brooding, melancholic presence that is the exact articulation or embodiment of masculine *mono no aware*, and existential exhaustion. The Kitano facial tick, a violent edge that runs across his face in scene after scene, is an inexpressive leak of the anger and hurt within; a marker of the volcano that lies quiescent within the man. Beat Takeshi's presence also of course gives embodiment to the director: Kitano's authorial signature, his concerns, his sense of things is given phenomenological 'body' through appearing in nearly all his films. This is no cameo, light-weight performance but a fully immersed and sentient presence that helps create the sense that the sweet refrains of loss are in front of, in-between, and behind the camera.

Bodily breakdown exists in the way characters dress up, take on performance roles in which genders are switched or subtly elided. One often finds the body in masquerade in a Kitano film: yakuza gangsters don civic clothes while on hide-out; performative masks and costumes are put on or take over (one) in heists and nightmare dream sequences; and there is the performance of cool detachment itself, brooding violence, and a nonchalant attitude to heterosexual love (if not homosocial attachment). The putting on of uniforms is a key recurring motif in a Kitano film. They designate social class, levels of empowerment and they draw into the affective economy of the film issues to do with identity and belonging. As Darrell William Davis suggests in relation to *Hana-Bi*, Kitano tries to subvert the very message that the uniform may carry in Japanese society:

> Beneath the obvious displays of class and job description, Kitano undermines the uniformity of Japanse uniforms. When social expectations follow the gear too closely, they beg to be exploited. There is a sly critique articulated about uniformity and presumptions of homogenization via masquerade and role reversals. If Japanese society is one that automatically follows external markers of jobs and authority, then this is a society easily hoodwinked (2007:287)

Masquerade is one of the devices that allow identity positions to be negotiated and transgressed. They draw attention to the fact that gender and sexuality is enacted (a performance) and can consequently be undone, underperformed, or re-cast As Butler reasons, 'one is not simply a body, but in some very key sense, one does one's body and indeed, one does one's body differently from one's contemporaries and from one's embodied predecessors and successors as well' (1997:403). The body is broken down and re-made in the act of masquerade. In *Zatoichi*, performativity and masquerade are particular dominant forms of bodily disintegration and re-inscription. The blind masseur can see and not see; he is/is not the master swordsman Zaotichi. Single and alone he limps through the film, and then slices and dices with precise and savage strokes of the red sword that is hidden in his cane. The concubine twins are actually male and female, and brother and sister; they are mirrored, revengeful killer assassins. The yakuza boss is a lowly barkeep and the hyper-masculine, lone wolf Ronin, a bullied youth and loving husband. No one in the film is what they first seem to be: no *body* is bordered, contained: they are doubled and divided and the various masks they wear a constant calling to the artifice, the fiction, that defines them. Drag is one of the conditions under which this breakdown and challenge to the heterosexual matrix is played out; it is a form of interval alterity addressed in the next chapter. These bodies in meltdown are found in the body genres that Kitano works in.

2. Body genre – All of Kitano's films can be approximately placed within popular genre frameworks. Even his most 'experimental' films can be connected to generic forms or traditions familiar to audiences. His oeuvre contains slapstick, the melodrama, the swordsman film, the cop and yakuza film, and the youth, and road film.

Kitano's rendering of these genres, even when they are not explicitly cardiovascular, is to centre the body as affect. The body genre film, as Linda Williams argues (1991), deal in excessive representations of bodily feeling whether it is the writhing, moaning woman of pornography, or the tear-jerking female malcontent of melodrama. The viewer's body watching the film undergoes similarly deep physiological and emotional transformations including arousal, revulsion and grief. In a related position, Torben Grodal (1999) suggests that film genres are mental structures which integrate sensations, emotions and actions, activating the viewer's body and mind. In a Kitano film, the terror that one experiences is both cognitive, the thinking on or of one's fear, and corporeal, the feeling of one self as if in danger. That these mental and sensorial qualities cross-connect and disconnect is of particular significance. As Wimal Dissanayake notes,

> The Western traditions, by and large, subscribing to a Cartesian duality, posit a definite separation of mind and body whereas the Eastern traditions posit a unity … true knowledge cannot be obtained simply through theoretical thinking; it can be obtained only through 'bodily recognition as realization, that is, through the utilization of one's entire body and mind. (1990: 48)

Central to Linda Williams' (1991) argument is the role of woman in body genre: it is their body that is opened up, aroused, violated or struck most forcefully by emotional outpouring and grief. Williams' three categories for the body genre film – horror, melodrama and pornography – clearly lend itself to this reading. However, by extending the definition of body genre to include those films that are centred on the body-without-organs where the chaos of sensation takes one beyond language, in the utilisation of one's entire body and mind, one can relocate the taxonomy to Kitano's oeuvre and his recurring concern with the body becoming.

In the Kitano film, the degradation of the body and the pathetic response it induces, touches everyone, everything, every space. While it is men in general who are done to, the grief washes over the entire filmworld. In symbiotic, inter-subjective alignment, the viewer undergoes an embodied response of tremendous becoming. Mind and body crash amongst the debris of the film. Again, the tonal qualities of Kitano's colour sensation is important here since they are qualities of human feeling and being in the world; they are blocs of growth and constriction, movement and stillness, of pain and beauty, and of pathetic loss and new horizons. In the penultimate scene of *Achilles and the Tortoise*, Machisu decides to paint his last picture while he takes his own life. He starts a fire as he tries to spark his imagination into life one final time. It is if he has imagined that at this life/death threshold moment he will be able to move beyond representational cliché. That this work of art will burn with him is not an indication that he thinks he will fail and the bad painting should burn with him, but that the suffering it has come from and will further produce (for his wife and daughter) will be better scattered in the wind.

3. *Body camera* – The material, experiential presence of the camera is often revealed in the Kitano film. Here I am not explicitly thinking about its subjectivity, or self-reflexivity, but rather its being-in-the-film-world. So very often the camera takes up a position in the text which renders it body-like, and in intersubjective connectivity with bodies that are experiencing it. As Vivian Sobchack beautifully contends, in an oft-quoted passage, 'we do not experience any movie only with our eyes. We see and comprehend and feel films with our entire bodily being, informed by the full history and knowledge of our sensorium' (2004: 44). She goes on:

> My experience of *The Piano*, for example was thus a heightened instance of our common sensuous experience of the movies: the way we are in some carnal modality able to touch and be touched by the substance of images, to feel a visual atmosphere envelop us, to experience weight and suffocation and the need for air, to take flight in kinetic exhilaration and freedom even as we are relatively bound to our seats, to be knocked backwards by a sound, to some-times even smell and taste the world we see upon the screen. (Ibid.)

In a Kitano film, camera movement and position is carnal in its seeing, being and feeling of the world. In particular the dislocated or disconnected use of direct address and point-of-view shots brings particular attention to the sensory impact of the image. Point-of-view shots, particularly those from the perspective of killer or victim, are often born witness to; with the character it is focused on suddenly becoming aware of its presence, as if the look of the camera has directly touched or entered their material being. They, in turn, return the look, entering the eye of our eye, hitting our bodies with a cold, dying or desiring stare. This is magnified when, through the position of a character, Kitano turns the camera-gun on the viewer, as bullets emanate from its nozzle, its blasting sound and light burst hitting, hitting and hitting us time and time again.

Laura U. Marks suggests that vision or haptic visuality can be tactile, as if one is 'touching a film with one's eyes'. Haptic vision is a more tactile-based, closer-to-the-body form of perception, where 'the eyes themselves function like organs of touch' (2000: 162). As Marks explains, in optical visuality the eye perceives objects from a far enough distance to isolate them as forms in space. And with optical vision there is an assumed separation between the viewing body and the object. By contrast, haptic visu-ality is a closer, more intimate form of looking, which tends to 'move over the surface of its object rather than plunge into illusionist depth, not to distinguish form so much as to discern texture' (ibid.). Not a body in the film, but the body of the film, which does the perceiving which we see, which moves the eye of the film which we look through, as if sitting in the 'brain of the screen'. This type of camera-brain consciousness is found across Kitano's oeuvre in part because it seems to have its own critical and perceptive autonomy. If the camera wants to stay on a dead space it does; if it wants to invade a subjective space or memory, it can, it and if it wants to cognitively interpret the world it records it creates speech acts that are beyond/before the diegetic world.

Clare Colebrook has argued that when art brings 'us to an experience of "affectuality" – of the fact that there is affect' (2005: 199), it has an ethical dimension. The pain we feel deeply, for example, is experienced as consequential and bio-political. It arrests us from our (usual, normalised) corporeal docility and shocks us morally, brings us to an awareness of the power and force of the body and its abuses in the world. In a Kitano film this ethics of pathos, of violent becoming and becoming lost, of nomadic wandering, has its most profound realisation, in the death that rises up in the image. In the death and life that rises up in the image.

Death and Life

The Kitano filmworld is built on the death and life logic of sensation: its materials, vibrations, colours, pull one towards and away from a blend (while blending) of first experiences, fecund potentials and rigor mortis. In its undulating, circular, chaotic heartbeat, life and death wrap one another, bathed in pathos, and the possibilities that pathos brings. In a Kitano film, one has to understand that life is a type of death, and that death is still-life and life beginning. To stop or arrest pathos, one needs to die; in fact one wills oneself death, so painful is life, so sweet is death becoming. To move beyond representational cliché into the chaos of new thoughts, requires a death of the image; through the pain image, the blood image, and the brain of the screen, one becomes a body without organs, born again into/through sensation. I would now like to take three instances of this death and life in a Kitano film.

First, it is not only that the characters express a death wish but that they may already be dead, can only die, their fate or course set. Abe Kasho (2000) argues that Murakawa in *Sonatine* (played by Beat Takeshi) exists as a ghost, a self-confirming, re-generating apparition who relives his death as he brings death to others. We rarely see his feet so that he floats in the film, a 'traditional' motif for the spirit in Japanese culture. Gerow insightfully reads an execution scene in *Boiling Point* in terms of desiring death and death desirable:

> Reacting neither with excess fear ... nor with prudent defence ... they instead barely move. Ozawa slowly stands up, as if to provide a better target. This has its own absurd implausibility, but instead of being solved by an alternative logic that renders the scene funny, it suggests more disturbing implications: that these characters somehow wish to die. (2007: 82)

The 'good times' memorial photographs at the end of *A Scene at the Sea* are also instructive in this regard. Kitano added these after test screenings found viewers dissatisfied with, and alienated from, Shigeru's death which originally ended the film. Nonetheless, this attempted closure to better affect emotional belonging opens up an alternative, disconnected, interval space with which death can be experienced. These good time images do not belong in *A Scene at the Sea's* alienated centre or its uncomfortable journey of love unrequited or not fully consummated, and so a catastrophic rupture opens up. These memorial photographs are clearly of an alternate

world, a heaven or nirvana to the pathos of the film proper. The musical number that ends *Zatoichi*, although signified or foreshadowed through the overall rhythm of the film, is another instance of post-life exuberance. All of the bad hands of the film have been extinguished, and *Zatoichi*, the extraordinarily accomplished killer in the film, is nowhere to be seen on stage (his work is done). An atmosphere of carnival enters the final scene, a show-stopping number. In masks, in drag, in bodies becoming new bodies, life goes on.

Suicidal thoughts, imagery and suicide proper are a type of death common to the Kitano film. It is honourable, often; it is an escape, a relinquishing of duty and the negation of anomic pain. It seems to be connected to a nationalist ideology which gives strength to the imagined national community and yet its death instinct is personal, individual, beyond or before the concerns of the collective. To take one's life – at the water's edge, or the edge of time, as is so often the case in a Kitano film – is to leave a Japan that cannot be materially left. One has to take out the body, one has to leave the body, to start again, and again. One becomes a post-self, a self that re-narrates itself over and over again.

Edwin S. Shneidman (1995) has suggested that people who commit suicide often do so after having imagined how their death would be received, and how they would in effect live on in the memories, activities and rituals of those family and friends who memorialise them. This post-death life was 'new', wrestled free from the pain of exist-ence that brought people to suicide in the first place. In the Kitano film this logic of suicide, created out of sensational blocks of colour, allows a particular affecting vision of the post-self to emerge. In *Achilles and the Tortoise*, for example, a re-born, re-made partially blind painter may or may not find the stroke of genius he has been looking for; at least this new life means he can start again.

The embodied or fleshed moment of death on film and our own death as screen-sensing viewers is seemingly impossible in cinema. No one really dies in a fictional film, and the viewer still has a beating heart come the end. As Sobchack points out, death is 'always in excess of representation: we do not ever "see" death on the screen nor understand its visible stasis or contours; instead, we see the activity and remains of the event of *dying*' (2004: 233). She continues: 'death can only be represented in a visible and vigorous contrast between two states of the physical body: the body as *lived body*, intentional and animated – and the body as *corpse*, thing of flesh unintended, inanimate, static' (2004: 236). Actual death is impossible because it is always already past-tense in film – a recording, a performance, a historical moment. It is caught in a double past-ness – the dead body's lack of consciousness to all that continues to exist around it, and its inability to express the trauma of its own loss except as the thing-without-a-spark. Nonetheless, one can approach death, one can watch it unfold, bear witness to its terror, to the slide that the body takes towards it. The body of film, the body of the body in film, and the body of the viewer are at most 0.01 second away from this stasis. And when forms are confused, such as the real killing of rabbits in *The Rules of the Game* (Jean Renoir, 1939), or the cattle in *Cannibal Holocaust* (Ruggero Deodato, 1980) then one can be brought close to the edge of existence.

Forms are continually confused in a Kitano film but not in any easy 'real death took place' scenario. There is the method acting, the realisation in certain scenes that people are been hit and hurt; there is the alternate realism of death that emerges out of stasis and pathos and fragmentations. And there is, most importantly, a constant call to bring into existence the post-self, or an alternative self. This intense alterity is the next stop in this monograph on flowering blood.

Intense Alterity

I try to buy a train ticket but cannot find the language to get my destination across. There is a queue of people behind me. No one speaks English; I cannot speak Japanese. This feeling is so strange. I find a map and point to the place I want to go. Later, I see Wong-Kar-Wai's Blueberry Nights *at a low-rent cinema. This Hong Kong auteur has made a film set in America. It is being screened in Tokyo with Japanese subtitles. I feel strangely at home.*

Introduction

It is the complex question of Otherness as it manifests in Kitano's oeuvre that is the concern of this chapter. As I will go on to argue, this alien Other is an exterior force, found outside the parameters of normal life – in marginal spaces, oblique sub-cultures, and in individuals marked as strange. It is also a local and interior manifestation, found within one's self, and in the 'home' spaces and familiar cultures that one is wedded to or born out of. In a Kitano film, the exterior alien Other is not, however, left as an imagined or lived point of difference that sustains insider and outsider dichotomies. On the contrary, the exterior Other is also located within an individual, in the same way as one's own alterity belongs out there, found in the psychology of the alien Other. The many moments in a Kitano film where a character is rendered speechless, unable to comprehend or respond to the event unfolding, and where there is a bend in their sufficient reason, is a perfect incarnation of this self-becoming Other. As Patricia MacCormack suggests,

> Speak and you can be named a pervert or normal (even if perversion is celebrated). Remain silent and you are no longer a subject but a molecular dissipative desiring affectivity and potentiality. (2008: 10–11)

As previously indicated, Kojiro Miyahara (in Gerow 2007) has argued that there is a vertical Other at work in a Kitano film. This is an absolute alterity which cannot be understood by recourse to semantic, semiotic chains of knowledge and representation. The vertical Other exists alongside one, in the same plane and at the same level of existence, but it cannot be comprehended so utterly different is its embodiment. Miyahara contrasts this with the horizontal Other, manifest in the self/other, in/out, core/periphery binary which is the standard of Western culture. In a similar way, Takao Suzuki (1987) has drawn attention to the fact that Japanese language has not historically had a structure in which personal pronouns were common, or employed to distinguish between I, me, you, we and them. Rather, self and Other are considered to be relational concepts that are inextricably and essentially connected. Nonetheless, as Carol Ota also contends,

> In Japan, the identity of an individual and his or her relationship to others and society at large is predominately influenced by his or her membership in various groups. Analysts of Japanese society use the term *uchi* (inside) and *soto* (outside) to describe the dichotomy experienced by an individual between elements within the group of which individual is a member and without. (2007: 12)

While these senses of self and Other are clearly at work in the forces of a Kitano film, my position is a fusion one. What makes Kitano's films so remarkable, transformative and transgressive is the way in which horizontal and vertical planes of alterity cross-connect and disconnect, like the over-heated circuit board of a complex machine. I would like to explore this idea of intense alterity through the way it manifests in gender, sexuality and nation. In each of these pockets of strange becoming, the body, the self, is undone and remade. Intense alterity leads to, or comes out of, extraordinarily powerful feelings and sensations, which leads to beyond the body experiences in the Kitano world. Nonetheless, to get to these *ulterior* positions I need to first consider the position that Otherness is indeed built on normative, heterosexist binaries in a Kitano film.

Ulterior Gender

If there has been a determining critique of Kitano's representational politics, it has centred on the way women are shown to exist as sexist stereotypes, and passively take part (and are taken apart) in violent and masochistic scenarios. Kitano's female characters seem to bear the hallmarks of patriarchal and masculine desires and fears, occupying the knowable, negative position of Other in a power-saturated binary.

First, in the Kitano film there is the figure of the trophy wife/girlfriend who puts up with the waywardness, coldness, detachment and/or brutality of the boyfriend/husband. Passive, compliant and coded to-be-looked-at, they do as they are told, and silently suffer emotional or physical abuse regardless. Masculine men will their selves into existence in part through the subjugation of women. For example, in *Boiling Point*, Uehara forces his girlfriend to have sex with Takashi, and then repeatedly assaults her

for doing so. That he later rapes an innocent bystander to a Yakuza massacre is a further indicator of the meat-value of women to the Kitano world. When in ambiguous fashion Yamamoto guns down his own girlfriend in *Brother*, we do not know whether he is trying to save her from her attacker or mow them both down indiscriminately. That we know he is a perfect shot, evidenced on numerous occasions in the film up to that moment, points to his pathology. In *Hana-Bi*, Nishi has for a long-time neglected his wife, now in hospital and dying of cancer, preferring instead to spend time with his buddy cop (the real love of his life?). That Nishi, suffering from guilt, a point I will take up below, rescues her from the hospital to take her on one final road trip, is an indicator of her passivity and his (belated) authority to affect events. In *A Scene at the Sea* Takako watches in a state of awe Shigeru ride the waves, while also neatly folding his clothes and tending to his needs. In *Dolls*, Ryoko returns to same bench in the same park at the same time with the same lunch for over twenty years, in the forlorn hope that her absented lover will meet her there as promised – a malady and devotion that could only effect a 'woman'. In *Achilles and the Tortoise*, Machisu's wife stands by him after every failure and setback, her life only lived through his dreams and desires. Supposedly all that Asao (Dankan) wants in *Getting Any* is to lay a/any girl, one gratuitous breast shot after another confirming this base desire and the camera's objectification of women.

Second, and related, there is the figure of the good mother/wife whose role is to raise and nurture her offspring. Often, however, this 'mother' is actually an aunt or a grandmother because the biological mother has absented herself, a problem that leads to the third, wanting female figure in the Kitano film.

Third, then, there is the figure of the home-wrecker, who has abandoned the family, particularly her (male) children. In *Kikujiro*, Kikijro (Beat Takeshi) and Masao go on a road trip to find the mother that has left them only to find her relocated as the sweet mother of another family. One can situate this third figure within a wider cultural context over concerns of the independent woman and their desire to work and have economic power. In the J-horror film, for example, the dreadful avenging spirit, or *kaidan*, is seen as encapsulating this crisis in designated gender roles: filial responsibility has broken down, men/fathers are absent or useless, mothers go to work; children are abandoned; and the community (patriarchal authority) has gone missing in terms of its supportive or structuring role. One can similarly argue that Kitano's masculine world speaks to this sense of dysfunctional and dislocated gender relations and relationships. In spaces where childish and primitive men exist in homicidal family units or fractions, there is nothing but violence and the status or power that violence brings, to hold them together and to keep women (who they secretly desire, need and are in mourning for) at bay.

Finally, there is the hysterical or madwoman figure, whose innate sensitivity to things, and pathetic essential core, render her exquisitely, dangerously feminine. Sawako in *Dolls* becomes insane through the 'loss' of her lover, who has decided to marry someone else. *Dolls*, crafted out of the *kyojo mono*, or 'madwoman play', from Noh theatre, renders the female a spectre, a haunting figure of dread that brings death to the masculine hero lost in her song. That ultimately she walks Matsumoto to his death, is testament to the way Kitano space and journeying is normatively, normally masculine.

In cultural and phenomenological terms, the negotiation of space (and the time of space) is arguably gender inscribed. One of the building blocks of male identity and masculine becoming is that man can navigate the world, always sure of his direction. Women by contrast are easily lost, and suffer a feeling of anguish and helplessness when faced with finding their way in new locales. As Sobchack powerfully summarises, 'negotiating unfamiliar worldly space is for me frequently an anxious state, always mutable and potentially threatening' (2004: 15). She contends that it is because women are more often the object of the patriarchal gaze, positioned to 'live as material things immanently positioned in space rather than as conscious subjects with the capacity to transcend immanence, that they cannot negotiate space as well as their male counterparts (2004: 32). In the Kitano film, one can readily see this masculinist gendering of space. Women largely stand-by, do or say little, and they are objectified or exist as objects in space while the main dynamic of the narrative action happens in and around them. Men, by contrast fill the space, take action and use space with skill and guile, particularly when it comes to violence.

One can further develop this idea of feminine-spatial inadequacy in terms of clearly defined bodily capabilities for women. According to Iris Marion Young, under patriarchal law women learn to experience their body as a limit, with clear physical limitations, best expressed through the practice of 'throwing like a girl' (1995). Feminine comportment is composed of restricted movement, a disconnect between being and doing, of aim and enactment, and involves the overall sensing of the body as a weak thing with a limited capacity. As Young summarises, 'the more a girl assumes her own status as feminine, the more she takes herself to be fragile and immobile, and the more she actively enacts her own body inhibition (1995: 44). In a Kitano film, while stasis, restriction and stillness affects all characters, one can argue that there are feminine and masculine differences made manifest in the body that moves and is controlled by or controls a space. The female characters in a Kitano film do throw like girls. In *Boiling Point*, Sayaka fails to swing the baseball bat. They are objectified and objects of the gaze; Miyuki (Aya Kokumai) is framed as an object of mysterious desire in *Sonatine*. And in their physicality they are reduced, or reduce themselves, to pencil-line figures that seem wispy and inert even to the relative inertia of the masculine characters. By contrast, Kitano men have an open gait, they take or fill up a space with their bodies, with nonchalance and a swagger that aggressively activates and asserts their being in

Miyuki as an object of mysterious
desire in *Sonatine* (1993)

the(ir) world. The consummate ease and success with which they turn to violence is a defining marker in their dominant masculine becoming.

In terms of alterity, the position identified above seems very readily to connect to the horizontal schema of Otherness that supposedly defines the West's relationship to it. These power-saturated gender binaries are honed out of knowable, cultural, discursive practices and activities. In the Kitano world it would seem that heterosexual patriarchy and mesomorphic masculinity is the subject position from which the female Other is brought into inferior existence. Nonetheless, to retrace the steps so far outlined in this section, I think there may well also be vertical, *ulterior* gender alterities in operation here. In fact, I see the cross-fertilisation and unhinging of these points of axis as contributing to the crisis in the self that marks his films, and for a desire to embrace the alien Other within. To return to Deleuze, one may very well 'become woman' in a Kitano film where, through the ruin of representation, the sexing of the experience of time and space is challenged then left behind (see Olkowski 1999).

Men in a Kitano film do not always, easily, navigate their way through space, and neither do their bodies succeed in the games they play, or the violence they carry out. In fact, male characters if not irrefutably lost at film's beginning, cannot find their way easily, if at all. *Sonatine*, in fact, foregrounds men's inability to find their way, to problem-solve or, ultimately, to master their own destiny. Murakawa finds himself in Okinawa without agreeing or wanting to be there. The elliptical cutting used to transport him from a yakuza meeting in Tokyo, where we see him refusing to go, to the back of the bus leaving the Okinawa airport, an establishing shot that is itself delayed, creates the impression that he has just been picked up and dropped there, at the metaphysical hands of fate. The way the Yakuza gang eventually end up at the hide-away in an Okinawa beach is an accident. They are led there, reliant on others to keep them safe. In fact, very little is planned, thought out or fully executed by the men. They drift in time and space. While at the hide-out, each man stumbles into a camouflaged hole set by Murakawa, a not too subtle metaphor that they won't be able to find their way out of the mess they are in. Murakawa crashes the car he is taking his girlfriend away in, needing to be rescued by his men. We subsequently learn that he cannot drive. While the narrative explanation for this might be that he is normally driven around by his foot soldiers, the inability to drive (an 'essential' masculine quality) renders him womanly, to appropriate the sexist associations here. The ending of *Sonatine* is itself arguably aimless, a happening without direction. Murakawa takes his own life with a bullet to the head. That the final disconnected shot of the film is given to Miyuki, standing alone in the road suggests a degree of direction hitherto absent from the film. Her absolute alterity shocks the pain image into life. The film strangely ends with her new beginning.

At the level of time image, this being dislocated-from-space obviously throws into disarray the usual coordinates that male characters follow. These disconnected blocks of spaces and blobs of time cannot be navigated with compass or guile so one is left feeling, to enrich the experiential analogy, *like a girl* in the face of such dislocations. That is to say, in a Kitano film there is a degree of border crossing when it comes to the experience of time and space. Of course, one can extend this idea of the reorientation

of time and space to argue that the environs men feel most complete or whole in are those designated as feminine, such as the shoreline, or that in the game-playing scenes they enact child-like qualities that call into ghostly being the figure of the mother who should have been there all along. Nonetheless, in these liquid spaces, in these liminal contexts, male characters move differently, dress differently, they take part in clearly designated performative acts and performance rituals, to such a degree in fact that one can argue they become more like, are in fact, 'woman', and are liberated or transformed by the experience. As already discovered, one cannot return from such an overthrowing of the senses and the rules of gender normativity. In this place of play and idle time, that they know (masculine) time and (masculinist) death will eventually catch up with them matters not a bit, because these new body becomings are awesome.

Kitano men fail at baseball, boxing, basketball, fishing and Sumo wrestling to name a few instances of inadequate or faulty masculinity in evidence across his oeuvre. It is actually Masaki who bats like a girl in *Boiling Point*, initiating a dream sequence where he metamorphoses into a more able-bodied male who hits the ball and gets the girl. By film's end, of course, this masculine awakening cannot come to pass. It is only in the dreamscape that the girl cannot throw and he can bat. In *Kids Return*, Shinji becomes bulimic (a 'woman's' ailment or illness) to keep his weight down, subsequently losing the fight that would have propelled him to boxing stardom. This failure, nonetheless, allows him to reunite with his lifelong, childhood friend, for whom he has been hitherto designated feminine/female to Masaru's masculine/male self. In *Sonatine*, the playful, parodic Sumo wrestling the idle yakuza take part in is not only emptied of its usual violence but filled with homosexual desire and longing. Coupled and inter-locked, Ken and Ryoji Sumo wrestle in a mock battle that pits these feminine men/latent lovers against retrogressive masculinity. Of course, Kitano's male characters are often 'disabled' in some way, so that masculinity itself becomes a limit in the world. Horibe in *Hani-Bi* finds himself at the water's edge contemplating suicide; wheelchair-bound following the shooting, and with his wife and daughter having left him, unable to feel the waves washing over his feet. His limit has been reached, his body has been breached.

Kitano's masculine men are often too early or too late for a fight, or they are not in the right time at the right place when violence arrives, and so cannot protect brothers or sisters, or defeat it, as is expected of them. That they fail as men leaves them with unquestionable guilt, remorse, a pain and pathos that usually belongs to 'lower status' figures such as women and children, to return to the position foreshadowed in the last chapter. In *Hana-Bi*, Nishi has gone to visit his dying wife on the advice of Horibe. As a consequence Horibe takes his place on a stakeout that ends up going terribly wrong. At the exact moment Nishi attempts to light a cigarette, while sitting by his wife's bed, a graphic, metaphorical match cut takes us to an unattributed point-of-view shot as bullets are being fired into a body. This is soon revealed to be Horibe's body, and the implication is that Nishi is responsible for his shooting, and that it should have been his body under fire. However, the film complicates this apparent parallel cut (both events happening at the same time) by threading the rest of the film with what we come to realise is pathetic flashbacks, a realisation that subsequently renders this sequence his memorial suffering, anguish and death wish. To return to the wheelchair-

bound Horibe, sitting at the water's edge, the suicide wish is not just his but theirs; it is a doubling and splitting that breaches both men's bodies and affective memories.

As one can discern from the analysis above there does seem to be a criss-crossing in and between woman as knowable and inferior Other; and woman as absolutely alien. This elision on my behalf is deliberate since it again suggests that operating is both an understanding and exploration of representational cliché, in this instance gender stereotyping, and forceful movement beyond this, to a position where gender identity and subjectivity begin to break up, collide and transmute into something beyond the body. Kitano's work draws on both horizontal and vertical planes of gendered Otherness and in so doing offers the opportunity to experience difference, the difference of the Other, and the difference of the Other that lies within. In a very real sense his work draws attention to the mythology of supposedly natural gender binaries and sexual orientation, and initiates a sensory engagement with these forceful movements. This is best expressed in the way in a Kitano film a number of the 'double' characterisations emerge out of male and female simultaneity. Man and woman fold into and out of one another, and in so doing create an 'interval' space where differences are shared, opened, understood as co-determinants of the lived body. In *Dolls*, for example, Sawako and Matsumoto incorporate one another into their mode of being-in-the-world. Their physical characteristics are similarly androgynous, although they are both more feminine than masculine. Their gait, echoes one another, and their movement in and between space suggest they co-exist in a liminal space or in a world of their own. Matsumoto takes the role of mother when Sawako is ill and this slide into femininity means he cannot protect her from the nightmare she subsequently has. However, this is not a critique of his feminine and liminal identity but a foreshadow that the harsh realities of the modern world will shortly intrude into their world.

For Judith Butler, the gendered and sexed body is mutually, discursively constructed. Once an individual is brought into the domain of language and kinship their feminine/masculine, and heterosexual subjecthood is attained and then consistently sustained through regulated performative acts:

> Performativity cannot be understood outside of a process of iterability, a regularized and constrained repetition of forms. And this repetition is not performed by a subject; this repetition is what enables a subject and constitutes the temporal condition for the subject. This iterability implies that 'performance' is not a 'singular' act or event, but a ritualized production, a ritual reiterated under and through constraint, under and through the force of prohibition and taboo, with the threat of ostracism and even death controlling and compelling the shape of the production, but not, I will insist, determining it fully in advance. (1993: 95)

Gender and (hetero)sexuality is twinned or aligned, given normative status, so that counter-feminine/-masculine thoughts and behaviours are eradicated and subject to regulation, punishment and discipline if wayward behaviour persists, while queer thoughts and impulses are suppressed and re-channelled into desire for someone of

the opposite sex and gender. Heterosexual patriarchy has to work very hard, nonetheless, to sustain the appearance that gender is essential and sexuality biological, and that together they sit at the centre of healthy, reproductive identity. In this working of the body into normative moulds, acts, rituals and performances emerge which draw attention to the lie at the heart of heterosexual ideology. For Butler, drag, cross-dressing, is an instance where the fallacy of gender and biology emerges to offer a vision where the feminine and masculine, the queer and straight, are thrown into confusion and can be re-made. Kitano's filmwork very often opens up a space in which these intense alterities are made powerfully manifest.

Ulterior Sexuality

The uneven ripple of sexuality is a constant questioning presence in a Kitano film, always threatening to disrupt and undermine heterosexual desire and coupling. In fact, homosocial, homoerotic and homosexual desire bubble up to the surface, wave after wave, creating queer intensities that reverberate across his oeuvre. This alternative to the heterosexual matrix is complimented by acts and performances of cross-dressing and drag, and the appearance of androgyny in the faces and bodies of those who inhabit his films.

In one sense, given the enclosed, masculine worlds that Kitano works within, it is no surprise that deeply committed homosocial relationships burn brightly. To take the example of the yakuza film: classically its power structure is pyramid shaped with a Patriarch or *Kumicho* at the top and loyal 'brothers' and 'sons' of various ranks below him. The guiding principle of the yakuza structure is the *oyaban-kobun*, or father/child, relationship. All yakuza 'children' promise unquestioning loyalty and obedience to their father, who in turn provides protection and good counsel. In the yakuza initiation ceremony the *kobun* and *oyaban* share sake – a symbol of 'blood' being mixed and a blood line established. These horizontal and vertical relationships ensure both distance from, and proximity to, figures of power and figures of equality. The affection built into such a structure of support and admiration, and the deep feelings of familial loyalty it demands from so-called lieutenants and soldiers, presents itself as love shared and requited. In a Kitano yakuza film, of course, the pyramid structure has broken down, betrayal and deceit corrupts the overall chain of command, with the consequence that micro-relationships, generally those with only one step in hierarchy between them, double their intensity. In *Brother* this is made most explicit in the homoerotically charged relationship between Yamamoto and Kato (Susumu Terajima). While on one level, the duty and servitude he expresses towards Yamamoto is classic yakuza staging, the flashback sequence, where he wistfully looks back at the good times they have shared, suggest a deeper intimacy. It conjures up a longing and a loving that will eventually lead to suicide, a sacrificial, love-drenched offering made to appease a young, upstart Yakuza boss. This ultimate sacrifice, a bullet to the head while a smile runs across the face (a memorial force registered as the love he has for Yamamoto) is itself an example of alien alterity.

That women, by comparison, are often (secretly) loathed, abused and rejected in a Kitano film is a sign of over-compensation for male love and bonding, their presence an attempt to aggressively re-direct, re-signify or channel the latent queer intensities that rise and fall, heat and cool these male character relationships. That men are womanly and women alien, however, undercuts this sexual sublimation, adding rather than taking away from the perversity of the desire, and the desiring presence of alternate sexual operations. When women (as women) are entirely absent from the central activities of a Kitano film this re-ordering of gender and sexual relations are at its most acute.

Kids Return takes place in an almost exclusively male world. Three of the central locations of the film – the boys' school, the boxing club and the various related masculine bars – are free of female characters. The fourth setting, a café, where the various male characters of the film drift in and out, is run by a woman, a matriarchal figure of wisdom, while her daughter who serves there is, first, an object of desire and then, later, a wife. The one other female who appears in the film, is the feted boxer's trophy girlfriend, who it is implicitly suggested takes his fighting power away – the sex with her has drained him of energy – when he loses a career-defining bout. Three of the four sexist, Kitano stereotypes, then, are seemingly located in this film. However, the absented mothers to the two main protagonists, and any reference to a biological family, are missing from the film. What is also seemingly missing is any lasting heterosexual coupling, or the consummation of heterosexual love. What replaces the mother, the blood family and the heterosexual lover and love affair, however, are fathers who mother, male groups or sub-cultures who provide kinship, and male friends who provide love, as they refuse to enact or embody gender norms, in an oscillating process of subversion and reversal.

The owner of the boxing club, and the yakuza boss, are the missing fathers of the piece and yet their affection for Shinji and Masaru, respectively, is relatively tender. The boxing club and the yakuza gang become the surrogate families, a home space where the two youths can find something to be good at and believe in. These tribes are a haven in a heartless world, albeit a violent and destructive one. Shinji and Masaru are, on the one hand, the brothers in the film but their brotherhood is not based on biology but simultaneity and doubling, through the recognition, or assimilation of each other's alien alterity. They are *doppelgänger* outsiders, who refuse to conform, to be regulated by schooling or disciplined by patriarchy, which consistently falters in the

Doppelgängers – Kids Return (1996)

film. On the other hand, they are wayward lovers, with each of them moving between and across gender positions, their youthful age an interval zone where liminal becomings are made manifest.

Shinji is initially 'girl' to Masaru's 'boy', androgynous in appearance and needing protection. Masaru is the protector, the navigator of space and the initiator of the crimes they undertake together, although Shinji is rather a passive accomplice, standing on the sidelines *like a girl* as the action takes place. When Masaru disappears for a while, after losing a fight, Shinji is literally and metaphorically lost without him. He returns to their usual hide-out on the roof of the school listlessly waiting for Masaru to return. However, when they join the boxing club and Shinji is proven to be the better fighter, Masaru quits, joining the yakuza. The feminine Shinji is now also revealed to be a hard-bodied fighter, and so the vibrations of his own ulterior self bubble to the surface in a new and trangessive way. As his skills are recognised as a boxer, however, he comes under the influence of renegade, washed-up fighter Hayashi (Moro Morooka) who teaches him to indulge (to eat and drink) and then throw it up before a fight. That he can be manipulated by this shadowy Daddy figure, and that his bulimia weakens him, transfers the gender binary once again. Shinji gets to feel or experience what it is like to be a woman who has to regulate her diet and take extreme measures if her body does nor measure up to patriarchal law. This management of desire is born of a border crossing.

Shinji is the second fighter in the film to lose a prize bout because of woman, although this defeat belongs to the woman within. The defeat, nonetheless, is not a call to reinstate gender norms, to bring back the 'man' to the womanly Shinji. Rather, the defeat can be reconstituted to recognise that with the absence of Masaru, his other, ulterior half, he is not complete. In a similar fashion, Masaru's fall from grace with the yakuza, culminating in his savage beating, is a recognition that their two hearts beat as one. That they are reconciled at the film's beginning and end, in Kitano's circular narrative structure, suggests a fusion of self and a love affair sensed into the body, timeless and memorial, transformative and changing. Their bodies then might also be said to be creating what Alexander Doty terms 'queer space' in which 'already queerly positioned viewers can connect with in various ways and within which straights can express their queer impulses' (2000: 340). The last shot of the film has the two youths – now young men – ride their way back to the school-yard that they first entered at the beginning of the film. Masaru's seating position on the bike has been reversed – they now face each other – although the impersonal, grey colouring and hard lines of the *mise-en-scène* confirm their difference to this space-place. Facing each other, with little prospect for success in the world, and with nothing to believe in, they nonetheless live again in the interval space that is in, within, and between them.

Kitano's films regularly throw into confusion gender and sexual binaries through drag performance, cross-dressing practices and masquerade. While both drag and cross dressing have particular cultural, historical roots in Japan, these border crossings are nonetheless full of potential becomings. Judith Butler (1993) suggests that performative acts such as drag denaturalise (demythologise) the discourse that the body is

gendered at birth and born sexually differentiated. Through the constructive nature of drag and transvestism, one can deconstruct the made-up nature of gender identity and experience same-sex sexual desire. In *Zatoichi*, Osei (Daigorô Tachibana) is a wandering geisha who subsequently is revealed to be a beautiful boy-male. Osei's drag or transvestism is narratively placed as 'disguise' so he can find the killers of his parents. However, so well is the geisha role performed that it comes as a shock when he is outed by the blind Zatoichi mid-way through the film. Osei has performed the role so impeccably that he/she has instigated male desire within the diegetic world, as well as with the viewer one would guess. Her ruse was outed not through sight but smell, a re-framing of identity that while suggesting a latent essentialism actually points to the invisibility of gender normativity. Shinkichi, a male loafer in the film, is so taken with Osei's beauty he turns to cross-dressing too, with the implication he wants to be as desirable/desired as Osei is. *Zatoichi*, then, troubles gender in potentially transgressive ways.

Masquerade, or the mask of womanliness as Mary Ann Doane (2000) posits it, is something that can be worn or removed. It is a cover but one which can be taken off, to reveal the hidden psychology beneath the mask. This pretence can manifest in ways which terrify patriarchy, and/or which reveal the mechanisms that produce the need for the performance in the first place. The femme fatale who seduces, and then suckers, the private eye of film noir is a striking case in point. While the figure of the femme fatale, a figure that Doane suggests has real power to reveal and reproduce gender norms is absent from the Kitano film, there are nonetheless female performances that are based on subterfuge, or donning a mask that cannot be easily penetrated. The absent mother of *Kikujiro*, for example, who has built a new life, a new family elsewhere, and who appears to Kikujiro and Masao as the idealised nurturing figure of patriarchy, is a powerful embodiment of traitorous female masquerade.

Nonetheless, it is these fixed feminine masks that women put on in a Kitano film that are particularly arresting. They undoubtedly perform their roles as doll, wife, sister, mother, so exactly or perfectly in fact, that the stereotype it is fashioned from raises up to question its own performance characteristics. This is not simply a question of Kitano revealing the weak hand of his penchant for minimal external psychology for his characters. Rather, there is such a thin transparency to the way these masks are performed that they become more than the sum of their parts; they in effect refer to their own artifice. Dolls are just dolls, and masks are revealed to be just that: placed on the face, scripted onto the body, forced to perform their designated roles. That the literal image of the mask repeatedly finds itself into the Kitano film world, through paintings, tattoos, staged performances, vases, kites and nightmares, allows one to see, and to compare them with the other forms of masquerade that ebb and flow there. Masks that are too transparent, that one can see through or into, need a complimentary space or location; they need an alternate sensation to tie one's meaningful glance down to. *What lies beyond, before the mask that I can see through?* In a Kitano film the answer is presented as a silence and gap – nothing essential or linguistic can represent it. The only truth that lies beyond the mask is a void, and in that void one becomes a bloc of sensation, free of language and power and control.

The Kitano mask is often made to slip, to show itself, through physical assault to the face, particularly to the eyes. In *Dolls*, after teen pop star Haruna's (Kyôko Fukada) car accident, she can no longer be the vacuous beauty that sustained her fame in the first place. Her ruined face, her partially blind vision, can no longer perform the role of desired object, or return the coy, kittenish gaze that made her complicit in such fantasy exchanges. In *Brother*, wannabe hood Denny is gouged with a broken wine bottle after trying to hustle Yamamoto (just off the plane from Japan) for money. His inability to perform the role of gangster throughout the film becomes a recurring marker of the fact that the mask does not fit him. That it is his eye that is punctured; that after the car accident Haruna can no longer see properly; and that numerous other characters in a Kitano film momentarily or intermittently lose their sight, or insight, or fail to clearly see the betrayal or subterfuge heading their way, is also a strategy for propelling characters into situations where they are forced to *see differently*. They are compelled to envision alterity in themselves and in the world. This not seeing, this partial vision, enables one to see into, through and beyond shapes, objects, vibrations and subjects that were hitherto hidden from normal, optical view. Sight/insight is reconstituted so that it is both invasive and haptic, penetrating into the very body of things in the world. That violence is one of the key ways in which vision is pierced and then restored suggests that the body needs to be broken up, its alterity revealed, for transformations and becomings to take place. One can see this re-envisioning and breaking up in the way the nation and the national is rendered ulterior in a Kitano film.

Ulterior Nation

The national imaginary in a Kitano film is a particularly striking sea of contradictions and collisions. His film work seems to call or cry out for the return of a mythical Japan that is long gone or never was. Nationalist sentiments enter his films through the repeated act of noble or honourable suicide; a fascistic, fatalistic masculinity; through recourse to social and political hierarchies, like that of the yakuza; and through place myths in which the Edenic rural, the garden, and the shoreline return lost wanderers (the lost generation) to existential plenitude. These compensatory heterotopias (see Foucault 1986) can be found across his work but crystallise most forcefully in the paradise that Okinawa offers his destitute characters. Arguably, there is a complicit, self-orientalising eulogising that also consistently repeats itself. It is as if Japan really is Other, unknowable and absolutely different from the West, or its embodiment, the USA, and is all the better or richer for it since it offers or proves social cohesion.

Nonetheless, the despairing pathos one encounters in a Kitano film, the social issues touched upon, the breakdown of the family, corruption, yakuza deceit and betrayal, a failing education system, and the liminal or temporary nature of the heterotopias one visits, draws attention to the fact that the national imaginary is actually a fractured ideology, truly mythic in form and history. It suggests that Japan is itself made up of different spaces, places and inhabitants, with failure, competition and conflict a marker of their relationship to one another. This paradoxical dialectic of a Japan that is cohesive and unified, fragmented and divided, Oriental Other and full of lots of alter-

nate others, works to undermine the nationalist project and, consequently, it opens up a space for the complexity of difference or alterity to emerge. Ultimately Kitano's films recognise the hybridity of culture, of how it flows and folds internally and globally, in networks and streams pulsating this way then that. He understands and appropriates the free trade in the trafficking of commodity signs that takes place in the global marketplace, so that as a totality the nation and national appear and disappear as an *über* horizontal and vertical alterity.

Koichi Iwabuchi has suggested that one reason why certain types of popular Japanese film have done well in the West, and the US in particular, is because of the way they are de-odorised or made more palpable for Western viewers through the erasure or flattening out of race and ethnicity indicators; Koichi terms this process *mukokuseki*, or 'the something or someone lacking any nationality' (2002: 28). He points to the de-raced faces of *anime* characters as a striking illustration of this. While Kitano's *Brother* can be argued to be a subtle evocation of *mukokuseki*, its yakuza-style violence made to appeal to Western viewers and to the particular tastes of the closet or latent Orientalist, I would suggest that all of his films engage in a more purposeful or radical version of the body that is not defined by nationality alone. In this respect, one can actually take issue with Koich's idea of *mukokuseki* because it indirectly reinstates a raced body as somehow rightly essential to the national imaginary and its creators and characters. The erasure of race while very often in the service of the Orientalist/ self-orientalist may also be the very tactic for doing away with the limitations of the body, for moving beyond the national.

In earlier chapters I have argued that Kitano's work is a cauldron of competing forces, influences, longings and distractions. It seems to want to haul the great, lost past of Japan into the liquid modern present, while at the same time refuting, calling into question such biological and culturally essentialist determinism. The idea that Japan is a cohesive, inclusive nation-state is constantly challenged in his films. The marginal, oppositional status of his characters, the rather kitsch use of Japanese iconography, and the largely metaphorical attempts to leave Japan, to find succour in minority Okinawa, forcefully dislocate nationalist sentiments. The Kitano film does not believe that the national can be recuperated, and neither do his films finally suggest that it should. Japanese bodies are constantly called into question; their failings and the border crossings split, divide, fold and regenerate into animal becomings that are beyond ethnic and racial lines. This ulterior Japan de-Japaneses itself, allowing its own alien alterity to rise up to throw into confusion the national imaginary and myth that the body is naturally, essentially raced. Given that gender and sexuality are also broken up in a Kitano film, one can argue that Kitano's project is to make minoritarian cinema, where, 'through the pleasures and horrors of the molecular dissipation of embodied subjectivity and desire minoritarian modes of perception reconceive the world' (MacCormack 2008: 11). This is a reconception that is asemiotic, affective, built on a sea of shocks and forces that coheres into view the body (of the nation) that has no organs to speak of. At the end of *Getting Any*, Asao, now a fly-monster, is brought to his death through being swatted by a giant meshed spade while eating off an enormous pile of shit. Government officials, scientists, politicians, the military are

all drawn into this unifying parody of a nationalist ending. That it is shit, ultimately, that draws the nation together, suggests that bodily waste is more important than the body which excretes it. Let us return to a quote by Kitano from earlier in this book:

> I thought at first that film was the pus created when Japan became infected by the disease called Westernization. But now I feel that pus has transformed itself into a good tissue. Inside of me that is. From a young age, I've experienced and absorbed many things. When I wondered which culture it came from, I realized it was the one that sneaked in – the American culture. I'm just an old timer infected by this culture creating a paper theater, but I'd like to keep creating better paper theater.

The materiality of pus is an interesting one – a poisonous substance that bursts out of boils, or infected wounds, its ability to ooze a quality that cannot be contained or bordered. That it can be transformed, that it can transform itself into 'good tissue' a reveal that suggests it is already composed of an alterity, as Kitano recognises that he is too. In *Takeshis*, the multiple faces, personas, masks, images that make up Takeshi Kitano/Beat Takeshi is an explosive play with the disappearing self no longer limited to racial, sexual or gender determinants. Nonetheless, I think *Brother* is the Kitano film that best draws into an affective economy these radical, shape-shifting alternatives. Gerow suggests:

> Kitano's assault on America is aligned with Japan's assault on Pearl Harbor. Considering this film was directed more at foreign audiences, at least in market terms, the attacks on the viewers become an assault on specifically foreign – possibly American – spectators, while also presenting the fantasy of the American (Denny) forgiving the Japanese for that attack and becoming close friends. (2007: 182)

Brother is a film made with international money, framed for a Western audience, and located in the urban wastelands of Tokyo and Los Angeles. The range of diaspora individuals that Yamamoto first meets and feels comfortable with on arriving in the US is a indicator of his own status as newly arrived immigrant, Japan's status as pariah nation and their collective status as minority citizens. That he and other diasporic Japanese we meet in the film bring Japan to the US, through ritual, dress, cuisine and architecture, is a sign of the 'home' being brought into an 'away' space, but also of multiculturalism and cultural hybridity. An ulterior transnational Japan emerges in the film but not as some ultranationalist force but as broken up and reconstituted in contradictory ways.

Nonetheless, at the beginning of the film, Yamamoto's biological younger brother has been completely Westernised and this is signified to be a problem. Yamamoto teaches Ken (Claude Maki) to be more Japanese, a process undertaken by all the other characters in the film. However, that Yamamoto and black American Denny are most closely aligned if not exactly doubled in the film, is a recognition of the shared, complicit alienation and disenfranchisement that they suffer as Alien alterities

in a white-washed America. They belong with, to, within one another, regardless or in spite of their ethnicity or race. The film's aesthetics directly call or repeat not only previous Kitano Yakuza films but *Scarface* (Brian De Palma, 1983), the ultimate American gangster film. The machine gun sequence is borrowed from *Boiling Point* and a clear echo of Tony Montana's rampage in *Scarface*. In fact, Beat Takeshi's Yamamoto undergoes a similar journey as Tony does, and their suicidal, final shoot-out ending becomes a haunting loop back across cinema time. This is a moving, moveable pain image of the minoritarian silently giving himself over to death so that he cannot be brought back to become the body of the majoritarian. The last line of the film, given over to a Japanese-American bar keep, 'you Japanese are so inscrutable', is an ironic comment on the films own play with identity and subjectivity, a recognition of splitting, and a linguistic rip into the homogeneity of representation. That Yamamoto goes to his death, through blood-red doors, is not a confirmation of his inscrutability but a rendering and re-rendering of the body that willingly falls in silence, a minoritarian death of pure becoming.

CHAPTER FOUR

Starring Kitanos

I step into a bar off the main drag in Shibuya. I am soaked through, another downpour taking me by surprise. Neon rain clings to my clothes. I sit at the bar drinking cold beer. Two young couples are in one of the booths to my right, and a group of salarymen are standing someway off to my left. Laughter fills the bar. Its red bar and table tops have heavy grains that one can dig your fingernails into. Then Beat Takeshi walks up to me and says hello. He lights a cigarette and puts it in my mouth. Then a guy I hadn't noticed before shoots us both dead.

Introduction

Takeshi Kitano/Beat Takeshi occupies a vexing position when it comes to the question of stardom and celebrity. As film-art auteur and troubled multi-talented genius, or *tensai*, he is a feted, auratic figure of fame. As film star Beat Takeshi he is typed to play certain explosive roles tinged with pathos and melancholy and when these roles are circumnavigated, this 'problematic fit' extends the semiotic and affective reach of his star image. As game-show host he is a television personality or celebrity, more ordinary and immediate than extraordinary and lasting, to paraphrase John Ellis's (2007) problematic distinction between the film star and the television personality. As *Brand Kitano* he exists in the slipstream of his films, books, art, promotional and television work. Office Kitano is where the real hard work of movie deals, endorsements and contract negotiations are done. That all these Kitanos may make different sense to different audiences, both in Japan and internationally, adds one final liquid ingredient to the multi-dimensional, split persona that emerges, converges and dissipates itself.

Christine Geraghty (2007) has usefully located three categories through which stars generate meaning. First, there is the 'star-as-celebrity' who is primarily represented in terms of their leisure pursuits and lifestyle, and who 'literally interacts with those from

other areas'. The star-celebrity exists in the public arena and this is what primarily interests us about them. Second, there is the 'star-as-professional', or the individual who plays to type, their star signification sustaining itself as a form of pleasure and attachment. The star vehicle promises a particular type of performance whether it is heroic action, slapstick comedy or idealised romantic coupling. Third, there is the 'star-as-performer', marked by an emphasis on 'impersonisation', improvisation and method acting; on a distinction between star and role which is effaced in the 'star-as-professional' category. The actor-star builds a performance out of the demands of their piece; their fame built on their greatness as actors and (often) on the diversity of the roles they take. While Geraghty recognises the articulations or links between these three categories, it is David P. Marshall who draws them together to recognise their full importance in liquid modern times:

> From an industrial as well as cultural vantage point, celebrities are integral for understanding the contemporary moment. As phenomena, celebrities intersect with a remarkable array of political, cultural and economic activities to a threshold point that it is worth identifying the operation of a *celebrity culture* embedded in national and transnational cultures. (2006: 6)

Kitano, as I will now go on to argue, pours in and between these categories, a watery movement which ultimately confirms him as a star of anomie and a brand of pathos ultimately in tune with an out of tune world. Kitano(s) is a supericonic, affecting image of these troubled contemporary times.

Kitano's Images

In the introduction to *Heavenly Bodies*, Richard Dyer sets up the dual hypothesis that firstly, 'Images have to be made. Stars are produced by the media industries, film stars by Hollywood (or its equivalent in other countries)' and secondly, star images relate to 'notions of personhood and social reality' (1998: 8, 9). Dyer suggests that it is only through combining textual and intertextual analysis of stars with an understanding of the ideological and historical contexts in which they emerge, that one can make sense of their fascination for audiences and their power to affect ordinary people's lives. As Dyer writes:

> Stars articulate what it is to be human being in contemporary society; that is, they express the particular notion we hold of the person, of the 'individual'. They do so complexly, variously – they are not straightforward affirmations of individualism. On the contrary, they articulate both the promise and the difficulty that the notion of individuality presents for all of us who live by it. (1997: 10)

Let me begin, then, with a textual and intertextual image-based analysis of Kitano's star self (although even this is tricky because there are always multiple Takeshi Kitanos

to contend with). Nonetheless, in one key respect, he seems to reverse the usual trajectory for how a film's star image is born. With a long history in popular entertainment, and with the brash, vulgar comedy persona of Beat Takeshi cemented in the Japanese cultural imagination, his first serious starring role in *Merry Christmas Mr Lawrence* (Nagisa Ôshima, 1983) was viewed as a 'problematic fit', one which fazed parts of the Japanese audience. They struggled to take his performance as a brutal prison camp officer seriously, his comedian persona standing in the way of their ability to suspend their disbelief. That Takeshi Kitano had to re-birth, refashion Beat Takeshi as a brooding, silent, exacting man of violent action and anomic desire was a conscious project to cleave him(self) into different roles and embodiments. If we take the Beat Takeshi film star persona as being built out of a split with his television personality, one can discern a collision between alternative versions of the entertainer/artist. Daisuke Miyao (2004) argues that the gap that exists between the two Kitanos is one that draws attention to the difference that exists between cinema (cinephilia) and television (telephilia). Miyao concludes rather apocalyptically that telephilia elided this gap with Takeshi Kitano becoming just 'another television personality', although this is a position that I will now take issue with.

John Ellis argues that 'the star is at once ordinary and extraordinary, available for desire and unattainable. This paradox is repeated and intensified in cinema by the regime of presence-yet-absence that is the filmic image' (2007: 93). In this way, the 'this is was' nature of the star 'awakens a series of psychic mechanisms which involve various impossible images' including 'the narcissistic experience of the mirror phase' (2007: 92). Ellis then goes on to set up his position on television fame which he considers being that much more present or immediate than cinema stardom. For Ellis television presents the viewer with

> personality … someone who is famous for being famous, and is famous only in so far as he or she makes frequent television appearances … In some ways, they are the opposite of stars, agreeable voids rather than sites of conflicting meanings. (2007: 96)

While one can clearly take issue with Ellis's position, particularly since television is increasingly cinematic and visual technologies have converged with specific regards to Kitano, one can readily see the film/television, star/personality dichotomy manifesting itself in Kitano's divided persona. Takeshi Kitano fashions films in which the past/present/future potential of the Kitano star image is brought into full view and where the associated awakenings and new becomings that the viewer experiences in front of such forceful sites of identification emerge. The black suited, dark shades-wearing and phallic-smoking active male that defines Beat the film star is the perfect(ed) personification of idealised masculine identity. The spontaneous, improvised performer that fleshes a character together in the moment is a necessary indicator of the authentic artist/actor wrapped around the star. That Beat Takeshi, the light weight, mouthy television comedian and game-show host, also haunts this film star image is part of the intertextual relay that gives further definition or a depth of crisis to the persona.

Two-body Kitano in
Glory to the Filmmaker! (2007)

In the body of Beat Takeshi, fat comedian meets muscular anti-hero; slapstick, foul-mouthed humour meets dramatic performer; void meets depth; language meets silence; and irony meets pathos. However, what is required of this body is to deny, while not being able to fully suppress, its television, celebrity half. In the body of Beat Takeshi is a struggle between the minoritarian (alternative, oppositional) film star-artist and the majoritarian (mass-produced) TV host. Of course, there is a third entity occupying the Beat Takeshi body, that of the director Takeshi Kitano. However, this possession may very well manifest itself in the head space, in the Takeshi stare, of the Beat Takeshi body.

The Beat Takeshi Stare

One can argue that the Kitano film is often a star vehicle for Beat Takeshi. The narrative is organised to enable him to display his star qualities – a setting/situation is arranged so that he can 'perform' his attributes and qualities. The character type that Beat Takeshi plays 'fits' the star image he brings with him to the text, while the aesthetic dimensions of the film enable him to be lit, dressed and staged in recognisable ways. I have earlier commented on the Beat Takeshi walk, the facial tic and the iconography employed to fashion his hard-bodied, silent and quick-to-react anti-hero persona. Now I would like to examine the Beat Takeshi stare since its penetration and silence is a particular affecting source of his star signification and of the body that lies beyond the constructed gaze. While in nearly all of his films characters are found staring at the camera, in a dislocated form of direct address, or into space, at someone, some thing or some 'memory' off-screen, the Takeshi stare is of a particularly intense form. This is in part because the weight of his star image bears down upon the look. The viewer comes to recognise this stare as inter-subjective, memorial and one that is caught looking deeply into things; at the past, future (including one's own death) and at parallel events it is not possible for it to be present at. In *Boiling Point*, the Kitano stare punctuates the narrative with a searing intensity that destabilises temporal and spatial continuity. Four inter-connected scenes are pulled into affective power through the dead-look that Kitano directs at the camera. As already mentioned, while on the way to get even with a yakuza mob, the hand-held camera takes up a position in the car that enables it to capture Uehara/Takeshi staring back at it, or into the imagined space it possibly represents. It is the cold, emotionless stare we have become used to,

but here it is rendered alien by the discordant, other worldly non-diegetic sound that enters the shot. This triggers the rapidly-edited dream or death prophecy sequence that itself includes two direct address shots. Later, in the field of flowers, Lion-man Uehara silently waits in the 'forest' to take his prey when the time comes: the direct address positions us as the lambs ready for the slaughter. This is directly followed by a cut to the car, stationary, with Uehara again staring deep into space, surrounded by the flowers they have picked. The reflections in and off the windscreen, however, place irregular patterns between him and the viewer-camera. Finally, in the scene where he takes vengeance on the yakuza mob, Kitano stares right into the retina of the lens and guns it down; a murderous, bloody gaze that the previous three sequences have prepared us for – death at the face of Kitano.

The Beat Takeshi stare is given impossible qualities, a vision capability in fact very like that of the film director, a blink of his eye registering like the cut between shots. The controlling look of Takeshi Kitano finds its way into Beat Takeshi's god-like view of events. And yet, Beat Takeshi often seems unable to control events but rather accidentally or inadvertently causes their happening and the death and violence that usually ensues. It is as if the director is pulling the strings of the puppet Beat Takeshi, and this adds to his pathos. As Kitano himself suggested: 'I'm having fun with Beat Takeshi and Kitano Takeshi. If I'm asked who I am, I can only answer, "I'm the man who plays Beat Takeshi and Kitano Takeshi"' (in Gerow 2007: 3). There is a self-destructive quality to the Kitano stare; it is a pathetic, violent, remorseful look, and consequently, and in addition, it carries the inherent violence of the cinema machine and the work of the film director into or out of the retina of his/their eye. Abe Kasho (2000) argues that Takeshi Kitano is actually breaking down the body of the television comedian Beat Takeshi so that the pathetic cinematic character can emerge. Beat Takeshi's blindness or partial vision, and his silence, is a sadistic gagging order imposed by the director. Beat Takeshi's waywardness is a rebellious snub to the 'cultured' director.

There is also a cold intimacy about the Beat look, particularly when aimed at the viewer. Its despair, found in one film after another, layering his brooding star persona, attempts to symbiotically resonate or connect at the level of anomic dissatisfaction that many viewers live through in the modern world. In fact, Beat Takeshi's dead-beat stare does not singularly emerge from his being, or that of the director, but is also a rebound look from the pathetic stares viewers throw at him when immersed in the film world. The viewer enters the text through the familiar eyes of Beat Takeshi and this vibrates throughout the looking regime of the film. The filmic world acts upon the viewer and the viewer act upon/in the events of the film, and these film-world-events are infused with pathos and death. Beat Takeshi cannot stand (the pain of) us looking at him while we feel the pain image intensely as it is thrown back at us. The blind Zatoichi is the result of Beat Takeshi not being able to bear looking on the world, or to see the viewer looking on him so mournfully. As argued before, these intense exchanges foster or cleave into existence an out-of-body experience. But why, how does the star Beat Takeshi achieve this god-/anti-god-like affect on fans of his work? Is it simply a matter of charisma?

Charisma of Anomie

Takeshi Kitano/Beat Takeshi is often written about in the popular press as having cool charisma, or an auratic presence that is special, unique and which naturally reveals itself in interviews and on camera. It is said that the charismatic Takeshi lights up the screen, and it is this supposed essential quality that fans are attracted to. Charisma, of course, is actually a mythic construct, in the service of dominant ideology, and 'is effective especially when the social order is uncertain, unstable and ambiguous and when the charismatic figure or group offers a value, order or stability to counterpoise this' (Dyer 1997: 31). Charismatic figures emerge most forcefully in times of social and political crisis, they are cohesive types who help paper over ideological and political differences and inequalities, and cultural shifts that have grown too large, and they are reliant on ordinary people to strongly invest in their message, art or campaign that the charismatic figure champions. For example, Dyer uses the star charisma of Marilyn Monroe, in particular her sexual chemistry and naïve innocence, to show how she 'seemed to be the very tensions that run through the ideological life of 50s America' (ibid.). More recently, I have suggested that Barack Obama represented a type of fusion charisma figure that attempted to connect with liquid moderns lost in the world, politics being the last refuge for cultural and political re-birth (see Redmond 2010). I would now like to argue that Takeshi Kitano/Beat Takeshi's charismatic authority can be read in a similar way but his affect is one that derails, to a degree, the dominant order rather than shoring it up. I will further break down the key constituents of his charismatic persona, looking at his suggested 'genius', and performative pathology or 'damage' as the way in which these intense relationships are made good. Kitano's charisma is one composed of anomie.

Womanly Kitano Genius

Takeshi Kitano/Beat Takeshi has all the traits or characteristics of the romantic artist and, perhaps less obviously, 'tortured genius'. His abilities extend across a range of art forms; painting, poetry, literature, journalism, film and television. As the press notes for *Hana-Bi* remind us, in 1995 Kitano

> was back hosting six network shows, writing six regular columns for national magazines and a sports newspaper and releasing his fifth film, the comedy *Getting Any?* ... He also writes poetry, essays, and serious novels and has published fifty-five books. Kitano took up painting after his accident and has created hundreds of striking artworks, including those featured in *Fireworks*. He also acts in films for other directors – most recently in Robert Longo's *Johnny Mnemonic* and Takashi Ishii's *Gonin*. He also starred in the film adaptation of his novel, *Many Happy Returns* (1993) a satire of Japanese religious cults.

His artistic method is said to be spontaneous and volatile, particularly when it comes to film direction and the rehearsal stage of a shoot. Kitano generally works with a

minimal script, characters grow or reduce in the rehearsal space, dependent on the interaction and quality of performances that emerge, and shooting is itself a rapid process with Kitano favouring a one-take regime. This knowledge we have of Kitano's working method – filtered through interviews, press-packs and Kitano's own auto-biographical accounts of his life – acts as an indicator of his desire to capture the essence or quality he is after at each and every moment of his creative life. Biographical accounts add to the artistic depth and mystique that surround Kitano. We learn that he is haunted personally, and that he had a difficult upbringing: there was little money in the house, and his father was a drunk who beat his mother, both perhaps indicators of his chronic sense of failure. We know that Kitano underwent a transformatory recovery from a near-fatal motorcycle accident, taking up painting, a pursuit triggered by his seeing/sensing/smelling flowers differently as if for the very first time.

One can read these accounts as the meeting place where public/professional and private/personal commentary fuses to render him an artistic star-genius who lives on/past the edge of psychological normativity. In terms of this alignment between public and private persona, the roles he takes are of pathetic men, often suicidal, always anguished, and nearly all on the verge, or past the point, of nervous, emotional exhaustion. This can be read as a manifestation of his real self. As Stephen Harper suggests,

> Today, as in the Renaissance and Romantic periods, mental illness is a token of both public greatness and private vulnerability; the celebrity, that most visible of attractions, is always imperilled by mental illness, the most solitary of afflictions. (2006: 314)

Celebrity genius, this most solitary of afflictions is gender encoded, as Harper goes on to demonstrate. On the one hand, the qualities and conditions of extraordinary talent are understood to be both masculine and feminine. On the other, the struggle for recognition and the troubles one faces on the road to acceptance is marked by heroic, triumphant becoming for male geniuses, and 'tragedy, melodrama and hysteria' for female artists. Harper points us to the various portrayals of Jackson Pollack and Sylvia Plath to illustrate his point that men overcome their psychological afflictions to claim their right as geniuses, while flowering female artists implode emotionally, an ultimate full-stop to their talent. I would like to take a moment to consider these articulations in relation to Takeshi Kitano/Beat Takeshi since I see them operating in/through the complexities of his divided persona, so that his 'genius' is marked by a border crossing and a pathos that becomes its over-determining characteristic.

Takeshi Kitano/Beat Takeshi's journey to feted auratic artist closely follows a rags-to-riches trajectory laced with masculinist sentiments. Kitano came from a working-class background, was a rebel at school, dropped out from university, and took what looked like a string of dead-end jobs, from 'janitor, waiter, airport baggage handler, taxi driver and finally elevator operator in the France-za burlesque theater in the Asakusa entertainment district of Tokyo' (in Shinozaki 1997). Of course, as these 'inevitable' becoming-star narratives prophesise, Kitano gets his first break at the theatre when he asked to step in for the partner of Beat Kiyoshi (Kiyoshi Kaneko). The two click

together and a new *manzai* comedy act was born: *Tsuu Biito* or Two Beats. They work the strip clubs and the theatres, until Beat Takeshi's big break in television comes. Success follows success, as his portfolio of skills grow, until he is asked to step into direct *Violent Cop*, each 'break' of course read subsequently as the recognition of the latent talent that was burning within him.

In fact, the movement from low-brow, mass-orientated art or media forms, to the high art of non-conventional, genre-breaking cinema, is seen as an inevitable result of Kitano's artistic vision. All three of the elements that Dyer argues goes into making the star success myth work are in play here: 'that ordinariness is the hallmark of the star; that the system rewards talent and "specialness"; and that hard work and professionalism are necessary for stardom' (1998: 42). Takeshi Kitano/Beat Takeshi seems to be the very embodiment of successful individualism, a *tarento*, who emerged in Japan's consumerist-driven economy proving as he did so the country's own success as an inventive, liquid capitalist nation-state. Nonetheless, that Kitano consistently wrestles with this becoming-special, with the ideology of the success myth, can be read as a desire to challenge the status quo and to move beyond representational cliché. He does this through becoming woman, becoming animal, by becoming a minoritarian.

Takeshi Kitano/Beat Takeshi's embodiment of his artistic talent seems to be one that has feminine and masculine qualities although the auto-destruction that regularly inhabits the characters he plays is a particularly feminine version of the tortured soul who cannot bear their life anymore. It is clear that the brute force of the characters Beat Takeshi plays is crafted out of phallic, masculine elements; and that his parallel wallowing and pathos is of feminine composition. In the preceding chapters I have indicated that the pathos that wraps itself around Kitano's film work, and Beat Takeshi in particular, is one usually confined to, or conferred on genres or characters of low status; women in melodramas, for example. I have argued that his films offer viewers the chance to become woman as instances of drag, mask and masquerade regularly take over his work, and take over/on the body of Beat Takeshi. There is also a queer impulse or intensity to his work, to Beat Takeshi's homoerotic and masochistic tendencies. In the wounding of the/his body, in the blood-spill that follows, one becomes or rather one *is* animal. In the star becoming woman and animal, in the border crossings that take place when Kitano silently weeps and kills, there is an intense recognition of his/our molecular, salty and fleshy, and wet and red being-in-the-world. As Patricia MacCormack explains:

> Becoming is the entering into a participation with specific molecular intensities of another element. Becoming is neither an imitation where we act like, nor a creation of a new Oedipal or capital family where we belong within a hierarchical structure of a different genealogy. Becoming selects certain specificities and intensities of a thing and dissipates those intensities within our own molecularities to redistribute our selves. We select a term and by opening to affectuations of forces of that term become a hybrid anomaly, a unique mingling. (2008: 92)

Takeshi Kitano/Beat Takeshi's unique self-Other comingling, the liquid confusion at the centre of his star-artist-personality persona, and the suffering he goes through in his films, is one based on marginal identity and minority becoming. Textually, then, Kitano's films challenge the very substance of the success myth, and of the trajectory of his own becoming-star. Through the dissolution of the star-artist body, through the womanly and the animalistic, and through the alien alterity that wraps itself around everything, one gets to sense, to experience a body beyond language, beyond the docility and disappointment from which it is usually rooted in. Kitano's sadism is matched by his masochism; the violence he puts out is itself put back into his body as it is pummelled, and turned into a pain image. Kitano does not simply beat up on his star selves, however, but on stardom and celebrity, and on liquid capitalism itself.

One can read the Haruna/Nukui/Aoki sequence from *Dolls* as a critical engagement with celebrity culture and the faulty para-social relationships it produces. Haruna only experiences the world through her celebrity self, while Nukui and Aoki only find pleasure or communion in the world through the figure of Haruna and the fan-tribes that emerge around her performances and output. Haruna cannot face the real world when her celebrity status is taken away. Nukui (Tsutomu Takeshige) and Aoki (Al Kitago) struggle to live in a (mediated) world without the celebrity image of Haruna to connect with. They were blinded by her 'love' before her car accident and Nukui blinds himself so that he can carry on the imagined connection that he (and now) thinks they share. This is an extreme form of fan journeying and worship. That these engagements end in tragedy is a sign of the liquid nature of the celebrity and the liquefying condition of modern living. One can read Haruna in *Dolls*, then, as the empty body of commodity celebrity as it manifests in contemporary Japan. She is a mediated, para-social entity whose manufactured performance lacks depth or meaning. Her blindness is the blindness of contemporary commodity life itself. For Kitano, of course, Haruna resonated with his own sense of celebrity following his motorcycle accident:

> Obviously her story parodies my own experience after the motorcycle accident. There were celebrities and fans in Chikamatsu's time too, and his plays suggest that the liaisons between idols and their fans were even more extreme than they are nowadays. Anyhow, like everything else in the film, the notion of a fan blinding himself to spare the feelings of his idol is caricature. It's the relationship between a celebrity and a fan as seen by a Chikamatsu doll. (Rayns 2003: 18)

Nonetheless, by the time Kitano makes *Takeshis*, the notion of a fan (the star-actor) going berserk is played out with telling significance. The idea that the mass-media is very doll-like, and that celebrity culture produces dolls and doll-like fans, is a powerful one and connects to the damage that fame can do.

This connection between fame damage and identification finds itself more directly circulating in the Takeshi Kitano/Beat Takeshi persona, a damage that senses itself into and out of the anomic world from which he and his fans materialise. Chris Rojek

suggests that the sense of loss and disconnect can help to explain the appeal of celebrities to audiences in such atomised societies:

> In societies in which as many as 50 per cent of the population confess to sub-clinical feelings of isolation and loneliness, para-social interaction is a significant aspect of the search for recognition and belonging. (2004: 52)

The celebrity is incorporated into a fan's worldview so that they feel they belong and can readily connect to the social centre.

Kitano Damage

Richard Dyer has argued in relation to Hollywood stars that the wealth and visibility that fame brings is often shown to have a destructive, dark side: 'Consumption can be characterised as wastefulness and decadence, while success may be short-lived or a psychological burden' (1998: 44). Stars can be said to be damaged by their success; their elevation in status taking them away from their humble backgrounds, while their God-complex isolates and alienates them from the real world. In this nether region of unhappy–happy existence they turn to drink, drugs even suicide to help them escape the loneliness of their lives. As I have argued elsewhere, this corrosive type of fame is said to offer the star or celebrity too much of everything that is vacuous and surface level, and very little of the intimate, the psychologically deep, or the long-lasting; stardom destroys their ability to be happy and contented (see Redmond 2006). While the damaged star is, of course, as much a mythic construction as the contented figure of fame, their inability to cope, their all-too-visible failure as stars, resonates in ways that has a profound effect/affect on those who are similarly placed in the cultural world.

The alienated, burnt-out star, marginalised by the media and abandoned by a great body of their fans, exists in a realm of exclusion, of inverted Otherness, that is familiar to the minoritarian individual who has similarly been marked as a failure and who consequently exists outside of dominant social networks. While the star is trapped in the 'artifice' of fame and infamy, the minoritarian is caged in the 'reality' of material inequality and social exclusion. What can emerge from such damaged mirrors of like-ness is a more symbiotic, inter-dependent affecting connectivity that runs its power in, through, and across the wounded bodies of star and minoritarian. The damaged star and the failing (in life) anomic fan share their pain in confessional acts that resonate at the carnal level of being-in-the-world. These are often the most intimate if seemingly destructive of sensory exchanges since they are expressed in suicide diaries and notes (Kurt Cobain, Lesley Cheung), cut into the flesh (Richie Edwards), sung out in heart-felt revelation (Judy Garland, Elvis Presley, Rhianna), or directly observed in verifiable mental breakdowns (Ian Holm, Adam Ant). This embodied intimacy or intensity of loss, alienation and death directly accesses the life force of the minoritarian. In Dyer's reading of Judy Garland, for example, she emerges as a crisis figure who had 'a special relationship to suffering' (1986: 143), and a 'gay sensibility' (1986: 154) that gay

men particularly identified with. When Garland sings there is an 'intensity and irony' (ibid.) to the performance that reverberates from the body of the screen into the bodies of gay men; a connection so profound that it feels exactly like the marginalisation they face in the world. In a similar vein, 'Kitano's works can be considered an alternative realism, one that, in films like *Violent Cop* or *Kids Return*, shows the true corruption or hopelessness of post-war life' (Gerow 2007: 31).

Takeshi Kitano/Beat Takeshi is not exactly a figure of fame damage, at least not in terms of his 'public', extra-diegtic persona. He is incredibly successful, wealthy and grounded. Nonetheless, there is enough of a story of personal crisis to begin to suggest an access point for the disaffected. When one considers the disaffected, suicidal characters he plays this opening multiplies exponentially and forcefully. However, it is in the articulation between all three classifications of the star that Geraghty outlines which I think pulls his persona into the liquid spill of modern life and living. Kitano is a star-celebrity, he exists as a celebrated pubic figure, subject to constant media scrutiny. Kitano is a star-professional, his star-image cemented in role choice and type, although this extends to encompass his directorial fame. Kitano is a star-performer, an actorly star that brings 'method' and improvisation to the parts he plays and consequently a heightened authenticity. Kitano's star-celebrity-professional-performer image is born of damage; he is critical of celebrity culture and has attempted to kill his own ulterior celebrity self (television comedian Beat Takeshi); his star image is crafted out of playing alien alterities, sociopaths and men-women gripped by pathos; his acting is 'real', revelatory or confessional, and comes from deep, interior forces that lie within his body; and he is a minoritarian, sadistic director who attempts to get his star-self to self-destruct, if only to become animal, to become woman. That critics such as Bo Darrell William Davis (2001) have argued this is all ultimately a branding exercise, an attempt to resituate the *über* nationalist and the savage orient into the national and transnational imagination, is my next stopping off point.

Brand Kitano

One can read Kitano's auteur-star-personality status as a form of commodity intertext, crafted, contracted and promoted through the various media sites and enterprises that he owns and controls. As Davis and Yueh-yu Yeh suggest,

> Kitano's importance in Japan is not only because of his international reputation, and almost daily appearances on television and in magazines, but also due to Office Kitano, his multimedia firm that manages a variety of film-television-publication-distribution-PR-advertisement-internet-sponsorship activities. Office Kitano subsidiary T-Mark pursues film acquisition and funds for emerging Asian filmmakers. (2008: 73)

In Japan, Brand Kitano is, on the one hand, home-grown and insular. The television personality and celebrity Beat Takeshi appears nightly on such shows as *Takeshi's Castle* (1986–89) and *Japanese, You Are Out of Line* and across a number of prime-time

shows, each requiring him to be irreverent, comedic, satirical and, at times, offensive. This inward-looking Takeshi brands himself as the agent-provocateur of Japanese culture and simultaneously their very talented home-grown (if not grown up) son. On the other hand, Brand Kitano is recognised to be of international significance in Japan. Kitano's feted auteur status in the West, his festival awards, and his acceptance into the 'canon' of great world filmmakers, a source of pride and the product of savvy promotion on his behalf. Of course, the validation or approval of the West can be said to be a form of Orientalist thinking and latent inferiority. Japan's admiration for Kitano's filmwork only fully ignited after they first were garnered with critical and commercial success overseas.

Brand Kitano is also transnational. His television shows are aired on satellite channels across the world, and adapted. For example, *Takeshi's Castle* was remade in the US as *Most Extreme Elimination Challenge*. However, it his films that have granted him transnational auteur status or that of a director whose work has had critical and to an extent commercial success across a number of territories in the world. *Hana-Bi* won the Golden Lion at the Venice Film Festival in 1997, and *Zatoichi* won the Silver Lion for Best Director at the same festival in 2003. *Sonatine* was distributed in the US with Quentin Tarantino's picture and endorsement prominently placed on the cover of the DVD. Darrell William Davis argues that Kitano's critical success is down to his conscious desire to transcend or transgress the constraints and identificatory markers of Japanese cinema while in effect re-producing them:

> Kitano shrewdly inserts himself into an unorthodox, atypical nationality that suits the transcultural forms international festivals celebrate. He references Kurosawa, the icon of Japanese national cinema, only to disavow the comparison. However, Kitano's disavowal of any family resemblance with samurai-Kurosawa-Asian stereotypes indirectly reinforces the lineage. Japanese tradition, as embodied in a canonized national cinema, is invoked, then dropped in favour of Kurosawa's brand-name value. (2001: 57)

It is this question of Kitano's uptake as auteur-star in the West that I now (re)turn to: why is Brand Kitano such an appealing 'product' in the Western imaginary?

One can connect the appeal of Kitano the star/star director with Asiaphilia and cultish appreciation of, and desire for, his renegade persona and anti-cinema cinema. Asiaphilia can be expressed by critics, reviewers, creative artists, cineastes and viewers and fans. This love of Asia, of the Asian art form, cuts across high-brow criticism, the fascination and admiration garnered on it by Western auteurs, the 'spicy' reviews of popular journalism, and the activities of everyday, consumers who excitedly purchase, watch and re-watch these adored transnational, translatable texts. Tarantino is of course someone who simultaneously takes up a number of these Asiaphiliac positions: as creator, critic, connoisseur, 'patron' and fanboy of Asian cinema (see Hunt 2008: 14). The Asiaphile, Tarantino included, may however be re-constituting an Orientalist mentality. This is one in which their desire is predicated on dreaming the beauty of the Other as if it belongs ultimately to the Occidental. It can be argued to be a suggestively

possessive re-colonilisation of the Other. His films can be said to present the West with a version of the savage Oriental, and the Orient as a feminine space/body, and is therefore pathetic because of it.

The masculine roles taken up in a Kitano film have pathological tendencies, and the violence that ensues is so alien in its trajectory, that for the Western viewer the fictive world reverberates with such a mystique, a danger, that it reconstitutes Japan as a savage (and savage to itself) land. One could point to the entire aesthetic architecture of *Violent Cop*, *Sonatine*, *Hana-Bi*, *Dolls* and *Brother* for signs of this savage-other mentality. Torture, self harm, abuse, *seppuku* and suicide litter the landscape of these films. Of course, the star Beat Takeshi/Takeshi Kitano has this savage propensity too; this widely reported story (contained in the press notes to *Hana-Bi*) a case in point. In 1986, the gossip magazine, *Friday*, published photos of a college student with whom he was reportedly having an affair. In retaliation, Kitano and eleven of his associates invaded the magazine's offices, attacked staffers with fists and umbrellas and were arrested on assault charges. The promotional posters and film stills released for many of his films often have Kitano in brooding pose, his body in action or clearly ready for action.

One can develop this Occidental appeal for his work through the way that Kitano also feminises Japan and Japanese sentiment, a position I have so far argued to be radical in this book. However, the argument that pathos wraps itself around his films, which is a distinctly 'feminine' quality, or a quality of people with lower or inferior status, can be read as a form of self-orientalising on Kitano's part, and its uptake in the West as predicated on Orientalist desires. As Davis forcefully suggests in relation to the *mise-en-scène* of *Hana-Bi*:

> Kitano sells Japanese tradition, the icons of 'Japaneseness', by selling out gender. The 'blatantly stereotypical Asian look' (epitomised by samurai films) that Kitano claims to hate is here domesticated, made palatable to a global market, by femininizing it. This is orientalism at its most stark; the Orient is always feminized for the West. Women and children are used to domesticate an invocation of highly-charged Japanese traditions. (2001: 72)

Overall, this reading suggests that Kitano's oeuvre and persona confirm and re-affirn Japanese stereotypes, sentiments and qualities voraciously gobbled up in the West to confirm its own hegemony, its ability to consume the Other on its terms, as its very foundation as the centre of culture dissolves away. Brand Kitano is seen to be complicit in this, commodifying and de/re-odorising his film work so that it sells abroad. According to this argument Brand Kitano only trades and traffics in representational cliché.

It is this reading that I would now like to (again) take issue with, first by drawing on Aisha Ong's extremely astute definition of the transnational:

> Trans denotes moving through space or across lines, as well as changing the nature of something ... [it] also alludes to the transversal, the transactional,

the translational, and the transgressive aspects of contemporary behaviour and imagination that are incited, enabled, and regulated by the changing logics of states and capitalism. (Quoted in Hunt and Wing-Fai 2008: 3)

The transnational is never simply a singular or static exchange; a fixed meeting or consumption point. The relationship between text and context, place and reception, translation and translatability is a myriad one, liquid in form, and which always involves a matter of becoming. The Other text is not passively taken-in, and is not necessarily rendered passive or mute in the moment it moves from home (minoritarian shore) to away (majoritarian warehouse). In the process of movement, in the act of reception, meanings and sensations shift, signs re-signify and ultimately transmute into precepts and affects way beyond representational cliché. One remakes the world and one is remade when one meets such a transgressive text as that which Kitano forges into existence. Because it is through transgression, finally, that I see the Kitano 'brand' reformulating the material relations of the world. This savage Other is of the same order, for example, as the savage men in a Scorsese film. This pathetic Other is of a similar kind to the melancholy that affect a large number of contemporary American male narrative agents such as Lester Burnham (Kevin Spacey) in *American Beauty* (Sam Mendes, 1999). This becoming animal, becoming woman, is like but not exactly the same as the forces and shocks that run across a Michael Haneke film, for example. I make these comparisons in one sense to lessen or devalue the argument that Kitano's films appeal because of their embedded Orientalism. Much of the cinema world is effected by the anomie I suggest runs through Kitano's work. Nonetheless, this is an anomie that in Kitano's soft but deadly hands wreaks havoc with the body, with bodies in space, and with transnational bodies' right across the world. In the next, final chapter, I return home by boat so-to-speak, to stand on the shoreline, that meeting place between land and sea, for my final look at flowering blood in the cinema of Takeshi Kitano.

CHAPTER FIVE

This is the Sea

It is a cool-blue spring day and the beauty of Okinawa beach is sublime. I have a copy of Murakami's Kafka on the Shore *with me. I take my shoes and socks off and begin to read. Every now and then something distant on the sea catches my eye and I strain to make out its shape. The sea is soon lapping at my feet and I close my eyes only opening them again when the moon has risen and holds the stars in its sway.*

Introduction

In this chapter I explore the way that Takeshi Kitano employs the sea and the shoreline, and the qualities of water, to explore questions of loss and belonging, and new becomings. In a literal and metaphoric sense, when his (male) characters go to the beach, or end up at the water's edge, they die and are re-born again, the mythic qualities of the sea heralding their transformation and guiding or sealing their fate. In a Takeshi Kitano film the sea and the shoreline are very often the conjoining locations where the social and existential crises of gender, tradition and belonging in a rapidly changing contemporary Japan is played out. This game of transformation and transgression is embodied, furnished in sensation, and at its most powerful or intense when the sign of the sea and the shoreline are surpassed by the sublime being doubled and the body emptied, beyond the horizon of signification. However, before I get to *This is the Sea* in the films of Takeshi Kitano I would like to first make a general reading of the cultural and associative meaning of the sea; and of the sea/water in Japanese culture, to better prepare myself to finish up at the shoreline, so to speak, of Kitano's magisterial filmwork. How can one read water and the sea in cultural, Deleuzean and phenomenological terms?

The sea and the shoreline are both the beginning and the end of things: encompassing the primal/creation scene, and the death scene. One stands at the shoreline and witnesses the moment that one came into existence and this is often at the same time as one stares into the nothingness of the here-and-now. All of life begins there and yet death is in the sea and in the seer who sees this emptying-out. The sea is a limitless space and the space of no return. Actual and phenomenological suicides take place there, in this elsewhere-here place. Where the shoreline meets the sea is the physical limit of the national imaginary and of the national body, a limit nonetheless that one can resist (through death) or overcome through a bio-politics that refuses the limit one is being offered.

The sea and the shoreline are a past and present space, a folding Deleuzian time image. One stands at the water's edge, a nomadic seer at the edge or in the midst of time unravelling, staring out, over and into the white horses, crests and shadows on the water; or across, back into the endless expanse of white sand. One is deeply connected and full but simultaneously disconnected and empty, a liquid state on the threshold of awesome potential. This is the terrifying potential of the double sublime: an out-of-body experience, an alien alterity, where one witnesses one's own witnessing of the power of nature, of the body becoming water, on the shoreline, at the edge of the sea.

Creation myths often begin in or arise out of the depths of the sea; for example the mythical journey of the Igbo people. Taken from West Africa aboard slave ships, they arrived in America and at the shore's edge they met their new white slave masters. Refusing slavery and still in chains, they decided to swim back across the ocean. They entered the water, their chains miraculously melted from their arms, and they swam home, to die, and live free again. According to Japanese Shinto mythology, at the beginning of time heaven and the earth were mixed together in a great cloud:

> Slowly, the clearer, lighter parts of the cloud rose up and became heaven. The heavier parts of the cloud descended and became an ocean of muddy water. Between the heavens and the earth, a pale green sprout began to grow. It grew swiftly and was extremely strong. When the plant's flower burst open, the First God emerged. This First God then created Izanagi, the god of all that is light and heavenly. Izanagi, whose name means 'the male who invites', and his wife and sister Izanami, whose name means 'the female who invites', are given the task of finishing the creation of the world. Standing on a rainbow called the floating bridge of the heavens, they plunged a jewel crested spear into the ocean. When they pulled it free, the water that dripped from the spear coagulated and formed the first island of the Japanese archipelago. Izanagi and Izanami went down to this island and settled down on it. Together, on this island, they made the islands of Japan.

If one threatens the serenity and plenitude of this nationalist myth then destruction is wrought. For example, *Gojira* (Ishirô Honda, 1954) an avenging super-destruc-

tive monster who has slept in the sea since prehistory, his/her accidental awakening evidence of anxieties about nuclear weapons and America's post-war occupation of Japan. Society is being menaced by a creature that is either Japan's monstrous manifestation in the face of defeat, the product of radiation or unleashed by atomic explosions. The opening sequence to *Gojira* in which a flash of white light sinks a fishing boat, directly references the 1954 nuclear detonation at the Bikini Atoll. The bomb was then the biggest man-made explosion until the USSR's 50-megaton test in 1961. Three weeks after the bomb was detonated it emerged that the Japanese fishing boat, *Lucky Dragon*, was within 80 miles (129 km) of the test zone at the time. Its 23 crew were severely affected by radiation sickness.

Historically, the sea is very often the means through which people arrive at a distant destination, where lives may be remade and reconstituted. The sea brings the exiled, the diaspora, and those looking for a better life. That these ships crash on the rocks and life dies away with them is a powerful reminder of the power of the sea and of the ghosts who haunt its immanence. Of course, the sea is also the method of land invasion, of the arrival of war machines, soldiers, spoiling for a fight, desiring to conquer. The sea can bring with it a storm of death, as it did to Japan, to Okinawa, during World War II. One can read *Gojira* as the collective ghosts of Japan's soldiers who died in the South Seas, returning home to exercise their anger and to be properly put to rest (see Inuhiko 2007: 107–8).

The sea is very often feminised. It has been traditionally connected with life, birth, re-birth, creation and creativity. For example, Venus/Aphrodite, is 'born of the sea foam', she was the 'goddess of love and beauty, poetry and art, laughter and love-making'. But the sea is also connected with unbounded feminine liminality, death and oblivion. Water, sea and ocean – as well as nature in general – is often used as a metaphor for destructive, supernatural femininity, and of elemental female abjection and treachery, which needs to be constrained/restrained. As Viola Parente-Čapkova suggests, watery symbols and metaphors construct woman

> as an emblematic 'other', mysterious, horrible and irrational, against which the male subject constructs itself as the guardian of rationality, the Lord and Master of the universe. (2006: 199)

One can see this monstrous version of watery femininity registered in the *kaidan* or 'avenging spirit' film, such as in *Ringu* and *Dark Water* (Hideo Nakata, 2002). Here, an abandoned female returns as a supernatural force to take revenge or right a supposed wrong. She is murderous/monstrous, insect- or reptilian-like, a devouring creature that comes from the water. She moves outside of herself in vibrations that are intensely Other, and she seems to ooze dank, polluted water. The avenging spirit is an iconic figure of dread and desire; her long black, matted hair, penetrating eyes/eye and tattered/torn (white) clothing is a devouring suggestion of vaginal (post-pubescent) terror. This collision and fusion between the feminine and the monstrous renders her a castration threat. In wider cultural or political terms the avenging spirit haunts the feminine domestic space that, it is argued, is no more in Japan. As Eric White suggests:

the *Ringu* films depict a social milieu in which the family matrix no longer provides the basis for psychological structure. Instead, omnipresent information technology functions as a vast psychic apparatus … randomly propagating affective dispositions, libidinal intensities, decontextualised personae and partial selves across the social sphere. (2005: 41)

In Freudian terms, the sea is a symbol for the unconscious. Deep water, oceans, seas, expansive lakes often symbolise the collective unconscious while smaller bodies of water may symbolise the personal unconscious. As Parente-Čapkova writes, in Freud's rendering of *The Water Mirror*, for example, a pool into which Narcissus looks, which is surrounded by long grass and hidden away from sun, is interpreted as his mother's genitals, as the mother's body. Thus the narcissist can be seen as seeking his own image within the frame, the flesh, of the mother's body. Both *Woman of the Dunes* (Hiroshi Teshigahara, 1964) and *Onibaba* (Kaneto Shindô, 1963) reconstitute Narcissus in the men who fall into the pits that have been set for them for mother-woman substitutes.

The sea and the shoreline are the place of natural play and a nostalgic place of belonging; their transcendental luminosity calling out to childhood memories, and for an ontological stability lost in the maelstrom of the modern world. It is a utopian Other space or heterotopia where the matter of the world fits and the matters of the world are left behind. Either their role is

to create a space of illusion that exposes every real space, all the sites inside of which human life is partitioned, as still more illusory … Or else, on the contrary, their role is to create a space that is other, another real space, as perfect, as meticulous, as well arranged as ours is messy, ill constructed and jumbled. This latter type would be the heterotopias, not of illusion, but of compensation. (Foucault 1986: 27)

The sea and the shoreline are empty; they in part encapsulate the Buddhist state of no-mind. Removed from the rush and the throng of the crowded metropolis, social hierarchy and human-made artifice, standing on the shore, staring over the sea, is a type of pure existence un-thought and unmediated. According to Zen, existence is found in the silence of the mind (no-mind), beyond the chatter of one's internal dialogue. Zen says that if one entertains no personal version or subjective interpretation of what one thinks existence is, if one clears the mind, one will experience existence instantaneously and spontaneously and as if it/you is in constant movement. The endless sea and the stripped or minimalist shoreline provide a *tabula rasa* environment for one to freely exist in the world. It is an empty mind and an empty space that allows, fosters the mind to be emptied, to be made pure, in the still-movement of its becoming.

The sea and the shoreline are connected to ideas and ideals of purification. Purification by water is a vital part of Shintoism. It serves to placate any restive deity. This involves one standing beneath a waterfall or performing ritual ablutions in a rivermouth or in the sea. The purpose is to remove sins (*tsumi*) and impurities (*kegare*), concepts which include bad luck and disease as well as guilt. In *Spirited Away* (Hayao

Miyazaki, 2001) for example, one finds purity and purification set against pollution, excessive/vile consumption, dirt and poison. In the film, the bath house is pivotal; it marks a return to Shinto beliefs versus the simulated consumer wasteland of the theme park of today.

One finds the source of one's creativity at the threshold space of the sea and the shoreline. The beauty of the ocean, its romantic and troubling associations with life and death, is an inspiration for visual artists, poets, writers and musicians. Its colours, vibrations and sounds, and its inherent logic of sensation, in which horizontal and vertical sheets of yellows and blues run like a loud-soft streak across the retina of the screen, ignite the imagination of the artist. The sea and the shoreline are an impulse to make art beyond representational cliché.

To get to the sea, the shoreline, to take time out at the beach, one has to take a journey. The beach is nearly always visited but rarely lived at permanently. The rivers that are its source, and the bridges and roads that runs over and alongside them, are the natural and synthetic arteries for the traveller/tourist/drifter/artist to arrive at the beach, to begin and die again. In the end, the sea and the shoreline are connected to the rural and the urban but only if one *looks* for such connections do they appear as such. One begins to find all these oceanic manifestations, ripples, and affects in a Kitano film. His sea and shoreline are interconnected, simultaneous interval zones of pure possibility, an argument I would now like to explore.

This is the Sea in Kitano

In the films of Kitano, the sea, shoreline and the beach are often the most significant sites of last rites and new beginnings. It is the place of (childish) play and of silent or abstract contemplation; it is a retreat and a nostalgic return to an imagined lost (Japanese) paradise, or a childhood that never matured or was arrested in some way; and it is the last 'exit' and the point-of-no-return for his yakuza warriors, misfits and outsiders. It is a 'feminine' place, and therefore potentially monstrous, devouring, and yet it is also serene and enigmatic; a place of purification. The womanly sea and the androgynous shoreline is an interval space where one can become a body-without-organs. In short, the sea, shoreline and the beach exist in paradoxical and contradictory states, mirroring, shaping, but also actively affecting the very crisis that one finds the characters in.

1. The outsider sea – In the closed, tightly-framed settings of yakuza bars, offices, joints and restaurants; and in the wider, urban settings of concrete blocks and grey buildings, the central yakuza characters are often most at 'home' and seemingly in control. By contrast, 'outside' the city space, standing/sitting by the water's edge, they are out-of-place and more vulnerable to an 'inevitable attack' by foes. And yet, in the city, and within their tribal spaces, these men often pathetically yearn or blankly emote for less spatial constraints, for the vulnerability and ethereality of the natural world; while down by the sea the freedoms they experience become all too much for them to bear. This restlessness, this up-rootedness, is of course captured through the disconnected

arrangement of shots, the impossible flashbacks and flash-forwards that characters are seemingly able to witness or take part in, and the blocs of sensation from which pathetic affect emerges. It is as if, then, Kitano's characters cannot settle or truly belong, moving through his films as if on a restless journey to nowhere and to no mind, as if they are on a journey to the place where the land meets the sea.

According to Donald Richie, genre convention has it that it is the fate of the yakuza hero to live and die in a closed space (1972: 33). In a Kitano yakuza film, by contrast, his anti-hero's fate is often sealed outside, in the sunshine, down by the beach, at the water's edge. They face death, see it coming, and welcome it in fact with a sincere, maybe even optimistic resignation. A character will blow his brains out staring out into the ocean or will be executed while they are experiencing a moment of pure delight. Such deaths and suicides appear less than nihilistic, however, and more a form of purification and transformative release from the woes of liquid modernity, gender normativity and faulty capitalist progress. Kitano's yakuza are caught in what David Desser calls a 'state of *mono no aware*, or sweet sadness, or an almost inexpressible sensation of life's mortality which is pleasantly painful' (1983: 28). I think one needs to take this pain image one step further, however, where one recognises not the mortality of the sensation buts its immortality, as it rises in those bodiless bodies that taste it so sweetly or saltily.

For example, in *Sonatine*, the nameless woman picked up by Murakawa quizzes him, resulting in a conversation out of which death can only emerge. She says, 'Not being afraid of killing people means not being afraid of killing yourself, right?' He replies, 'When you're scared all the time, you almost wish you were dead.' This is a prophetic and pathetic foreshadowing of his demise at film's end. Murakawa walks through the film with a death-wish; it is as if he is already dead, a ghost looking to find peace beyond death. Hence, the Okinawa beach hide-out becomes an interval zone between one death and another for him and his yakuza henchmen. They know death, or the end of death is coming, but at the water's edge they are able to play, and partially or momentarily wash away their sins. The scene in which Ken and Ryochi use the rain storm to shower is particularly prophetic. The rain stops before they have time to rinse away the soap and suds and so they are left in-between clean and dirty, and in-between purity and the profane. This is a state which mirrors their in-between sexuality, their in between youth/adult state, and their state of being in between these deaths that occur either side of the visit to the beach. Of course, it is at the end of the film where this interval existence is most pronounced. Murakawa kills himself with a shot to the head, while sitting in the car he has only just learned to drive. *How else could he have got back to this moment with almost everyone else dead or absented?* This is a return to an enclosed space (his fate to die trapped) but it takes place by the sea, in an expanse of open space and wet air. He chooses his death, his time to die, as the tide comes in, and as the woman who earlier in the film 'announced' or guessed this ending, stands in a sublime state of shock. She becomes a sensation on the screen, caught in a double sublime moment: she watches the alien alterity, Murakawa, be taken away by the terrifying beauty of his own death moment. Down by the sea we feel the sensation of her terror looking on as Murakawa looks at or into his own death. And the waves roll in.

This logic of sensation is of course made out of coloured, weighted and textured qualities. In *Sonatine*, *A Scene at the Sea* and *Kikujiro*, for example, the blue of the ocean and the yellow of the sand heat and cool the *mise-en-scène*, and the sand can appear sticky and porous while the sea can be thick and velvety. Where the sand meets the sea, these sensorial qualities wash over one another, testing the limit of the shoreline, while transgressing the lines that supposedly separate them. While the shoreline is supposedly the limit (the cage) of the nation-state and Okinawa its most distant prison, in a Kitano film sensation cannot be so easily bordered.

Sonatine starts with a close-up of a blue fish shot against a blood-red environment. A spear runs through the fish and beyond the edge of the frame. It is a dramatic, expressive image, a non-diegetic insert that is meant to conjure up the pathos of the film, and the fact that the yakuza characters are doomed. It is also a pain-image, the fishes' blood has soaked into the sky, the clouds, the membrane of the film world. In mythological terms, it hints at Japan's violent birth as a nation, speared into existence, its psyche ever a bleeding wound. It is a sensational image, the blue and the red are violent contrasts and they each bring a texture, a taste, a smell, a touch to the newly introduced film world.

It is not just yakuza who find themselves down by the beach. Many of Kitano's outsider or 'minority' characters also visit the sea, the beach, and in so doing are transformed by the experience. Death, or a type of death, manifests in these contexts, not only as a life being extinguished but a type of subjectivity being left behind. In *Dolls*, Haruna goes to the beach after her car accident has rendered her scarred and partially blind. She cannot face the world but at this limit space she can at least begin to *see* again. Her Barbie-doll pop persona has been cracked open so she has to begin again, somehow. Only the ocean can afford her this opportunity.

In *A Scene at the Sea*, Shigeru and Takako's relationship manifests itself through the act of them being divided but connected by the sand (she stays on the beach watching) and the sea (where he surfs and eventually dies). These elemental pulsations are what give their love a communicative language, the language of sensation. She reaches the limit (the shoreline) and he moves beyond it, taking her with(in) him as he does so. The chemical borders of gender are again reached and breached. Their lowly position in society, and their deafness, can be left behind once one comes together in the waters beyond the limit. In the film, Shigeru's perspective or point of view is not directly shown, an absence or passive position that is normally taken by a woman. Rather his look is one that is aligned or consumed through the minority vision that marks much of Kitano's work – it is tied to a space off-screen, to a vanishing point that is nonetheless made visible through the aesthetic play with, and subversion of, depth and centring cues. This invisible-visible is his look of/at death, or another point of no return.

Aoyoma Shinji has argued that the tacked on, memorial images at the end of *A Scene at the Sea* result in the 'closure of the ruptured gap' (quoted in Gerow 2007: 99) that the film has tried so hard to cleave into existence. For Aoyoma, Shigeru does have a point of return through the internal/memory space that these images are able to manufacture. He goes on to suggest that this is 'typical of how Japanese national ideology has tended to absorb the other into closed and safe narratives' (ibid.). However,

I think that these memorial images may in fact do the exact opposite, a position noted earlier in this book. While these post-self images do attempt to re-narrativise the film, to resurrect the lives that have just been taken, they appear otherworldly when compared, or rather are remembered, in relation to the thick pathos, disconnect and supercharged re-connections of the film proper. The film and the bodies in the film remain floating in and around these memorial images, bringing a different death to the ones they intend to conjure into view.

In *Kikujiro*, the beach is clearly marked as the transitory space for both Masao and Kikujiro. They have both been identified as outsiders: Masao has few friends, is bullied, and because his mother and father have both left him, he feels incomplete and abandoned. Kikujiro is seemingly a yakuza gangster without a mob, a street fighter who gets beaten up. He fails at almost every step to perform his role as navigator for the road trip they go on. When they eventually get to their destination, the mother they have gone in search of has been found with a new life, a new family, and so the beach/sea they retire to, to recover from this revelation, is saturated in meaning or significance. When Masao and Kikujiro hold hands, in what is a heavily sentimental moment in the film, their identifications shift and align; their alterities are revealed, shared and cross-connected. Their Otherness will continue in the film but without an over-determining sense of disadvantaged alienation; and their affection for one another will grow but it will not (again) be over-sentimentalised or ever be simply father/son. That this transformation takes place on the beach is hugely important. It is only really here that the Angel can appear to re-birth them, and that both characters can begin to look up (rather than down, the defining characteristic of their point of view so far) to see the world anew again. The vertical shift in looking, fully realised later when Masao looks up in wonderment at the stars, works relationally with the horizontal planes of the sea and the beach, its own logic of sensation.

In all of the examples listed above one could argue that sea and the shoreline fulfil the function of a heterotopia of both illusion and compensation. This other world of the beach stands in stark contrast to the mean streets, the urban crawl and the commodified time of liquid modernity. The city and beach are locations of difference and opposition, both in existence to give value, reason or meaning for the other space's logic. It can be argued the city space and the beach justify and sustain one another's

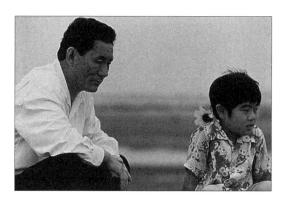

The beach as a space of transition in *Kikujiro* (1999)

hold on the bodies in the world. The other world of the beach is of course utopian or edenic, its qualities and intensities are what is missing from the other, real world of hard existence and alienated living. This compensation for perceived lacks and losses nonetheless sustains the very thing that it takes to task. That we can visit the beach means we can return to the city once we are refreshed.

Nonetheless, it might be more productive to think of the sea and the shoreline as the nomadic space of pure becoming. Faced with a world of continuing and effortless deterritorialisation, and a simultaneous nomadic-like sense of one's place in Japan, in the world, what Kitano's characters find at the beach is an ulterior space with which to exist in, and the limit experience of this nomadic wandering. *There is nowhere else to go*. The nomad faced with the beginning and the end of space, and with a different temporal and spatial logic, and with the pure force of nature within one's grasp, becomes something else entirely different. Few people return to the real world after they visit the beach in a Kitano film. If they do it is with the full realisation that they know the beyond, beyond the limit.

2. The bridge – At a formal level, one can argue that Kitano's films more generally attempt to get us close to a transformed, non-subjective state of being, or to an interiorised, no-mind state of existence; to animal purity itself. Again, the space of the sea and the shoreline are key. As already suggested, Kitano often holds his camera on an object or transitory space (such as a corridor, entrance, field of flowers, ocean, or sand bar) for longer than is narratively necessary. According to Mark Freeman, writing about the relationship between *Hana-Bi* and the films of Ozu, and whom I have also suggested Kitano has a close connection with, such *mu* and *ma* spaces reveal 'an emptiness that is populated and deserted, still but moving, past but present tense' (2000). In Zen terms, these are transitory spaces that allows characters and viewers to empty their minds and experience the fact that every atom in the universe is somewhere different every millionth of a second. They enable characters and viewers the chance to become *mujo* aware and to therefore recognise 'the fleetingness of all earthly things' (McDonald 2006a: 75). Spending time at the beach is a particularly heightened sense of this *mujo awareness*, and it is an awareness that Nishi and his wife reach at the end of *Hana-Bi*. A young girl plays with a kite on the beach where they sit. The kite struggles to take flight, and performs a zig-zag dance on the breeze. Temporal connections between the three are themselves interrupted through what appear to be elliptical cuts. The images dance between one another. Nishi deliberately breaks the kite but we later see it fly. The girl flying-the-kite has a dream or ghost-like quality; is she an apparition or reincarnation of the daughter they have lost? The girl becomes the 'missing third term in Nishi's family' (Gerow 2007: 145) – the deceased daughter. It is at the beach where the family is reunited, the one unifying space where the body and the family can be re-made. Nonetheless, all of these moments and images of moments are fleeting. The two shots that ring out signify the death of Nishi and his wife by suicide are a reminder of the passing of time, and times of continuity or ever-presence in the world. In an instant they are gone, their passing witnessed by the girl but not the viewer whose eyes

rest on the sea. In an instant (I swear I saw) the breeze take the kite and fly it higher and higher, and yet it remains flightless, in the girl's tight grip. And the waves roll in.

Kitano often employs the pillow shot or cutaway still life, which is empty of human characters, and only weakly tied to the diegesis. This pillow shot directs the spectator's attention to a frame in which neither human characters nor narrative information is centred. Borrowed from Japanese poetry, the pillow shot is inspired by pillow words, or are words that do not lead out of or into the rest of the poem but provide a resting place – a pause or punctuation. The pillow shot also 'undermines anthropocentrism, functioning as a kind of reiterative assertion that man is not the centre of the universe' (Burch 1979: 15). When Kitano brings this pure filmic form to the purity of the sea, matching style to content, and when he brings together the painterly in execution and palette, one enters a timeless place. The sea and the shoreline becomes an extended pillow shot, a resting place that we dwell in until we/the characters/the film itself dies and is endlessly reborn and remade, re-thought, unthought, over and over again.

In *Kikujiro* it is the river that flows beneath the bridge, the location that starts and ends the film, which poetically provides the current for the film's cyclical plot structure. The river is a constant but it is also ever-changing. At the beginning of the film, Masao and Kikujiro are both lost in the world. The bridge is initially the connector to one bad experience after another; it leads to nowhere new. When they decide to take a road trip, when they cross the bridge not as a limit but as an opening, the 'river' carries them to the absent mother, and then to the sea, the shoreline, and the stars, that are transformatory encounters and becomings. At the end of the film they stand on the same bridge, newly-born, returned to the beginning but not the same beginning. The bridge remains an opening if they so choose to walk it.

3. The sea clock – In a Kitano film, the sea, shoreline and beach are a timeless place. They exist outside of the regulated and punishing rhythms and tempos of modern capitalist life and they exist outside of cause and effect – of the laws of the movement image. And yet this is also a place where time runs on an unstoppable paradox: time stands still and yet time is running out for those who have gone there to escape and rejuvenate. The past waits to call on the present. Kitano uses the beach, shoreline and the sea, then, to play out the idea or sense of the impossibility of time, of being able to hold it down or to check its onward march forward. Of course, time cannot be stopped. In direct, narrational terms, his yakuza henchmen will kill or be killed, and his misfit outsiders will move on or self-destruct. However, time can be unthought, unlearned, and one can wrap oneself around it. Time can become a sea clock, tidal in nature, and in the tide of time past, present and future converge and merge.

A particularly productive way to examine time and tide in Kitano's filmwork is through Deleuze's conception of the time image and the any-space-whatever. In the time-image film, characters find themselves in situations where they are unable to act and react in a direct or immediate way. Action fails them; their active agency fails them. This leads to what Deleuze calls a breakdown in the sensor-motor system (1989: 3). Characters look on, are caught deep in thought, they say little but express a lot, and are catatonic or struck numb by pathos. They are interior beings in a world that asks

for them to look inwards. The time image cut off from sensory-motor links becomes 'a pure optical and aural image', and one that 'comes into relation with a virtual image, a mental or mirror image (Deleuze 1989: 52). The result of this pure optical and sound image is, according to Deleuze, a direct image of time (a time-image or crystal-image). Such images are themselves free now to express forces or 'shocks of force' (1989: 139). In a Kitano film, the sea and shoreline are archetypal any-space-whatevers – or a space of virtual conjunction, 'grasped as pure locus of the possible' (1989: 109). Interiorised narrative agents set to play in an episodic narrative find themselves in a struggle between the darkness as it stretches out to sea and the spirit contained on the white shore.

4. The sea road – Kitano's vision of the sea and the shoreline can be read in ideo-logical terms. In general, if quite loaded terms, one can argue that his films respond to the breakdown of the family unit and the disintegration of male subjectivity in a rapidly changing Japan in the age of liquid capitalism. This detteritorilisation invites a sense of powerlessness around the main protagonists – events act upon them and there is nothing that they can or (perhaps) should do about this. The modern world has produced the condition of the neo-tribe, the nomad, and with it an overwhelming sense of pathos, loss and alienation. The metropolis is the space that produces this condition of comatose. In this context, the sea and the shoreline are a timeless haven in a heartless world. One escapes the condition of liquid modernity when one enters the idle time and the playful spaces of the beach.

In an American context, Timothy Corrigan (1991) argues that the post-World War II road movie responded to the breakdown of the family unit and the erosion of male subjectivity. He argues that in narrative terms, these films invited a sense of powerlessness around the protagonists: events and circumstances acted upon them and there was nothing that they could do about the issues they faced. The political 'machine' was bigger than the human caught in its relentless grip. For Corrigan, however, positive or transformatory forms of identification emerged around the machine, which became the only promise of male self-empowerment: the motorcycle or car was something that could be fashioned, that could be controlled, and gave one the power to be free. The motorcycle or car became a fetishised object and a portable haven in a heartless world. In these films, there was often an absence of women so that in effect the road movie promoted a male escapist fantasy.

One can immediately discern a number of similarities in Kitano's work with only really the machine and the destination obvious differences. In a Kitano road or journey movie, the machine often fails, people walk rather than drive, or public transport is used to move people along. There is an anti-glamour and anti-masculine representation of the machine in the Kitano film. Cars and motorcycles crash or they are bloodied by death and mayhem. However, while the machine is itself in disarray, the machine-body is given potential. In fact, the body that walks its way to the sea, to death, is of higher value. In a Kitano film, a sense of belonging does emerge during the road journey but this is not through an (outside) machine aesthetic but rather one where characters embrace their shared alterity and come to accept their Otherness and outsiderdom.

When they reach the sea, stand on the shoreline, or sit on the beach, the full realisation of what they can become is actualised. Characters can leave their bodies behind and grasp the pure possibility of their becoming something different, a difference beyond the limit, a limit that stands outside subjectivity.

CONCLUSION

Standing Outside Office Kitano

Death by Kitano

Since the 2005 release of *Takeshis*, the first in a trilogy of films that consciously self-reflected on Kitano's own role as a film director and actor-star, and the process of filmmaking itself, Kitano has arguably been in the process of further disintegrating, multiplying his personas in a violent process of self-rejection and refusal to conform. Kitano's own self-loathing and suicide wish manifests itself in number of ways. In this trilogy of 'creative destructions' his own status as a director-artist and television star is criticised and assaulted through narratives where his art fails him, his stardom kills him, and reinvention leads to ridicule and rejection.

There are no less than four Takeshi Kitanos in *Takeshis*: on screen and in the narrative we find the director, the television star, and the amateur actor/crazed fanatic, all being played by Beat Takeshi, while behind the camera remains the puppet master, Takeshi Kitano, pouring himself onto the screen in a relentless process of self-splitting, self-awareness and self-doubt. In *Takeshis*, when the amateur fan finally goes off the rails, people are mowed down in a shower-dance of bullets. Beat Takeshi (Takeshi Kitano) is killing everyone he has ever come into contact with. The film is a critical commentary on the way celebrity images are created, and how they negatively affect the Japanese sense of self. Nonetheless, it is also fractal, to appropriate Kitano's own word for the film, in which multiple personas collide and split in a liquid modern world that rises and falls, impossibly dreamy, but shockingly real. This is Kitano's personal version of the nightmare that haunts all liquid moderns.

In *Kantoku Banzai!* (*Glory to the Filmmaker!*, 2007), Kitano's alter-ego, his ulterior self, is a papier-mâché doll that is often the fall-guy in the film. The film pairs Beat Takeshi and the doll through identikit blue uniforms. In this film, Kitano's self-loathing migrates to an alien-other body, not quite human, who can stand-in for him when there is boredom or a pratfall needs to be unleashed. Kitano, again taking on the

role of the film director but bereft of ideas, attempts to resurrect and reinvent his career through remaking one genre film after another. These sequences of pastiche and parody are a desperate call to find meaning beyond representation, which he consistently and self-consciously fails to achieve in the film. In his pastiche treatment of an Ozu film, for example, Kitano cannot give the time the film needs to silently become awake. He is too frustrated a figure to now want to wait for film to experience movement through stillness, hitherto his aesthetic preference. The film rushes head-long into the arms of the imagined viewer raised on speed and urgency. A viewer who demands fast cuts and faster action. A worn-out Kitano tries to make a film like everybody else.

The film is also part autobiographical: the family drama sequence re-builds his own family, violence and all. Its alcoholic house-painter father (Kitano), abused house-wife mother, studious older brother and mischievous younger brother are all based on Kitano's own dysfunctional family. The matter of his life has become the canvas on which he paints his desperation. That the Cannes Film Festival rejected *Kantoku Banzai!* for the competition part of the programme is a real-time postscript to the malaise at the heart of this film and at the heart of this director wrapped in the pathos of his own debilitating pain image and life of pain.

In *Achilles and the Tortoise,* the trilogy is concluded with Kitano taking up the role of a painter. The arc of the film allows us to see this desire to be a great artist move from childhood aspirations to near-death, where having failed to produce anything original or unique, Machisu (played by Kitano) tries to paint one last picture as the fire he has started burns around and within him. In one sense this can read as a simple allegory for his film and television career: Kitano, now in his mid-sixties is looking back at his work and finding little of substance for him to be proud of. Even though Machisu has given his entire life over to painting, he hasn't found the spark, the fold or bend in reality, to move beyond imitation. We can read this abject sense of failure as Kitano's own diagnosis of his art.

The painter's kid.
Achilles and the Tortoise (2009)

However, the film ends with Machisu having been released from hospital covered from head to toe in white bandages, with only one thin eye slit allowing him to see and therefore navigate the world. He ends up alone, sitting, facing the river, as the world rushes by. His long-suffering wife then turns up, smiles at him, and silently they walk off into the distance as the camera cranes up to reveal the full width of the river and the cityscape either side. It is as if we have returned not to the same bridge, or the same part of the river, as we were taken to and from in *Kikujiro*, but this is where we have ended up. However, what is most important about this scene, one which offers a more positive spin on Kitano's own position on art and his art in particular, is the warped vision that he now faces the world with. Like so many characters in a Kitano film, Machisu can no longer see straight, his vision has been reduced or re-focused; he has to use his peripheral vision to get by. This re-centring of sight and of the body that now sees or senses differently, may very well be the access point to ideas that work outside, beyond or before representational cliché. Machisu's near-suicide may have brought him to the brink not of death but of a life-after-death. This ending may very well be one of Kitano's most positive: new art lies beyond the bridge. Kitano will return to less esoteric, less self-deconstructive filmmaking; Kitano will make *Outrage* and *Outrage Beyond*.

Since Kitano's motorbike accident he has worried that he either did die following it, or that he exists in a world where the dream and the real fold into one another:

> I had a terrible motorbike accident several years ago and I was bedridden and later, the doctors told me that I could have been dead with the accident. I still remember the first moment I woke up from that accident. Every now and then while I'm working in Japan, or here talking to the British journalists asking me about my films, while giving interviews I can't help shaking this fear of, 'what if I'm still dreaming?' And after all these years ... I've made several films after the bike accident, all of these are just a dream and I would wake up one day and find out about the condition I'm in, and what if everything that happened after the motorbike accident was a dream? For instance this morning I wake up, I can't instantly open my eyes. I gradually open my ... 'It's not a hospital is it? No? Okay, I'm in London, I'm in London, I'm doing promotion!' (Cole 2005)

Kitano's near-death experience is one from which he continually questions his own ontology, and the realist logic of the world. Like many of his characters, Kitano dreams his death, acts as if he may be dead, and finds in death the very power, force and intensity to carry on. At the heart of this death, remains a director/artist/star, who has left the limits of the body and its limit-materiality behind.

A Painter's Kid

In March 2010 Kitano's first ever art exhibition, *Gosse de Peintre*, opened at the prestigious Fondation Cartier on the Left Bank in Paris. The week previously he had been made a Chevalier des Arts et des Lettres – France's highest artistic award or accolade.

In 2010 it was clear that Kitano's artistic star was on the rise again. He is finding the vision that Museru's partial blindness indicated he would. This Kitano vision finds itself in this wild and free exhibition organised like a giant funfair or low-rent theme park. In one installation of the exhibition, for example, one can fire paintballs at large cut-out dinosaurs, or observe scale-sized models with elephants that have guns symbiotically connected to their trunks. Animals, fish, objects, things and people seem to fuse together right across the exhibition.

Most impressive or interesting is the Kitano Sewing Machine, a huge sculpture made of metal, steel, plastic, wood and wool, and partially shaped like a gigantic elephant steam-engine. Its physical energy is all productive labour as if hot, cloudy air might rush out of its mouth and bring back into existence the industrial revolution. However, its giant feet, which turn the engine, are dressed in socks with holes in, and the actual thing the machine-monster produces is little pieces of fabric. The Kitano Sewing Machine is old technology fused with old production methods; the hands and feet of manual labour, and the toil that vision of hard-graft it conjures up. It does not belong in the twenty-first century, in the age of virtual technologies and hi-tech production streams. The feet of course are a subtle trope in many a Kitano film; Kitano's walk, the aimless walking, and the walk of/to death, pound the beat of his films. The hard-graft brings to mind the job his father did as a lowly painter and decorator. The Kitano Sewing Machine also recalls Kitano's artwork, such as that found in *Hana-Bi*, where two or more different natural or biological entities are brought together, such as the flower-lion. In some respects, the installation pieces in this exhibition feel very like the imagination of the child, new before the world, where mutating forces are everywhere, and everywhere it is possible to transform or zap things into different shapes and assortments. The exhibition conjures up a number of important truths about Kitano, not least his desire to rebuild the body through the eyes, and *for* the eyes of the awe-struck child. Kitano is the painter's kid, and he is child-like in his humour and in dreamscapes. Nonetheless, in the Kitano Sewing Machine one witnesses something else, at the edges of vision, in the bent shapes, and violent assaults that populate the exhibition. There, sometimes silently, sometimes with a roar, the body without organs emerges, as the language to make sense falters and the expanding/contracting machines hurl into view, and hurl one out of the gallery and into spaces beyond the imagination. Child-like, I begin again.

Standing Outside Office Kitano

Having been lost in Tokyo, I find myself standing outside Office Kitano in the pouring rain. I feel this moment as a Kitano film moment. I see myself in a long, still shot, with the blue-rendered building behind me the centre of the frame. I imagine being in Kitano's peripheral vision, only the left side of my shrinking body visible in the shot. I stare silently back at the camera that captures my pathos, shaking its consciousness as I do so. I stare back at Office Kitano not yet established in the scene. The rain washes my face, the street, the roads, its metric beat borrowed from *Zatoichi*. I light a cigarette, raise a smile, look sweetly into the space of no space while imagining gun brawls in

the most vivid of colours and temperatures. An explosion of flowering blood bursts out of my body, painting the blue door behind me. I am not sure if this is a flashback, flashforward, something happening this instant, or if I am caught in another character's subjective awakening. I am in an any-space-whatever, in the intensity of a time image, a body without organs. I walk towards the door, although this is not filmed, the camera having remained on the spot I have just vacated, the pain of the image staining the lens red-blue. I enter Office Kitano. I enter Office Kitano. I dream I enter Office Kitano...

In this book-length study of Takeshi Kitano I have examined his authorship in terms of a Deleuzean framework washed with phenomenology. I have argued that there are sensorial peaks, flows and valleys that rise and fall, and which pulsate across his filmwork. I have focused on the temporal and spatial coordinates that liquefy the *mise-en-scène*; his logic of sensation; and the alien alterities that divide his characters in two. I have found violent vibrations and carnality in the way characters are defined and narratives constructed. I have sensed right across his oeuvre a terrible pathos, a pain image, a death-wish, and a death that leads to a body without organs. Nomadic characters wander or journey very often ending up at the sea and the shoreline. Kitano's own self-reflexive, allusive, self-destructive star personas have been found to speak to a minoritarian form of existence and to an interval space beyond the limit. Kitano's creative aims, I have suggested, are continually to find a point beyond representational cliché. That this very issue has haunted or structured his three last films suggest an artist-machine looking to find the double sublime, a certain sensation beyond subjectivity. In the next few months, Kitano's latest film, *Outrage*, a yakuza film, will hit our screens. I welcome the pain of it already.

Cut

I now know why I am here; it dawns on me after all these years of thinking, teaching and writing about Kitano. My father was a painter and decorator too, or at least he drifted into it when he lost his job as a scaffolder during Margaret Thatcher's economic experiment on the working class in 1980s Britain. He got a job painting the ceiling of a large factory in Coventry. I cannot now remember what the factory produced. The job was poorly paid, back-breaking work. I do remember, however, my father telling me that by the time he had finished the ceiling it was time to start painting it all over again. His painting job was an endless, repetitive affair, an eternal recurrence. I have often thought about what he thought about as he painted those monotonous brush strokes. How did he pass the time, cope with the boredom? Did he see beyond the vanishing point; did he daydream repetitive dreams; did he dream of a death that would take him away from this death at work? Such pathetic questions, such a powerful logic of sensation and connection I seek/see/sense here.

I Welcome the Pain of it Already

Kitano Pain

In an interview at the 2010 Cannes Film Festival, where *Outrage* was in competition, Kitano responded to a question about him supposedly wanting the audience to feel the pain in the film by saying the following:

> While I was writing this script and while I was shooting, my intention was that all the violence should look as painful as possible because that's how it is in real life. Violence is a painful thing. (Jahn 2011)

He goes onto connect the inherent pain of violent action with comic reaction, suggesting that the violence in the film is often comical, and therefore pleasurable and cathartic. Comedy and violence, as I have indicated, runs through the Kitano opus, drawing a sensorial envelope around the body that hurts and laughs at the same time. This comedy is savage, nonetheless, inviting us to laugh at the body as it is being wickedly violated. In *Outrage*, eyes are sliced, ears are invaded, teeth are drilled, a head is garrotted, fingers are chopped off and stomachs are cut open, but this occurs in contexts where, for example, the digits of the hand end up in soup being served in a restaurant. The body is constantly animal-like and appears often as an open wound, but there is something funny about such carnography. It as if Kitano is attacking every major sense organ of the body so that all is left is pure bodiless material in its spilled-out entirety, and the asemiotic register of the laugh (that doesn't know why it is laughing) that occurs in place of words, language. Kitano sees comedy as being demonic:

> I think comedy and humour have this demonic element in them. It is always prepared to raise its ugly head to seep into the situation. The more serious

and sacred the situation is, the funnier it is when something goes wrong. For instance, when you're at a funeral or a sacred event, such as a marriage, and somebody messes up, people laugh but for the person himself it's a tragedy (Pichon-Sintes 2010)

In one now infamous scene, Ôtomo tracks down a yakuza boss, Murase (Renji Ishibashi), to his dentist. Murase is at his most vulnerable, child-like, sat back in the chair, ready for an extraction. From his point of view, Ôtomo enters the frame and takes the position of the dentist. His yakuza gait and twitching face a comic, incongruous sight. He then uses the dentist's drill to split open Murase's mouth and eviscerate the teeth. Blood gushes up and out of the mouth, while the drill whirs its atonal and black metallic soundings. Murase's own scream is muffled by or mixed with the bubbling blood and the sound of the drill hitting teeth and gum. Murase isn't able to speak again in the film, and his attempts at speech are often a comedic interlude from the sombre situation going on around him.

The silencing of Murase occurs at a juncture in the film where dialogue in general decreases and violent action increases. Language fails and is made to fail in the film, leaving a gap for laughter, and for brooding blocs of silence and animal becomings – as men undertake violent action – to emerge. These violent, comedic situations are often absurd or rather they draw attention to the absurd nature of the encounter. In so-doing they reveal the impossibility of finding inherent meaning in any action that one takes. The violence destabilises ethical and moral certainty and turns the body into an animal, while the comedy refuses one the opportunity to speak.

Outrage, Kitano's first yakuza film since *Brother*, marks a return, then, to particular forms of violent action, masculine pathos and comedic underpinning, both surreal and distinctly carnal. The contestation between loyalty and corruption of the various yakuza families continues the well-worn theme of the contemporary yakuza film, and Kitano's own work in this genre, but in *Outrage* no one character in the end remains truly honourable, or at best honour is akin to a death-instinct since it is seen as archaic and anachronistic.

Kitano's character, Ôtomo, follows to the letter the orders of his yakuza fathers, not realising they are using him as a pawn in their game to achieve greater success. Ôtomo demonstrates the qualities of what David Desser (1983) has referred to as *giri* (obligation and responsibility) and *jingi* (the code of honour) over and above *ninjo* (personal inclination) – although this is still a minor source of conflict for him in the film. By contrast, his yakuza fathers demonstrate *ninjo* above all else and are caught living lives of excess, punctuated by corruption and extortion. In the film, it is suggested that material wealth and power are all that ultimately matter to the modern yakuza, and indeed the police who conspire with them.

Ôtomo hasn't changed with the times, doesn't see the betrayals coming, and is powerless to stop his own downfall once events are in process. At the end of the film, betrayed by everyone but his own men, all of who have been killed or have taken their own lives; he is knifed to death in a prison courtyard by one of the yakuza henchmen he had violently assaulted earlier in the film. Revenge ultimately takes out all the key

Stillness in *Outrage* (2010)

characters in the film, leaving only a corrupt police detective and a diabolical yakuza chairmen left in office. *Outrage* may well be one of Kitano's most dark films.

Stylistically, the film captures his minimalist formalism, and the dynamic interplay between stillness and movement, silence and sound, and graphical matches and mismatches. There are moments of ellipses, slow-motion photography, uncertain parallel edits, and the use of pillow shots to destabilise narrative continuity and uncouple time and space. Death when it comes again involves a complex interplay between initial point of view, grotesque revelation and a deferral of witnessing the bodies that have been destroyed. For example, in the scene in which Ôtomo kills Murase and his foot soldiers at the sauna club, we initially take Murase's point of view as he is fired at by Ôtomo. It is only after Ôtomo leaves that the camera tracks back to see the bodies bloodied and dead, beautifully arranged in their expired state. We seem to move from a character's point of view, to Ôtomo's point of view, to an omnipresent camera eye that surveys all, and is not tied to narrative causation. This camera-consciousness – which may be detached, inter-subjective and embodied – splits the different types of self and subjectivity found in the film, and the subjective selves of the viewer as they watch. Kitano's own divided authorship can be detected in this type of self-reflexive framing. Beat Takeshi leaves the scene as Ôtomo; Takeshi Kitano emerges as the director of the time image, wrenching the film world free from yakuza cliché into new animal becomings, as the bloody corpses become blocs of sensation.

The shocking nature of such brush strokes remain. Pain rises up in the Kitano image. Pain rises up in me. This is an outrage.

It is beyond outrage.

Red Resurrection

In *Outrage Beyond*, Ôtomo rises from the grave, never really having being killed at the end of the first film. Such a deception is telling, not simply in enigmatic narrative terms, but in the way Kitano determines the fate of his characters, of his star self, and shows his hand as a regenerative author who can sanction his own symbolic immortality. Such a resurrection is telling in terms of Kitano's oeuvre. This is the first time that he has worked on a sequel, with the plot and storyline intersecting and cross-connecting between the two films. This return again to the yakuza film is a resurrection generically and thematically; a revisitation to familiar haunts, dilemmas and honourable concerns, but with and through a new embodied self. Ôtomo is a character that has been shaped and coloured by all the lone wolf figures that have gone before him; and yet he rises in this film as a ghost figure, no longer human, but the animal reincarnated, hungry for revenge.

Kitano, the auteur, is resurrected in this film, his greatness measured in and through these blood-soaked, urban texts. And yet there is a sense of defeatism, of the troubled politics of the modern, liquid age seeping into the film, with deceit washing its entire world, and Ôtomo's inertia and exhaustion, disgust and rage, perhaps a coda for Kitano's own disgusted self in the world. Kitano/Ôtomo has to go to through the beyond, has to be an agent of and for destruction, since the world cannot be recuperated in the here-and-now. *Outrage Beyond* is a deeply nostalgic film for a world long gone. Kitano's career is slowly coming to an end, he is still feted but no longer garners the same critical attention or reception; age creeps up on his mortal body; he begins to like the world less and seek an afterlife where his animal instincts remain sharp and vital. There is a tumultuous set of operations and relations at play in the film.

In *Outrage Beyond*, Machiavellian, anti-gang Detective Kataoka (Fumiyo Kohinata) hatches a plan to limit the burgeoning operations of the Sanno yakuza. He first does this through manipulating a number of disgruntled Sanno gangsters into switching sides, to take up with their Kansai rivals, the Hanabishi-kai, led by the wise and canny Chairman Fuse (Shigeru Koyama) and his two lieutenants: the cerebral Nishino (Toshiyuki Nishida) and the quick-to-violence Nakata (Sansei Shiomi). Kataoka then approaches Ôtomo, betrayed by the Sanno and left to rot in prison, and Kimura (Hideo Nakano), the former gang boss whose face was brutally disfigured by Ôtomo – and who knifed Ôtomo in prison as revenge at the end of *Outrage*. Kataoka asks them to join forces against the Sanno, and with these 'pawns' now supposedly in play, the film begins to weave its anarchic spell of deceit, animal violence and melancholic revenge.

Thematically, there are two dominant strands I would like to comment on. The first is the sense that the yakuza have been thoroughly bureaucratised, their operations and structures turned into pale imitations of warranted hierarchy and noble tradition. The Sanno is run like a large-scale company with relationships built on need, greed and impersonal connections. Their operations interconnect with other (legitimate) bureaucracies, and their goal is to simply make more money, control more turf, expand into other areas and markets for growth reasons alone. Yakuza traditions

are still partially held, but these are read as obligations forced upon the modern, who fail to respect them. Kitano films these scenes of obligations in tight angles but with a green sheen over the lens, so that they become haunted spaces of the past.

One can link the representation of the Sanno to the GFC, and Japan's own economic slow down. The Sanno become the banks and bankers who expanded too quickly, brokered impossible deals, increased profits and profitability at the expense of its 'customers'. The destruction of the Sanno is Japan's revenge for those who became too greedy, too corrupt; those who let go of traditional relations and family-orientated goals. It is also Kitano's authorial commentary on the failing of contemporary Japan and the fast changes undergoing, undoing contemporary life.

The second theme that dominates *Outrage Beyond* is one of disgust. This manifests itself in three ways. The central characters are or can be disgusting; in language use, ethical behaviour, violence and deception. The central characters and narrative events produce moments of disgust, particularly through violent acts that are deliberately gory and painful. The central characters, particularly Ôtomo, feel and experience disgust at the behaviour and activities that surround them. Ôtomo still passionately believes in the yakuza virtues of giri and *jingi* and the betrayal he has suffered wounds him deeply. His desire for revenge is one borne out of wanting to see these values re-instated, resurrected in the amoral universe he feels adrift in. He knows though that his time has past and his desire for revenge is to know a world that can no longer be known. Pathos and melancholy wash the film as it has done in some many other Kitano films, but here it seems a terminal condition.

Disgust can be understood as a gatekeeper emotion; a technique or mechanism that is used to propel or keep at bay that which threatens. It can also be understood as an anti-democratic force that opens up the body to new experiences and sensations that are usually repressed or denied expression. Disgust can be understood to be a border-crossing emotion, a particularly hyper-charged form of affect, a type of 'beyond' normal experience that cuts one free from language and a stable or known subjectivity. *Outrage* constantly offers the viewer this type of disgusting experience, while offering them a literal embodiment (Ôtomo) of how disgust can manifest in an individual. And yet Ôtomo is a figure of the past, brought back from the dead to impress upon the world the need for duty, obligation and loyalty. His border-crossings are transgressively carnal, borne of disgust, but they are also retroactive, a step back into the past, where the animal was king – where he was the lion man.

Aesthetically, one can read *Outrage* as classic Kitano, in terms of static framing, tight shot composition, cardio-vascular editing, slow and quick movement, desaturated colour and lighting. Bodies fall in a hail of bullets before the sounds are heard, there are rapid editing sequences of violence and violent action, there is stillness as a form of contemplation and existential silence, and the urban spaces are claustrophobic, menacing, haunted by the past or sanitised by the present.

Two sound aesthetic aspects are worth drawing attention to, however. The first is the heavy concentration on dialogue and shouting matches in the first half the film, what I would like to suggest is a violence of sound. Captured in short, staccato Japanese, words become bullets and bombs that shoot out of mouths that are weapons of

negation. So, while these are linguistic exchanges, the monosyllabic words used strip language right back to its bare essentials, and meaning becomes transmitted through the aural, the sonic; the angry, metallic vibrations of aggression thrown across a room. That the second half of *Outrage Beyond* is all physical violence, symbiotically connects violent words to actions, and violent actions to words, in a synthesis of mind (words) and body (action) that is experiencing an animal becoming.

The second sound aspect is the electronic-jazz score provided by Keiichi Suzuki, who also worked on *Outrage* and *Zatoichi*. The score is a mixture of industrial beats and atonal compositions, and a lighter, more melodic jazz style. At times, the music provides the exact rhythm to narrative action, but it also undermines what is being represented. In the same way that sound isn't always synchronized with narrative action, the music isn't simply used to confirm and reaffirm the emotional state of the film. This undermining of what we see and hear is another form of border-crossing, since the music seems to exist as a living entity in itself. It has its own animal intensity. The music also speaks to the film's own divided heart; the industrial beats sound out the terror and traumas of contemporary Japan, while the jazz draws one back in time, to a past where honour, duty and obligation were true and everlasting, where Japan was free, undefeated, and great filmmakers that Kitano reveres were being born or were beginning to make their mark in the film world.

I finish this postscript on sound, heard as a calling across time and space, a liberating but also threatening composition that scores the animal within us, and the nostalgia for a past where the wolf roamed free, where the wolf roamed free and flowers were made of blood.

FILMOGRAPHY

1989

Violent Cop (*Sono Otoko, Kyobo ni tsuki*)
Length: 103 min
Leading cast: Takeshi Kitano, Maiko
 Kawakami and Makoto Ashikawa
Director: Takeshi Kitano
Screenplay: Hisashi Nozawa
Cinematography: Yasushi Sasakibara
Editor: Nobutake Kamiya
Music: Daisake Kume
Sound: Senji Horiuchi
Executive Producer: Okuyama Kazuyoshi
Production Companies: Bandai
 Media Department, Shochiku-Fuji
 Company

1990

Boiling Point (*3-4xugatsum*)
Length: 96 min
Leading Cast: Takeshi Kitano, Yûrei Yanagi
 and Yuriko Ishida
Director: Takeshi Kitano
Screenplay: Takeshi Kitano
Cinematography: Katsumi Yanagijima
Editor: Taniguchi Toshio
Sound: Senji Horiuchi
Executive Producer: Okuyama Kazuyoshi
Production Companies: Bandai Media
 Department, Shochiku-Fuji Company,
 Yamada Right Vision Corporation

1991

A Scene at the Sea (*Ano natsu, ichiban
 shizukana umi*)
Length: 101 min
Leading Cast: Claude Maki, Hiroko
 Ôshima and Sabu Kawahara
Director: Takeshi Kitano
Screenplay: Takeshi Kitano
Cinematography: Katsumi Yanagijima
Editor: Takeshi Kitano
Music: Joe Hisaishi
Sound: Senji Hiriuchi
Executive Producer: Yukio Tachi
Production Companies: Office Kitano,
 Toho Company, Totsu

1993

Sonatine (*Sonachine*)
Length: 94 min
Leading Cast: Takeshi Kitano, Aya
 Kokumai and Tetsu Watanabe
Director: Takeshi Kitano
Screenplay: Takeshi Kitano
Cinematography: Katsumi Yanagijima
Editor: Takeshi Kitano
Music: Joe Hisaishi
Sound: Senji Hiriuchi
Executive Producer: Kazuyoshi Okuyama
Production Companies: Bandai Visual,
 Shouchiku Co., Shôchiku Eiga, Yamada
 Right Vision Corporation

1995

Getting Any? (*Minna yatteruka!*)
Length: 108 min
Leading Cast: Takeshi Kitano, Dankan,
 Moeko Ezawa
Director: Takeshi Kitano
Screenplay: Takeshi Kitano
Cinematography: Katsumi Yanagijima
Editor: Takeshi Kitano, Yoshinori Oota
Music: Hidehiko Koike
Sound: Senji Hiriuchi
Executive Producer: Yasushi Tsuge
Production Companies: Office
 Kitano, Bandai Visual, Right Vision
 Entertainment

1996

Kids Return (*Kizzu ritân*)
Length: 107 min
Leading Cast: Ken Kaneko, Masanobu
 Andô and Leo Morimoto
Director: Takeshi Kitano
Screenplay: Takeshi Kitano
Cinematography: Katsumi Yanagijima
Editor: Takeshi Kitano
Music: Joe Hisaishi.
Sound: Masashi Furuya
Executive Producer: Yasushi Tsuge
Production Companies: Office
 Kitano, Bandai Visual, Ota Productions

1997

Hana-Bi (*1997*)
Length: 103 min
Leading Cast: Takeshi Kitano, Kayoko
 Kishimoto and Ren Ohsugi
Director: Takeshi Kitano
Screenplay: Takeshi Kitano
Cinematography: Hideo Yamamoto
Editor: Takeshi Kitano
Music: Joe Hisaishi.
Sound: Masashi Furuya
Executive Producer: Yasushi Tsuge
Production Companies: Bandai Visual
 Company, Office Kitano, TV Tokyo,
 Tokyo FM Broadcasting Co.

1999

Kikijuro (*Kikujiro no natsu*)
Length: 121 min
Leading Cast: Takeshi Kitano, Yusuke
 Sekiguchi and Kayoko Kishimoto
Director: Takeshi Kitano
Screenplay: Takeshi Kitano
Cinematography: Katsumi Yanagijima
Editor: Takeshi Kitano, Yoshinori Ohta
Music: Joe Hisaishi.
Sound: Senji Horiuchi
Executive Producer: Masayuki Mori
Production Companies: Bandai Visual
 Company, Nippon Herald Films, Office
 Kitano, Tokyo FM Broadcasting Co.

2001

Brother
Length: 114 min
Leading Cast: Takeshi Kitano, Claude
 Maki and Omar Epps
Director: Takeshi Kitano
Screenplay: Takeshi Kitano
Cinematography: Katsumi Yanagijima
Editor: Takeshi Kitano, Yoshinori Ohta
Music: Joe Hisaishi.
Sound: Senji Horiuchi
Executive Producer: Masayuki Mori
Production Companies: Recorded Picture
 Company (RPC), Office Kitano, Bandai
 Visual Company, Fuzzy Bunny Films
 (I), Little Brother Inc., Tokyo FM
 Broadcasting Co.

2002

Dolls (*Dōruzu*)
Length: 114 min
Leading Cast: Miho Kanno, Hidetoshi
 Nishijima and Tatsuya Mihashi
Director: Takeshi Kitano
Screenplay: Takeshi Kitano
Cinematography: Katsumi Yanagijima
Editor: Takeshi Kitano,
Music: Joe Hisaishi.
Sound: Senji Horiuchi
Executive Producer: Masayuki Mori

Production Companies: Bandai Visual Company, Office Kitano, TV Tokyo, Tokyo FM Broadcasting Co.

2003

Zatoichi (*Zatôichi*)
Length: 116 min
Leading Cast: Takeshi Kitano, Tadanobu Asano and Yui Natsukawa
Director: Takeshi Kitano
Screenplay: Takeshi Kitano
Cinematography: Katsumi Yanagijima
Editor: Takeshi Kitano, Yoshinori Ohta
Music: Keiichi Suzuki
Sound: Senji Horiuchi
Executive Producer: Masayuki Mori
Production Companies: Asahi National Broadcasting Company, Bandai Visual Company, DENTSU Music And Entertainment, Office Kitano, Saitô Entertainment, TV Asahi, Tokyo FM Broadcasting Co.

2005

Takeshis'
Length: 108 min
Leading Cast: Takeshi Kitano, Kotomi Kyôno and Kayoko Kishimoto
Director: Takeshi Kitano
Screenplay: Takeshi Kitano
Cinematography: Katsumi Yanagijima
Editor: Takeshi Kitano, Yoshinori Ohta
Music: Nagi
Sound: Senji Horiuchi
Executive Producer: Masayuki Mori
Production Companies: Bandai Visual Company, Office Kitano, Tokyo FM Broadcasting Co., DENTSU Music And Entertainment, TV Asahi

2007

Glory to the Filmaker (*Kantoku Banzai!*)
Length: 108 min
Leading Cast: Takeshi Kitano, Toru Emori and Kayoko Kishimoto
Director: Takeshi Kitano

Screenplay: Takeshi Kitano
Cinematography: Katsumi Yanagijima
Editor: Takeshi Kitano, Yoshinori Ohta
Music: Shinichirô Ikebe
Sound: Senji Horiuchi
Executive Producer: Masayuki Mori
Production Companies: Bandai Visual Company, Office Kitano, Tokyo FM Broadcasting Co., DENTSU Music And Entertainment, TV Asahi

2009

Achilles and the Tortoise (*Akiresu to kame*)
Length: 119 min
Leading Cast: Takeshi Kitano, Kanako Higuchi and Kumiko Asô
Director: Takeshi Kitano
Screenplay: Takeshi Kitano
Cinematography: Katsumi Yanagijima
Editor: Takeshi Kitano
Music: Yuki Kajiura
Sound: Senji Horiuchi
Executive Producer: Masayuki Mori
Production Companies: Bandai Visual Company, Office Kitano, TV Asahi,Tokyo FM Broadcasting Co., Tokyo Theaters Company, WoWow

2010

Outrage (*Autoreiji*)
Length: 109 min
Leading Cast: Takeshi Kitano, Kippei Shiina and Ryo Kase
Director: Takeshi Kitano
Screenplay: Takeshi Kitano
Cinematography: Katsumi Yanagijima
Editor: Takeshi Kitano
Music: Keiichi Suzuki
Sound: Senji Horiuchi
Executive Producer: Takeshi Kitano, Masayuki Mori
Production Companies: Bandai Visual Company, Office Kitano, Omnibus Japan, TV Tokyo, Tokyo FM Broadcasting Co.

2012

Outrage Beyond (*Autoreiji Biyondo*)
Length: 112 min
Leading Cast: Beat Takeshi, Toshiyuki Nishida, Tomokazu Miura, Ryo Kase, Hideo Nakano
Director: Takeshi Kitano
Screenplay: Takeshi Kitano
Cinematography: Katsumi Yanagijima
Editor: Takeshi Kitano, Yoshinori Ota
Music: Keiichi Suzuki
Sound: Kenji Shibazaki
Executive Producer: Masayuki Mori, Takio Yoshido
Production Companies: Bandai Visual Company, Office Kitano, Omnibus Japan, TV Tokyo, Warner Bros Pictures Japan

BIBLIOGRAPHY

Abe, Casio (2004) *Beat Takeshi vs Kitano Takeshi*. New York: Muae Publishing/Kaya Press.

Ahmed, Sara (2000) *Strange Encounters: Embodied Others in Post-Coloniality*. London: Routledge.

Ang, Ien (1985) *Watching Dallas: Soap Opera and the Melodramatic Imagination*. London: Methuen.

Appadurai, Arjun (1993) 'Patriotism and its Futures, *Public Cultures*, 5, 3, 411–29.

Artaud, Antonin (1976) 'To Have Done with the Judgment of God', in *Antonin Artaud: Selected Writings*, ed. Susan Sontag. Berkeley, CA: University of California Press, 553–71.

Bakhtin, Mikhail (1993 [1965]) *Rabelais and His World*, trans. Hélène Iswolsky. Bloomington, IN: Indiana University Press.

____ (1997) *Excitable Speech: A Politics of the Performative*, New York: Routledge

Bauman, Zygmunt (1992) *Intimations of Postmodernity*. London & New York: Routledge.

____ (2003) *Liquid Love: On the Frailty of Human Bonds*. Cambridge: Polity Press.

Noël Burch (1979) *To the Distant Observer: Form and Meaning in the Japanese Cinema*. Berkeley, CA: University of California Press.

Butler, Judith (1993) *Bodies That Matter: On the Discursive Limits of 'Sex'*. New York: Routledge.

____ (1997) Performative Acts and Gender Constitution: An Essay in Phenomenology and Feminist Theory, in Katie Conboy, Nadia Medina, and Sarah Stanbury (eds) *Writing on the Body: Female Embodiment and Feminist Theory*, New York: Columbia University Press.

Cole, Graeme (2005) 'Eyes Wide Open: An Interview with Takeshi Kitano', *Kamera*. http://www.kamera.co.uk/interviews/an_interview_with_takeshi_kitano.php

Colebrook, Claire (2005) 'The Space of Man: On the Specificity of Affect in Deleuze and Guattari', in Ian Buchanan and Greg Lambert (eds) *Deleuze and Space*. Edinburgh: Edinburgh University Press, 189–206.

Corrigan, Tim (1991) *A Cinema Without Walls: Movies and Culture After Vietnam*. London: Routledge.

Davis, Bob (2003) 'Takeshi Kitano', *Senses of Cinema*, http://archive.sensesofcinema.com/contents/directors/03/kitano.html

Davis, Darrell William (2001) 'Reigniting Japanese Tradition with *Hana-Bi*', *Cinema Journal*, 40, 4, 55–80.

_____ (2007) Therapy for Him and Her: Kitano Takeshi's *Hana-Bi*, in Alastair Philips and Julian Stringer (eds) *Japanese Cinema: texts and contexts*. London: Routledge. 284–295

Davis, Darrell William and Emilie Yueh-yu Yeh (2008) *East Asian Screen Industries*. London: British Film Institute.

Deleuze, Gilies (1988) *Foucault*, trans. Sean Hand. Minneapolis: University of Minnesota Press.

_____ (1989) *Cinema 2: The Time Image*, trans. Hugh Tomlinson and Barbara Habberjam. London: Athlone.

_____ (2001) *Pure Immanence, Essays on A Life*, Zone Books New York 2001

_____ (2003) *Francis Bacon: The Logic of Sensation*, trans. Daniel W. Smith. London: Continuum.

_____ (1986) *Cinema 1: The Movement Image*, Trans. Hugh Tomlinson and Barbara Habberjam, London: Athlone

Deleuze, Gilies and Felix Guattari (1988) *A Thousand Plateaus*, trans. Brian Massumi. London: Athlone.

Desser, David (1983) 'Toward a structural analysis of the postwar samurai film', *Quarterly Review of Film and Video*, 8, 1, 25–41.

Dissanayake Wimal (1990) Self, Place, and Body in *The Woman in the Dunes*: A Comparative Study of the Novel and the Film, in Jean Toyama and Nobuko Ochner (eds) *Literary Relations, East and West: Selected Essays*, University of Hawaii Press, 41–54

Doane, Mary Anne (2000) 'Film and the Masquerade: Theorising the Female Spectator', in E. Ann Kaplan (ed.) *Feminism and* Film. Oxford and New York: Oxford University Press, 418–37.

_____ (2004) 'Pathos and Pathology: The Cinema of Todd Haynes', *Camera Obscura*, 19, 3, 1–17.

Doty, Alexander (2000) 'There's Something Queer Here', in Joanne Hollows, Peter Hutchings, Mark Jancovich (eds) *The Film Studies Reader*. Arnold: London Press.

Dyer, Richard (1986) *Heavenly Bodies: Film Stars and Society*. New York: St. Martin's Press.

_____ (1998) *Stars*. London: Routledge.

Ellis, John (2007) 'Stars as a Cinematic Phenomenon', in Sean Redmond and Su Holmes (eds) *Stardom and Celebrity: A Reader*. London: Sage, 90–8.

Eisenstein, Sergei (1977 [1949]) *Film Form*, trans. Jay Leyda. Los Angeles: Harcourt Brace.

Flaxman, Gregory (2000) 'Introduction', in Gregory Flaxman (ed.) *The Brain is the Screen: Deleuze and the Philosophy of Cinema*. Minneapolis: University of Minnesota Press.

Foucault, Michel (1986) 'Of Other Spaces', *Diacritics*, Spring, 23, 22–7.

_____ (1990) 'Maurice Blanchot: The Thought from Outside', in Michel Foucault and Maurice Blanchot, *Foucault/Blanchot*, trans. Jeffrey Mehlman & Brian Massumi. New York: Zone Books.

_____ (1998) 'What is an Author?', trans. Josué V. Harari, in James D. Faubion (ed.) *Aesthetics, Method, Epistemology*. London: Penguin, 205–22.

Freeman, Mark (2000) 'Kitano's *Hana-Bi* and the Spatial Traditions of Yasujiro Ozu', *Senses of Cinema*, http://www.sensesofcinema.com/contents/00/7/kitano.html; accessed 14 November 2005.

Gerow, Aaron (2007) *Kitano Takeshi*. London: British Film Institute.

Geraghty, Christine (2007) 'Re-examining Stardom: Questions of Texts, Bodies and Performance', in Sean Redmond and Su Holmes (eds) *Stardom and Celebrity: A Reader*. London: Sage, 98–110.

Gomery, Douglas (1991) *Movie History: A Survey*. Belmont, CA: Wadsworth.

Grodal, Torben (1999) *Moving Pictures: A New Theory of Film Genres, Feelings, and Cognition*. New York: Oxford University Press.

Harper, Stephen (2006) 'Madly Famous: Narratives of Mental Illness in Celebrity Culture', in Su Holmes and Sean Redmond (eds) *Framing Celebrity: New Directions in Celebrity Culture*. London: Routledge, 311–28.

Heidegger, Martin (1975) *Poetry, Language, Thought*, trans. Albert Hofstadter. New York: Harper and Row.

Hunt, Leon (2008) 'Asiaphilia, Asianisation and the Gatekeeper Auteur: Quentin Tarantino and Luc Besson', in Leon Hunt and Leung Wing-Fai (eds) *East Asian Cinemas*. London: I.B. Taurus, 220–36.

Hunt, Leon and Leung Wing-Fai (2008) 'Introduction', in Leon Hunt and Leung Wing-Fai (eds) *East Asian Cinemas*. London: I.B. Taurus, 1–6.

Inuhiko, Yomota (2007) 'The Menace from the South Seas: Honda Ishiro's *Godzilla* (1954)', in Alastair Phillips and Julian Stringer (eds) *Japanese Cinema Texts and Contexts*. London: Routledge, 102–11.

Igarashi, Yoshikuni (2000) *Bodies of Memory: Narratives of War in Postwar Japanese Culture, 1945–1970*. Princeton, NJ: Princeton University Press.

Ivy, Marilyn (2000) 'Revenge and Recapitation in Recessionary Japan', *South Atlantic Quarterly*, 99, 4, 819–40.

Iwabuchi, Koichi (2002) *Recentering Globalization: Popular Culture and Japanese Transnationalism*. Durham, NC: Duke University Press.

Jacobs, Brian (ed.) (1999) *Beat Takeshi Kitano*. London: Tadao Press.

Jahn, Pamela (2011) '*Outrage*: Interview with Takeshi Kitano', *Electric Sheep*, http://www.electricsheepmagazine.co.uk/features/2011/12/06/outrage-interview-with-takeshi-kitano/

Jermyn, Deborah (2008) 'Still Something Else Besides a Mother? Negotiating Celebrity Motherhood in Sarah Jessica Parker's Star Story', *Social Semiotics*, 18, 2, 163–76.

Kant, Immanuel (1987 [1973]) *Critique of Judgment*, trans., James Creed Meredith. Oxford: Clarendon Press.

Kaplan, E. Ann (1997) *Looking for the Other: Nation, Woman and Desire in Film*. London, Routledge.

Kasho, Abe (2000) *Nihon eiga ga sonzai sura* (Japanese Films Exist). Tokyo: Seidosha.

Ko, Miko (2004) 'The Break-up of the National Body: Cosmetic Multiculturalism and Films of Mikke Takashi', *New Cinemas*, 2, 1, 29–39.

Kracauer, Siegfried (1997 [1960]) *Theory of Film: The Redemption of Physical Reality*. Princeton, NJ: Princeton University Press.

_____ (1998) *The Salaried Masses: Duty and Distraction in Weimar Germany*, Trans. Quintin Hoare, London: Verso

Lyotard, Jean-Francois (1988) *The Inhuman: Reflections on Time*, trans. Geoffrey Bennington and Rachel Bowlby. Cambridge: Polity Press.

MacCormack, Patricia (2008) *Cinesexuality*. Aldershot: Ashgate.

Marks, Laura U. (2000) *The Skin of the Film: Intercultural Cinema, Embodiment and the Senses*. Durham, NC: Duke University Press.

Marshall, David P. (1997) *Celebrity and Power: Fame in Contemporary Culture*. Minneapolois, University of Minnesota Press.

McDonald, Keiko I. (2006a) *Reading a Japanese Film: Cinema in Context*. Honolula: University of Hawai'i Press.

_____ (2006b) *A New History of Japanese Cinema: A Century of Narrative Film*. London: Continuum.

McRoy, Jay (ed.) (2005a) *Japanese Horror Cinema*. Edinburgh: Edinburgh University Press.

_____ (2005b) 'Case Study: Cinematic Hybridity in Shimizu Takeshi's *Ju-on: The Grudge*', in Jay McRoy (ed.) *Japanese Horror Cinema*. Edinburgh: Edinburgh University Press, 175–84.

Mercer, Kobena (1992) '"1968": Periodizing Politics and Identity', in Lawrence Grossberg, Cary Nelson and Paula Treichler (eds) *Cultural Studies*. New York: Routledge, 424–49.

Miyao, Daisuke (2004) 'Foreward', in Casio Abe, *Beat Takeshi vs. Takeshi Kitano*. New York: Kaya, 1–6.

Nicholls, Mark (2004) *Scorsese's Men: Melancholia and the Mob*. Melbourne: Pluto Press.

Nygren, Scott (2007) *Time Frames: Japanese Cinema and the Unfolding of History*. Minneapolis: University of Minesota Press.

Olkowski, Dorothea (1999) *Gilles Deleuze and the Ruin of Representation*. Berkeley, CA: University of California Press.

Ota, Carol (2007) *The Relay of Gazes: Representations of Culture in the Japanese Televisual and Cinematic Experience*. Plymouth: Lexington Books.

Pichon-Sintes, Romain (2010) '*Outrage* and the Yakuza: the Way of the Chopped Finger Takeshi Kitano', *In Focus*, http://www.nisimazine.eu/Encounter-Takeshi-Kitano.html

Parente-Čapková, Viola (2006) 'Narcissuses, Medusas, Ophelias...Water Imagery and Femininity in the Texts by Two Decadent Women Writer's, *Wagadu*, 3, Spring, 189–216.

Ranciere, Jacques (1998) 'Le movement suspendo', *Cahiers du Cinema*, 523, April, 34–6.

Rayns, Tony (2003) 'Puppet Love', *Sight and Sound*, 13, 6, 18.

Redmond, Sean (2006) 'Intimate Fame Everywhere', in Su Holmes and Sean Redmond (eds) *Framing Celebrity: New Directions in Celebrity Culture*. London: Routledge, 27–43.

_____ (2008) 'When Planes Fall Out of the Sky', in Sean Redmond and Karen Randell (eds) *The War Body on Screen*. London: Continuum, 22–35.

_____ (2010) 'Avatar Obama in the Age of Liquid Celebrity', *Celebrity Studies*, 1, 1, 81–95.

Richie, Donald (1972) *Japanese Cinema: Film Style and National Character*. London: Secker and Warburg.

Rojek, Chris (2004) *Celebrity*. London: Reaktion Press.

Scarry, Elaine (1987) *The Body in Pain: The Making and Unmaking of the World*. New York: Oxford University Press.

Schrader, Paul (1972) *Transcendental Style in Film: Ozu, Bresson, Dreyer*, Berkeley: University of California Press

Sharrett, Christopher (2005) 'Introduction: Recent Trends in Japanese Horror Cinema', in Jay McRoy (ed.) *Japanese Horror Cinema*. Edinburgh: Edinburgh University Press, xi–xiv.

Shinozaki, Makoto (1997) 'Interview with Kitano Takeshi', *Studio Voice*, November.

Shneidman, Edwin S. (1995) 'The Post-self,' in John B. Williamson and Edwin S. Shneidman (eds) *Death: Current Perspectives*, fourth Edition. Mountain View, CA: Mayfield, 454–60.

Slaughter, Marty (2004) 'The Arc and the Zip: Deleuze and Lyotard on Art', *Law and Critique*, 15, 231–57.

Slocum, David J. (2001) 'Introduction: Violence and American Cinema: Notes for an Investigation', in David J. Slocum (ed.) *Violence and American Cinema*. London: Routledge, 1–34.

Sobchack, Vivian (2004) *Carnal Thoughts: Embodiment and Moving Image Culture*. Berkeley, CA: University of California Press.

Stacey, Jackie (2000) 'The Global Within: Consuming Nature, Embodying Health', in Sarah Franklin, Celia Lury and Jackie Stcey (eds) *Global Nature, Global Culture*. London: Sage, 97–145.

Standish, Isolde (2006) *A New History of Japanese Cinema*. New York: Continuum.

Studlar, Gaylyn (2000) 'Masochism and the Perverse Pleasures of the Cinema', in E. Ann Kaplan (ed.) *Feminism and Film*. Oxford and New York: Oxford University Press.

Suzuki, Takao (1987) *Reflections on Japanese Language and Culture*. Tokyo: Keio University.

Thompson, John (1999) 'The Media and Modernity', in Hugh Mackay and Tim O'Sullivan (eds) *The Media Reader: Continuity and Transformation*. London: Sage, 13–27.

Tsutsumi, Ryuichiro (2006) 'Finding an Alter Ego: the Triple-Double Structure of Brother', *Iconics*, 8, 135–57.

White, Eric (2005) 'Case Study: Nakata Hideo's *Ringu* and *Ringu 2*', in Jay McRoy (ed.) *Japanese Horror Cinema*. Edinburgh: Edinburgh University Press, 38–50.

Williams, Linda (1991) 'Film Bodies: Gender, Genre, and Excess', *Film Quarterly*, 44, 4, 2–13.

Yamane, Sadao (1993) *Sekai no naka no nihon eiga* (Japanese Films in the World). Nagoya: Kawai Bunka Kyoiku Kenkyu-sho.

Young, Iris Marion (1995) *On Female Body Experience: Throwing Like a Girl and Other Essays*. New York: Oxford University Press.

INDEX

Kitano Blue 47, 49

Light 5, 17–18, 23, 29, 53, 77, 88, 107
lion-man 39, 76
luminal 10, 14, 28–9, 34, 42, 49, 62–3, 66, 88

ma 20, 94
machine 17, 33, 58, 71, 76, 88, 96, 101
majoritarian 71, 75, 85
masculinity 9, 35, 50, 61–2, 68
masochism 44, 80
masks 6, 12, 51, 55, 67, 70
masquerade 44, 51, 66–7, 79
melancholy 39, 71, 85, 107
memory 21–2, 36, 53, 75, 92
memorial image 13, 27–9, 92–3
minority cinema 18, 35
minoritarian 20, 69, 71, 79, 81–2, 102
monstrous 9, 88, 90
mother, motherhood 21–2, 40, 59, 62–3, 65, 67, 78, 89, 93, 95, 99
movement image 17
mu 20, 94
mujo awareness 94
multiplicity 10, 35

national identity 45
national imaginary 10, 19, 30, 68–9, 87
negative space 25–6, 39, 50
Noh theatre 59
Nomad 24, 34–5, 42, 54, 87, 94, 102

Occidental 14, 83-4

Orientalism 1, 4, 14, 84–5
Otherness 1, 4–5, 9, 11, 13–14, 34, 56, 58, 61, 63, 93, 96

pain image 14, 36, 38–45, 54, 61, 76, 80, 91, 99
pathos 14, 24, 40, 45, 47–50, 54–6, 62, 71, 73, 79, 82, 93, 95–6, 99, 101–4
phenomenological 1, 6, 12, 50, 60, 86, 102
pillow shot 26, 30, 95
point of view 19–20, 39, 92–3, 104–5
post-self 55–6, 93
purification 89–91

queer space 66

recession 18, 45
road movie 96
rural 68, 90

sadism 80
samurai 83–4
sexuality 44, 49, 51, 58, 63–4, 69, 91
silence 18, 20–5, 39, 41, 67, 71, 75–6, 104–5, 107
sound 21, 38, 48, 53, 76, 96, 104, 107–8
space 1, 5, 7–13, 16, 19–32, 35, 41, 49–56, 59–62, 69, 76, 84, 87–91, 93–6, 101, 103, 105, 107
star image 35, 71, 73–5
stardom 14, 62, 71, 79–81, 98
stereotypes 35, 58, 65, 83
Sonatine 16, 28–9, 40, 42, 47, 54, 60–2, 83–4, 91–2

suicide 21, 28, 32, 40, 55, 63–4, 68, 81, 87, 91, 98, 100
systolic 32–3, 49

Takeshi, Miike 4, 36
Takeshis 14, 70, 80, 98
time image 8, 13, 17–19, 26, 54, 61, 95–6, 105
tonality 31
torture 44, 46, 77, 79, 84
tradition 9–10, 30, 86
transnational 10, 14, 24, 30, 70, 73, 82–5
transgressive 4, 13, 43–4, 67, 85, 107

violence 14, 18, 23, 31–3, 36–41, 43–5, 48–51, 59–62, 68, 76, 80, 84, 99, 103, 106–7
Violent Cop 16, 43–4, 79, 82, 84
Void 8, 23–5, 30–1, 67, 74

Western, Westernisation 1, 4–5, 19, 23, 46, 50, 58, 69–70, 83–4
wound 14, 22, 30, 38–9, 70, 79, 81, 92, 103, 107
woman 9, 27, 44, 52, 59, 61–6, 77, 79–80, 88–92

yakuza 9, 26, 28–30, 33, 39, 44, 51, 59, 61–6, 68–9, 90–5, 104–7

Zatoichi 5, 28, 47, 50–1, 55, 67, 83, 101, 108
zen 89, 94
zero 18, 29–30